Teen Film

Berg **Film Genres** series

Edited by Mark Jancovich and Charles Acland

ISSN: 1757-6431

The *Film Genres* series presents accessible books on popular genres for students, scholars and fans alike. Each volume addresses key films, movements and periods by synthesizing existing literature and proposing new assessments.

Published:

Fantasy Film: A Critical Introduction

Forthcoming:

Science Fiction Film: A Critical Introduction
Historical Film: A Critical Introduction
Anime: A Critical Introduction
Documentary Film: A Critical Introduction

Teen Film

A Critical Introduction

Catherine Driscoll

Oxford • New York

English edition
First published in 2011 by
Berg
Editorial offices:
First Floor, Angel Court, 81 St Clements Street, Oxford OX4 1AW, UK
175 Fifth Avenue, New York, NY 10010, USA

Berg is the imprint of Bloomsbury Publishing Plc.

Library of Congress Cataloging-in-Publication Data

A catalogue record for this book is available from the Library of Congress.

British Library Cataloguing-in-Publication Data

A catalogue record for this book is available from the British Library.

ISBN 978 1 84788 687 3 (Cloth)
 978 1 84788 686 6 (Paper)
e-ISBN 978 1 84788 845 7 (Institutional)
 978 1 84788 844 0 (Individual)

Typeset by JS Typesetting Ltd, Porthcawl, Mid Glamorgan

www.bergpublishers.com

This book is for Sean, with love.

Contents

Illustrations

Acknowledgements

This book was made possible by the editors of Berg's Film Genres series, Mark Jancovich and Charles Acland, and by Tristan Palmer, our editor at Berg. But it would have been more difficult without the exciting and supportive research environment in which I work. Thanks, as always, to my colleagues in the Department of Gender and Cultural Studies at the University of Sydney. I wrote most of this book while on sabbatical at Columbia University in the Institute for Research into Women and Gender. In the course of this research not only many colleagues but friends and family members enthusiastically shared with me their understandings of teen film and favourite or despised examples of the genre. For more personal support and advice I am grateful to Jane Glaubman, Morgan Howard, Meaghan Morris, Jane Park, Ruth Talbot-Stokes and, especially, my son Sean, who vehemently disagreed with most of my ideas about teen film and without whom this would be a very different book. Finally, this is the first book I have written with undergraduate students particularly in mind. It began as a set of lectures on youth culture, adolescence, and teen film, and I want to sincerely thank my students (at the universities of Melbourne, Adelaide, and Sydney) for everything they've taught me.

Differently directed and heavily supplemented articles based on Chapters 1 and 7, and an essay drawing heavily on this research but focused on girl sexuality in teen film, are all forthcoming at the time of publication.

Catherine Driscoll

Introduction – The Adolescent Industry: 'Teen' and 'Film'

As a teenager in rural Australia I saw many films that now appear in studies of teen film. I remember seeing *Grease* (1978), *Friday the Thirteenth* (1980), *Little Darlings* (1980), *WarGames* (1983) and many more that are included in some histories of teen film and surveys of the genre but excluded from others – *Saturday Night Fever* (1977), *The Warriors* (1979), *Blue Lagoon* (1980), and *An American Werewolf in London* (1981). Whether or not I liked these films, I understood them to represent an experience of youth with which I vaguely identified – an adolescence that was unsettled, uncertain and transitional. The social positions and experiences associated with being a teenager in these films didn't really describe my life, and probably few people have ever felt their adolescence was accurately portrayed by teen film. But these films seemed to be addressed to me, which often meant I felt especially equipped to reject them. And they sketched for me a broadly shared terrain on which young people negotiated social transitions that were as simultaneously constrained and volatile as my own.

To this point my experience conforms to most discussions of teen film. But I felt this way about teen film at the movies with my family before I went to high school, at the drive-in with my boyfriend in my mid-teens, at home on video with adult friends in my late teens and across many formats with a wide variety of friends and family (including my son) through my twenties and thirties. At none of these points did the transitions of adolescence on film stop being somehow both relevant and alien to me. In recent years I regularly teach courses on youth culture for which I set teen film texts and my students' responses now contribute to my sense of consistencies and shifts in the field of teen film. My students approach teen film with very varied attitudes and experiences but overwhelmingly recognize two dominant ideas about teen film (although sometimes they disagree with them). First, that teen film is defined most of all by its audience and, second, that whether comic, angst-ridden or violent, the appeal of teen film is as transient as adolescence itself.

David Considine credits the inspiration for his book *The Cinema of Adolescence* to the discovery, while teaching in Australia in the 1970s, that 'Humphrey Bogart and the Dead End Kids' (*Dead End*, 1937) and Jim Stark in *Rebel Without a Cause* (1955) were just as relevant to his students as they had been decades earlier. His surprise is based on apparent historical and cultural differences. But teen film, Considine found, offered ways of understanding the experience of 'Lebanese

students who spoke almost no English' but could nevertheless watch American teen films of an earlier generation as 'images of themselves' (Considine 1985: v). For Roz Kaveney (2006: 85), writing about the lack of fit between images of American high school and English experiences of adolescence, this would be a colonizing imposition of Hollywood film on the imaginary of youth in other cultures, but I think the question of where teen film comes from, what it represents and for whom, is far more complicated.

My approach to teen film is predominantly discursive rather than aesthetic. That is, I am not going to attempt to define teen film by directorial or editing styles. But an emphasis on adolescence itself, rather than on questions of film style, and a more sociological than formalist approach to generic conventions, is common in studies of teen film. Teen film is generally thought more interesting for what it says about youth than for any aesthetic innovations, and is represented as closely tied to the historically changing experience of adolescence. There are certainly narrative conventions that help define teen film: the youthfulness of central characters; content usually centred on young heterosexuality, frequently with a romance plot; intense age-based peer relationships and conflict either within those relationships or with an older generation; the institutional management of adolescence by families, schools, and other institutions; and coming-of-age plots focused on motifs like virginity, graduation, and the makeover. Engaging with teen film as a genre means thinking about the certainties and questions concerning adolescence represented in these conventions. As Adrian Martin (1994: 66–7) argues, 'the teen in teen movie is itself a very elastic, bill-of-fare word; it refers not to biological age, but a type, a mode of behaviour, a way of being ... The teen in teen movie means something more like youth.' Martin finds useful in this sense Robert Benayoun's list of 'normal qualities of youth: naïveté, idealism, humour, hatred of tradition, erotomania, and a sense of injustice' (Martin 1994: 67). In addition to typical narrative conventions, character types, and formal elements, like the incorporation of contemporary popular culture, there is a sensibility to teen film which Benayoun's list goes some way towards capturing. And this sensibility also explains why neither its subject matter nor its appeal is confined to teenagers.

Not every film with this range of conventional content about teenagers is a teen film (not documentaries, for example) and some films not literally about teenagers are (including most 'college' films, for example). Both 'youth' and 'adolescence' might be more appropriate names for what centres teen film than 'teen'. While 'teen' names a set of tendencies and expectations rather than an identity mapping onto the years thirteen to nineteen, the concept 'teenager' is too narrow to define a genre that is preoccupied with the difficulty as well as the importance of borders. The fact that we label this genre of films 'teen film' is nevertheless significant. 'Teen' describes an historical extension of, and limit on, a period of social dependence after puberty. The contradiction between maturity and immaturity that 'teen' thus describes is central to teen film. But if the genre label is useful, teen film is not defined by

representing teenagers. It is actually as difficult to establish the boundaries of 'teen film' as it is to specify when 'adolescence' begins or ends, and this difficulty is entirely appropriate. I have nevertheless given priority in this book to those films most widely recognized as teen film – that is, I have given priority to mainstream popular anglophone films that predominantly address a youthful audience for stories about adolescence. I do want to ask questions about this prioritization, one which unites other available texts on teen film, but for the first half of the book I am concerned, first of all, with what constitutes this received category of teen film. This means that my discussion of Japanese, Indian, or even Australian teen film, will finally be less extensive than that of much-discussed American standards but this is a necessary sacrifice when striving for a balance between exploring what else can be known about the apparently transparent genre of teen film and questioning the limits of the genre itself.

One apparently central and transparent fact about teen film is that it is *for* adolescents. Previously, when writing about popular film as girl culture, I have distinguished between 'youth film', packed with rebellious subcultural cachet, and 'teen film', centred on the institutional life of adolescents at home and school – the former being generally identified with boys and the latter with girls (Driscoll 2002: 203–34). Other critics make similar claims and Kaveney's (2006) definition of teen film in particular is remarkably similar. This definition differs strikingly from that proposed by historians of the genre like David Considine, Timothy Shary and Thomas Doherty, for whom youth problem films like *Rebel Without a Cause* are paradigmatic examples. For myself, researching this book has brought me to the conclusion that separating 'teen' and 'youth' film obscures the importance of their shared discourse on adolescence. Some films emphasize the institutionally framed world of dependent adolescence, and others the refusal or struggle with that framing, but a vast number of films explore their interdependence.

In this context, defining teen film is also not a matter of assessing which films 'teens' watch, even if my emphasis on the teen films of John Hughes rather than those of François Truffaut could be explained that way. As Emma French argues, a consideration of marketing is useful for defining teen film; distinguishing some films as 'for' as well as 'about' adolescents (French 2006: 102ff). But this does not mean the teen-film audience is a specific demographic. Referring to a range of studies of youth audiences, including a 2000 survey by the Motion Picture Association of America (MPAA), French notes that even the category 'teen audience' is not confined to teenagers. The MPAA study, for example, encompassed viewers from twelve to twenty-four (French 2006: 104–5). The relation between teen film and its audience is 'a complex one which cannot be adequately explained in empirical terms, according to how many teens attend certain films' (French 2006: 107) or even by 'a theory of the ideal spectator inscribed in the text' (French 2006: 107, quoting Morley). But the idea that teen film is made to be watched by the ideal teenager of a particular time and place is taken for granted by most scholarship on teen film.

If my approach to teen film focuses on content rather than style it does not isolate films from their context. It begins with history, although it does not produce a single historical account in which teen film mirrors teenage lives. I agree with Georganne Scheiner (2000: 2) in thinking 'it is productive to use film to understand history, history to understand film, and both to understand adolescence.' As Benton, Dolan and Zisch (1997: 88) argue, introducing a useful bibliography of scholarly work on teen film, 'Studying the films is an important way of understanding an era's common beliefs about its teenaged population within a broader pattern of general cultural preoccupations.' Their bibliography also points to the wide array of available commentary on teen film, including in film magazines and other periodicals, that precedes and surrounds the emergence of Anglophone books on teen film in the 1980s. For this study I have principally drawn on and responded to the more extended discussion of monographs and edited collections, but film reviews in particular offer an appropriately diverse and shifting picture of the genre somewhat lost in scholarly books, including mine.

Shary's short book *Teen Movies: American Youth on Screen* (2005) includes a more comprehensive history of teen film than most on the subject. Listing many key films, Shary presents a chronological narrative which stresses how teen film represents a changing American adolescent experience. This restriction of the idea that teen film represents teenagers to American teenagers is very common in scholarship on teen film. Most of the films I have named thus far were produced in the United States (US), and the genre has been strongly identified with a range of specifically US motifs, like cheerleaders and 'the prom'. But the idea that teen film is especially American is also one this book questions, and not only by referring to films that in every way seem to be teen films but are made in Australia, Canada, India, Indonesia, Israel, Japan, the United Kingdom (UK), or elsewhere. The more significant question is whether the idea of adolescence on which I argue teen film is based is an intrinsically American one exported to these other contexts.

Scholarly texts on teen film as a genre, including those by Considine, Kaveney, and Shary, are often critical of its unrealistic portrayal of adolescent experience. They also tend to judge films in the genre as good or bad in terms of a responsibility to represent adolescence in ways that would be *good for* adolescents. This tendency to moral judgement reflects a tendency in the genre itself to take a moral tone that understands adolescence as both object of training and subject of crisis. In teen film, adolescents are routinely set apart from, and often in conflict with, the 'parent culture' of families, schools and so on. Reference to generational difference threads through the stories, audiovisual styles, and marketing of teen film. While the genre's image of adolescent experience maintains a remarkable consistency – as Considine's anecdote about 1970s teenagers watching *Dead End* implies – it is consistently contradictory. Teen film suggests that adolescent experience consists of both passionate consumption and rejection of conformity, both peer identification and anomie (aimlessness), both emotional intensity and fashion-consciousness,

both rebellion and gullibility. Can these all be unchanging psychosocial facts of development and, at the same, clearly mark out generational difference? Such ideas about adolescence and generation are clearly popularized by teen film, but it is also teen film that over and over again frames these ideas as new to each new generation when it has not produced these ideas in the first place. This presents a problem for any *mimetic* understanding of teen film as a reflection of adolescent lives.

Overall, then, three claims about representation dominate scholarship on teen film: that it is American, that it represents teenage life and concerns, and that it fails to represent teenagers accurately. But does teen film actually represent teenagers at all and, if it does, how and for whom does such representation appear and in what ways does this question of representativeness matter? In order to offer a history of teen film, outline its central conventions, and also ask such questions, I have elected not to write this book as a survey of teen films. Instead, clusters of film examples have been arranged around key questions for defining the genre and for considering its relation to broader ideas about adolescence. Thus I want to conclude my introduction by stressing that film and modern adolescence emerged at the same time and have consistently influenced each other.

In May 1924, film producer B. P. Schulberg published a short opinion piece in the US magazine *Photoplay* entitled 'Meet the Adolescent Industry: Being an Answer to Some Popular Fallacies.' This was one of many defences of cinema published in the popular press in the 1920s. Schulberg associates film with a mesh of promise and vitality, vulnerability and development that we still associate with adolescence. He further claims the contemporary film industry is, like an adolescent, still maturing and not yet predictable although it has developed unique characteristics. But more is at stake in this claim than it might first seem. As I have argued at length elsewhere, the modern idea of adolescence is quite different from the markers of majority and ideas about education of earlier periods (Driscoll 2002: 47–77; 2009: 21–65). Adolescence as an identity crisis bound to both emerging sexuality and training in citizenship was 'discovered' in the nineteenth century by new social sciences and new modes of cultural criticism at the same time as experiments with cameras and film were tending towards cinema. Adolescence and cinema were in many respects new industries for the twentieth century. Two years after Schulberg's (1926: xi) essay, film producer, historian, and film magazine editor, Terry Ramsaye would claim that 'Like all great arts the motion picture has grown up by appeal to the interests of childhood and youth.' In fact film is probably the first artistic medium of which this could be said.

Schulberg and Ramsaye suggest the importance of ideas about the film audience to early associations between adolescence and film. Discussion of cinema's new ways of speaking to its audience sometimes focused on the impressionable audience for expanding mass culture industries, for which youth formed a pivotal example – in, for example, the Weimar essays of Seigfried Kracauer. Sometimes the focus was on the dangerously undiscriminating consumption of irresponsible youth – see, for

example, the essays by Wilton Barrett and Donald Young in a 1926 issue of *Annals of the American Academy of Political and Social Science* (Barrett 1926; Young 1926). In the mass media and in expert books on film, on youth, and on modern life, whether they celebrated or condemned film, youth at the movies was the pivotal test case for the promise and danger of cinema. Concern about what youth sees at the movies might seem like a contemporary issue to readers of today's newspapers, magazines, and blogs, but modern adolescence has always been a sign for and site of cultural change.

Teen Film is divided into three parts, the first discussing histories of teen film, the second generic conventions centred on the characterization of adolescence, and the third the limitations of defining teen film by those conventions. In Part I three chapters deal with three distinct histories of teen film: the pre-World War Two origins of youthful stars and youth-centred film narratives; the institutionalization of the teenager across multiple subgenres in the 1950s; and the apparent renaissance of teen film in the 1980s. Part II explores key themes cohering teen film adolescence: the rite of passage to social independence; the bodily and social trauma of developing a coherent individual identity; and the interplay between developing agency and social alienation. Finally, Part III approaches the ongoing significance of teen film by asking if the genre can be defined in other ways. It considers 'teen film' as part of what studies of youth and youth culture understand as the 'liminal' form of adolescence. These chapters approach teen film as a product of film censorship and classification systems; as a hub for transmedia adaptation; and as a cross-cultural commodity that helps produce cross-cultural ideas about adolescence.

Part I
Histories

–1–

Modernism, Cinema, Adolescence

Betsy: 'I'm allowed to go to picture shows,
That is, if nurse is feeling able;
But we only go to Mickey Mouse,
I'm not allowed Clark Gable!
It's such an imposition
For a girl who's got ambition
To be an in-between!'

Love Finds Andy Hardy (1938)

In film buff histories, the retrospective compilations produced for awards shows, and in commentary on youth culture, there are two commonly cited histories for teen film. One begins in the 1950s and the other in the 1980s. These stories are often compatible – the story about the 1950s focuses on the emergence of the teenager about whom teen film could be made, and to whom it could be sold, and the story about the 1980s focuses instead on the consolidation of 'teen film' as a tight singular generic form. I will consider the 1950s and 1980s-centred stories about teen film in the next two chapters. In this chapter I want to problematize both approaches by thinking about what adolescence meant in cinema before the 1950s.

Taken as a whole, Part I offers a critical historiography of teen film by comparing the most influential accounts of teen film as a genre. David Considine's *The Cinema of Adolescence* (Considine 1985) is my central reference point in this chapter, while the next two chapters focus respectively on the work of Thomas Doherty and Timothy Shary. But as these texts often refer to the same films and themes I often refer to intersections and differences between them. I don't expect to resolve these texts into a single and complete history. Instead I want to approach the history of teen film much as we would a history of fashion – noticing that while, in retrospect, particular styles stand out as characterizing periods, even for such a retrospective eye particular conventions and even dramatic changes can become more or less visible over time. For example, although the 1980s are often represented as a high period for the genre, *The Cinema of Adolescence*, published in 1985, represents the generic shape of teen film as well established before then. Considine's history emphasizes the importance of the 1940s and 1950s for crystallizing a cinematic image of adolescence, as well as discussing teen film in the 1960s and 1970s unaffected by later claims that little

happened for teen film in these decades. What we define as teen film depends on very particular historical vantage points.

'The Little Shopgirls Go to the Movies': The Age of Cinema

As I suggested in the introduction, film's popularity among youth, and its images of youth, have been an important way of talking about cinema for as long as there has been a cinema to talk about. Public discussion of the threat of mass culture and the vulnerable impressionability of film audiences (Paul 1995: 6–8) frequently met up with concerns about adolescence as an especially vulnerable and important life stage. Considine, Doherty, and Shary in different ways all note that, 'From its inception, the cinema has attracted the attention of individuals and groups who believed that it exerted an undesirable influence upon the young' (Considine 1985: 2). Through the 1910s and 1920s, cinema was associated with rapid technological and cultural change. A generationalizing rhetoric pervaded debates about contemporary society, from changing employment patterns or skirt lengths to the impact of modern psychology and sociology. Both youth and cinema exemplified social change, the state of the present, and the prospect of the future. In popular media, legislative debate, and scholarly analysis, diverse authorities opined about which films youth should see and whether or not film could be good for youth. 'Youth' thus figured as exemplary audience for the public discourse on cinema that surrounded its industrialization and the increased coherence and wider dissemination of popular genres that marks the emergence of the film studio system. While cinema market analysis was a product of this industrialization, such questions were always central to discussions of film's social role.

The modern adolescence underpinning these discussions of 'youth' is often associated with American sociologist G. Stanley Hall. The influence of his model of adolescence as a period of *sturm und drang* (storm and stress) has been generally recognized by scholarship on teen film (Doherty 2002: 32–4; Shary 2002: 19).[1] But despite Hall's reference to a longstanding association of America with youth and Europe with age it is misleading to think of this adolescence as particularly American. Hall's pivotal publication, *Adolescence: Its Psychology and Its Relations to Physiology, Anthropology, Sociology, Sex, Crime, Religion, and Education* ([1904] 1911), was directly indebted to contemporary European debates about psychological and social development and especially to the work of psychoanalyst Sigmund Freud. Hall's model of adolescence conjoined psychoanalytic and sociological theories, defining adolescence as a personal crisis but also a key social indicator.

After the First World War a range of images of modern life strengthened presumptions that the problems of adolescence revealed broader social problems. The two 'Middletown Studies', conducted in 1929 and 1937 respectively by sociologists Robert and Helen Lynd (Lynd and Lynd 1929, [1935] 1982), reveal the increasing centrality to everyday life of both the institutions that managed adolescence, like

high school, and representations of adolescence, including cinema.[2] The images of and ideas about adolescence proliferating across popular and public culture in the late nineteenth and early twentieth centuries were widely in dialogue with social sciences, like sociology and psychology, for which how we come to be particular kinds of people is crucial. In fact, these emerging ideas about adolescence helped give important social authority to the 'social sciences', which were emerging at the same time. I want to stress here that the idea of adolescence to which we are now accustomed was produced by interactions between social and cultural theory, public debate, and popular culture.

Psychoanalysis is a particularly influential example. In 1909, Hall brought Freud and Carl Jung to lecture in the US, establishing the influence of psychoanalysis there. For Freud, adolescence was not a passage into adult roles for which childhood had been a training ground. Instead it was a complicated clash between new sexual capacity, already conflicting and often inexpressible fears, ideals, and desires built up and elaborated in childhood, and new social expectations built into immanent adulthood. These ideas shaped new approaches to education and the family across a wide range of experts and institutions, and they continue to dominate ideas about adolescence. Direct reference to Freud also entered the field of popular cinema – so that *Photoplay* could describe Alla Nazimova's *Salome* (1922) as a 'petulant princess with a Freudian complex' (*Photoplay* 1922: 67) and the Shirley Temple vehicle *The Bachelor and the Bobby-Soxer* (1947) could joke about an 'Oedipal complex'.[3] But psychoanalysis is not the only important theory of adolescence shaping early teen film. Early twentieth-century sociologists and psychologists in the US (Mitchell 1929), Britain (Wall and Simson 1950), and Europe (Storck 1950) stressed the importance of studying film's effect on youth. Elizabeth Hurlock's overview of such research in *Adolescent Development* – published in 1949 and updated and expanded in 1955 – demonstrates that research often associated the proper management of youth with film as a problem (see also Scheiner 2000: 29–31).

This transnational story about modern adolescence centred on *difficulty*: adolescence was a struggle for independence and a site of vulnerability; a moment of crisis in which new desires clashed with a new awareness of limits and possibilities. And Hollywood was not the only film industry it influenced. In the 1920s and 1930s, during which period many of the conventions of teen film emerged, the US did not have the only emerging studio-dominated film industry. In Germany, for example, the dominant studio system between the wars fed intense debate about the impact of film on society and on young people in particular. My subtitle, 'The Little Shopgirls Go to the Movies', is taken from a 1927 essay by German critic Siegfried Kracauer in which he uses the newly important social category of working girls to exemplify the problem of the cinema audience.

Watching films the shopgirls watch, Kracauer (1995: 301) declares that, 'According to the cinematic testimony, a human being is a girl who can dance the Charleston well and a boy who knows just as little.' For Kracauer, the audience can

enjoy such film formulae while being completely aware of the unreality of cinematic cliché. Moreover, the film industry works, he argues, by taking this awareness into account: 'business considerations require the producer to satisfy the need for social critique among the consumers' (Kracauer 1995: 291). Given that Kracauer also stresses the homogeneity of popular film across the US and Germany, his suggestion that this young audience has a critical perspective is important. It points to a complexity in relations between youth in the audience and youth on screen rarely factored into discussions of teen film except as a feature of the generic self-consciousness characterizing popular film in the 1980s and 1990s. For Kracauer, film never reflects life, exactly, but dominant ideals – ideologies and fantasies that are nevertheless real in their effects. Kracauer's readings of film are both Marxist (he sees film as concealing what things are really like and facilitating satisfaction with the social status quo) and Freudian (he sees film as revealing, indirectly, what human psychology and relationships are really like):

> Stupid and unreal film fantasies are the *daydreams of society*, in which its actual reality comes to the fore and its otherwise repressed wishes take on form. (The fact that major issues do get expressed – albeit in a distorted way – in both sensational film hits and in literary bestsellers does not detract from this claim.) (Kracauer 1995: 292).

But if Kracauer's shopgirls were an adolescent audience, were they watching teen film?

It seems that no one used the label 'teen film' before the 1950s 'teenpics' – and teenpics and teen film might even refer to different generations of film for and about adolescence. However it is nevertheless useful to ask where these teenpics came from and what modes of cinema for and about adolescence appeared before the 1950s. There are four necessary conditions for teen film, the first of which is the modern idea of adolescence as personal and social crisis discussed above. But teen film is not defined entirely by what adolescents are represented as being and doing and the second condition for teen film is the incorporation of that idea into film regulation. It is impossible to understand teen film without considering how film censorship and classification systems are premised on protection of youth. This is indeed so important that I have devoted Chapter 7 to discussing it. This chapter merely stresses that systems for managing film production, distribution and consumption always relied on a set of debates about age, maturity, citizenship, literacy, and pedagogy that are not only an important context for teen film but shape its content.[4]

The public association between film and youth at this time was not only centred on calls for protecting youth from film. Arthur Krows's (1926) pessimistic account of cinema argues that film 'must meet *the level of intelligence* of every audience which is to see it' and thus appeal to 'the lowest intellectual level'. In support he cites a declaration by 'Adolph Zukor, head of the largest film producing, distributing and exhibiting organization in the world' that 'the average moviegoer intelligence

is that of a fourteen-year-old child' (Krows 1926: 72). And Terry Ramsaye's ground-breaking *A Million and One Nights: A History of the Motion Picture*, also published in 1926, claims film emphasizes childhood and adolescence as a locus for representing hopes and dreams and as a focus for human interest in 'sex and combat' (Ramsaye 1926: xi). Ramsaye also usefully places this focus on youth in the context of transnational exchange, particularly in the ways American films, after the First World War, aimed to compete with international film production (Ramsaye 1926: 324, 381). At the time Kracauer, Ramsaye, and B. P. Schulberg were writing, cinema's industrialization was increasing its emphasis on technological innovation (including the appearance of the 'talkies'), and thus refining the ways in which cinema constructed its continued novelty (see Gunning 2004). The construction of a recognizable array of genres appealing to and naming popular tastes and lifestyles was crucial to this development.

This comprises the third condition for teen film – the emergence of targeted film marketing. The idea that teen film is film sold to teens raised in the introduction has been given different histories. For Doherty, the teen market was a dramatic development of the 1950s, for Considine it is a more gradual emergence, and for Shary it both appears gradually and is dramatically shifted at particular points, most notably in the 1950s and the 1980s. However, these writers all agree, taking into account Considine's later introduction to Shary's *Generation Multiplex* (2002), that teen film emerges when the film industry actively solicits a youth market through manipulations of genre. The industrialization of cinema that makes this possible clearly begins earlier than the 1950s. Almost as an aside, Shary (2005: 2) notes that 'one of the reasons the teenage population became more visible' in the early twentieth century 'was due to the spread of movie theatres, where young people would congregate.' Shary gives a great deal more weight to changes in theatre attendance following the emergence of malls and 'multiplexes' in the 1970s and 1980s, but the earlier impact of picture theatres as youth venue is equally important.

The fourth condition for teen film is the translation of modern adolescence into institutions for the representation, analysis, and management of adolescence. I'm principally referring here to social theories, public policies and social institutions but this fourth condition in fact reaches back through the other three. Modern adolescence is defined by such ideas and practices, censorship and classification systems belong among these institutions, and new film genres made clear contributions to defining what kinds of adolescence were a problem and how they might be managed. For example, the expanding significance and expectation of high school not only gave new coherence to age cohorts, further generationalizing culture, but introduced a setting for teen film that was both accessible and dramatic. The expansion of high school attendance depended on new explanations of its necessity by new social and psychological theories about development, family, and culture. Nevertheless, when high school was a less common step between childhood and social independence, cinema still found in youth an exciting figure of vulnerability and promise.

Ingénue in the City: Gish, Chaplin, Rooney, Temple

Shary (2005: 1) claims that, until the 1930s, with *All Quiet on the Western Front* (1930), 'American cinema depicted young characters on screen in wildly inconsistent ways (and rather infrequently at that).' However, some very important types and tropes emerged between 1910 and 1930, forming key precursors for teen film. These are images of conflict between independence and dependence, rebellion and conformity, maturity and immaturity that shape the ways the drama of adolescence has been presented on film. One of the most pervasive types for the developing field of narrative cinema was an image of youthful innocence known as 'the ingénue'. The ingénue's type of innocence is vitally adolescent because it is always on the edge of disappearing: out of date, under threat, or already compromised by the necessities of life and the demands of growing up.

Considine lists Mary Pickford first among the pre-talkies icons who shaped the 'cinema of adolescence', noting that she was 'barely sixteen at the time she was placed under contract to D. W. Griffith' (Considine 1985: 2). In the later 1910s, Pickford was a well-known media figure, dubbed 'America's Sweetheart' for her successful representation of a particular image of girlhood. In early classics like Griffith's *Birth of a Nation* (1915), the American girl simultaneously represents a culture under contestation, virtues of the past, and the promise of a new world. Despite the overt claims of *Birth of a Nation*, this image of girlhood was not confined to the US but appears wherever cinema engages with a clash between cultural identity and modernization: for example in Alfred Hitchcock's early British films and in Charles Chauvel's outback Australian films. Pickford's girl opposed the corrupting influences of modern life and to accomplish this she was held – rather like Lewis Carroll's Alice – just on the edge of adolescence. Pickford's famous long curls symbolized both her little-girlhood and an idealization of the past, referring to a nineteenth-century convention for girls tying up their long hair as a sign of entering womanhood, and it was matched by costumes with similar connotations. This image of girlish virtue was attached to Pickford even as the fashions for clothing and hair around her changed and she herself aged.[5] The problem of how Pickford's girl might grow up is inseparable from her success as a woman playing a little girl: the Pickford girl was always too knowledgeable not to raise questions about sophistication and maturity.

The exemplary female ingénue of this period is Lillian Gish, filmed by Griffith as a beautiful victim. *Birth of a Nation*, the most famous Griffith–Gish collaboration, intersects male and female ingénue narratives by combining boys going off to war with girls who find themselves at the mercy of corrupt men. But I want to focus on the melodrama *Broken Blossoms* (1919), where Gish plays Lucy Burrows, an innocent who knows too much about the world. Twelve-year-old Lucy is routinely beaten by her father but she knows that she must lie about this. As with the Pickford girls and *Birth of a Nation*'s Elsie Stoneman, Lucy's long unbound hair represents

both her innocence and her age. Twelve is an important age for stories about adolescence, taking up English Common Law standards that defined minority as prepubescent. This standard was displaced by the introduction of laws on education, child labour, and sexual consent that confirmed a distinction between physical and social maturity. But the older marker has been retained as distinguishing between childhood and adolescence; giving force to distinctions between immature and mature education (high school) and the idea of the 'teenager'.

Physically mature and theoretically capable of leaving her father, Lucy is constrained by family, church and money. Her choices, at the centre of this story, are to stay with her father, become a prostitute, or find a man to protect her. The evident sexualization of her alternatives is furthered by elements that became important to later teen film: a makeover plot in which new clothes offer a new outlook that reveals her intrinsic beauty and a story about the desirability of innocence. It is Lucy's innocence that her would-be lover, Cheng Huan, admires. Although much older, Cheng is also framed as an ingénue. The film opens with his departure from China to the West, where he has high hopes for dialogue between cultures and even for converting the West to Buddhism. But the London where we next see Cheng is seedy, violent and unjust, and has relegated him to opium dens and despised service. Lucy defines it by opposition – her faintly hopeful earnestness against its slovenly intemperance. But Cheng too clings to idealism in his upstairs rooms – a world of secret orientalist beauty that explains his desire to save Lucy.

For Gish's famous on-screen presence, youth was crucial to the types of fear, love, and disgust she was displayed as feeling. Griffith explained her type of beauty as immortal and spiritual, defined against female sexual maturity where 'The years show their stamp too clearly.' (*Photoplay*, December 1923a: 35) But on-screen youth wasn't only a staving-off of death and redundancy. The Griffith–Gish films emphasize the problem of what adolescents can do and what they cannot control at the border of the private and the public. In both these respects I want to juxtapose these stories of innocence with a set of films that do not centre on teenage characters: the ingénue-in-the-city films of Charlie Chaplin. I think these films provide an interesting limit case for an argument that the cinematic adolescent is defined less by age than by a slippery social position that juxtaposes promise and powerlessness.

Chaplin's 'little tramp' character is neither young nor old but a figure of entwined innocence and experience. As a character named in credits (later defined by his iconic costume of bowler hat, shabby black suit, and cane) the tramp appears in Chaplin's second film, *Kid Auto Races at Venice* (1914) where, both knowing and not knowing, the tramp plays a game with the camera and the audience, repeatedly walking into frame as if by accident. Across dozens of films, Chaplin's tramp plays innocent knowingfulness against the corrupt and sometimes inhuman sophistication of the city. His agelessness is central to this performance so that his tricks and manipulations, as much as his clumsiness and confusion, seem innocent rather than malicious or idiotic. In films like *Modern Times* (1936) he occupies the adult world like a child in a huge doll's house.

In *The Kid* (1921), the tramp is played against type as a parent figure to a street urchin. He is both a criminal and yet too innocent to withstand the worldly machinations of characters with less capacity to love. Promotion for *The Kid* emphasized a parallel between 'tramp' and 'kid', posing them to emphasize their matched perspectives on the world: looking back over their ludicrously baggy trousers with twin melancholy expressions, or peering wide-eyed around a corner under ill-fitting hats, their fingers grasping the same wall. The tramp isn't usually a parent. His comic failings are generically failure at adult roles – to hold down a job, to be a provider, or find a romantic partner. A number of Chaplin films combine this failure with fantasies of success, as in the famous scene in *Modern Times* where he entertains his love interest with a fantasy of the world providing everything for them. The dramatic centre of Chaplin films is usually a clash between virtue and opportunism, and institutions are always against the tramp. If adult roles escape him they also oppress him. Any exception is almost unbelievable good fortune, as in the close of *The Kid* where, in a sequence that could be a dream, the tramp is not only welcomed into the house where the kid has been restored to his long lost mother but is helped to that reunion by the previously hostile police. The tramp is necessarily mobile, permanently dissatisfied and always making do. But he is as tolerant as he is cynical, and the tramp's triumph lies in his insistent innocence in the face of knowing exactly how the world works. In never growing up precisely because he knows the score. Without ever playing an adolescent, Chaplin was the Holden Caulfield of his time.[6]

In Hollywood before 1950, growing up on screen was not only a matter of the development of characters in particular films but of narrating stardom across sequences of films. In *The Kid*, the kid is played by Jackie Coogan in a precursor to an array of 'tough kid on the street' films in which the protagonists ranged from small children to young adults in their twenties. Their relation to proper adult roles and institutions with social authority unites them, often in angry protest, marking out a place that would eventually be called 'the juvenile delinquent' (j.d.). The j.d. film is often associated with the 1950s but it emerged gradually across previous decades. Considine's history rightly emphasizes not only key texts like *Boys Town* (1938) and *City Across the River* (1949), but also the broader subgeneric conventions established by popular film series (Considine 1985: 165–7, 178–9).

Drawing on the movie *Dead End*, 'The Dead End Kids' is a label uniting a range of films about juvenile gangs called the Dead End Kids, the Little Tough Guys, the East Side Kids, or the Bowery Boys. They focused on the question of what brought 'kids' to crime and what might keep them out of it. As in *Dead End*, where Humphrey Bogart plays the tellingly nicknamed 'Baby Face', older characters often replicated the Kids' narrative about trying to escape a life of crime. These films gave popular form to what would become teen film's key narratives about rebellion and authority but also class and destiny. The Kids belong to 'Code' Hollywood, when new moral guidelines meant that judgement and punishment were built into film representations of villainy. Commencing in 1930 and given more authority in 1934

with the establishment of the Production Code Authority (PCA), the Code both responded to film images of youth and the putative effects of film on youth and encouraged particular stories about youth (see Chapter 7). And Code films found in the young offender some interesting contradictions. The j.d. raised questions about environment, responsibility, and socialization that linked film to 'realistic' current issues and films centred on the j.d. could satisfy the demand for punishment while allowing opportunities for both pathos and debate. Some films explicitly reformed the Kids, for example through military service, but their potential for reform was generally apparent: in many films the *Angels With Dirty Faces* (1938) only had to be cleaned up (Considine 1985: 170–2).

Claims to provide young offenders with institutions that might protect them from delinquency appeared in film alongside public sphere discourse along the same lines. In a 1944 *Saturday Evening Post* feature, for example, the nation's delinquency problem is understood as much through narrative film as through the social programs it ostensibly reports, referring to the poverty narratives of the Kids and directly citing *Boys Town*. One anti-j.d. strategy is referred to as 'the Boys' Town plan' (*Saturday Evening Post*, 1944) and another is aligned with that film's hero, Father Flanagan. While the editorial insert on this feature compares the apparent escalation in 'wartime delinquency' with the post-World War One 'Lost Generation', the representation of delinquency and its management in cinema had clearly expanded.

Jimmy Cooper mixed street-kid roles with adolescent romantic comedies and with coming-of-age films like Paramount's Henry Aldrich series. Cooper traces the diversification of genres centred on adolescence across the 1930s and 1940s along a path shared by others, including Mickey Rooney. In fact the Aldrich series directly replies to the success of the MGM Andy Hardy films starring Rooney (Considine 1985: 43–4). Rooney's own image was built through a mix of comedic films and dramas (including *Boys Town*, in which he played the j.d. junior lead). But the Hardy films were central to his success. There were eighteen between 1937 and 1946, followed by a relatively unsuccessful sequel with an adult Andy in 1958. A representative still from *Love Finds Andy Hardy* (1938) is reproduced as Figure 1.1. Like many other critics, Considine (1985: 28) sees this series as a 'distortion of reality that both confirms and denies, heeds and ignores, the changing nature of the American family', but the Hardy films appear within a contradictory field of films about adolescence at the time.

Despite the reassuring predictability of the plots centred on him, Andy is an engaging character because his terror in the face of judgement is tempered by earnestness, ambition, and enthusiasm. He established a type for film and television adolescents that remains recognizable today. *Love Finds Andy Hardy* typically begins with a demonstration of the reasonable authoritativeness of Andy's father, Judge Hardy. But the film is driven by Andy's quest to improve his social standing by negotiating relationships with three different girls who want to be his girlfriend.

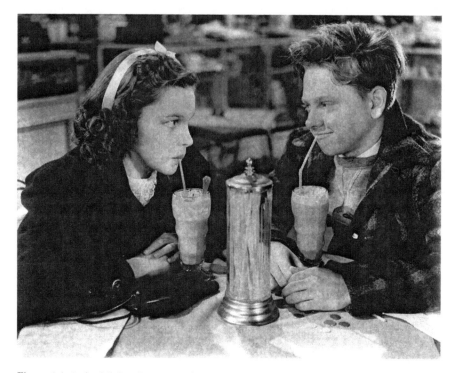

Figure 1.1 Andy (Mickey Rooney) and Betsy (Judy Garland). *Love Finds Andy Hardy* (1938). Director, George B. Seitz. Courtesy of MGM/The Kobal Collection.

The gains he might make from each must be juggled with urgent hormonal impulses, which are always in conflict with the virtue of girls and, at the same time, his father's expectations. In *Love Finds Andy Hardy*, fifteen-year-old Andy is very sure about the kind of man he should be in ways that contrast sharply with the heroes of many later teen films, but he is entirely unsure how to achieve this goal. In 1941's *Life Begins for Andy Hardy*, Andy graduates from high school and moves to the city, but the 'begins' component of this title is indicative for the series as a whole. Andy is forever waiting for things to be real for him – for a real car, a real job, real love.

The epigraph to this chapter is from a song sung by one of Andy's girls in *Love Finds Andy Hardy*, the young Betsy Booth (Judy Garland – Figure 1.1). Georgeanne Scheiner (2000: 1) opens her book on pre-1950 movies about girls with the same lyric. Betsy's adolescence is more clearly marked by clothes and admiration than is Andy's, but both understand adolescence as a place of potential in which one strives to attain an image of adult sophistication hoping that respect will follow. While the series suggests that style alone is insufficient to maturity, maturity is also never entirely independent of it. Betsy's 'In Between' represents the difficulties of adolescence as progress through popular culture (Mickey Mouse versus Clark Gable) as much as in socialization (toys versus boys) or age (she yearns to be

sixteen, the age of consent). While no special youth culture between child and adult is identified with this in-between-ness, Andy's stories are punctuated with activities, like the swimming pool and the soda shop, that seem particular to youth. And Andy's character is presented through tastes and attitudes aligned with his generation. Generational difference and cultural change are central to the Hardy series and *The Courtship of Andy Hardy* (1942) implies that Andy's parents had similar conflicts with their own parents.

Placing Shirley Temple in a history of teen film might initially seem more problematic, given that she is most famous for her roles as a small girl, styled in extravagant curls and baby-doll dresses. But not only did Temple later play adolescent roles, her 'little girl' is another version of the ingénue trope. The Temple girl was so excessively knowing that her innocence was a comic question rather than a banal fact. At first, Temple's career responded directly to Pickford's girl-played-by-a-woman, unfaithfully remaking a number of Pickford films as musical comedies. If Temple was a different kind of child-adult than Pickford, how much or little girls should do or know remained central to her characters. Like Chaplin's tramp, the Temple girl makes a virtue of suffering under institutions. She is frequently pressed into roles inappropriate to her years because of accident or neglect; very often orphaned, or at least motherless. The danger this exposes her to generally remains implicit, however, because, unlike Gish's girls, a 'little princess' film demands happy closure.

In *Stowaway* (1936), Temple plays Ching Ching, an orphan raised in China, who is sent away from her foster home to avoid a dangerous raid and inadvertently ends up on a ship going to America. Comparing this story about intercultural encounters and youthful innocence to *Broken Blossoms* throws up many differences in style, narrative, and performance but it leaves one crucial similarity. These girls are wise beyond their years because they have suffered – as Tommy (Robert Young) says, Ching Ching speaks like an adult. The advice Ching Ching repeatedly offers is not a product of childhood instinct but the careful rehearsal of learned pseudo-Confucian homilies. Although Temple was often cast as a trained performer, in *Stowaway* she is just a natural. The vignettes in which she sings and dances are nevertheless knowing tableaux of ideal childhood that raise questions about training and environment.[7]

Rooney made a successful transition to adolescent star that was unavailable to Pickford and that Temple failed to make. Shary (2005: 8) speculates that 'Americans seemed far more prepared to watch a boy grow into manhood than to watch a girl grow beyond adolescence.' But Garland's role in the Hardy series makes it clear that a girl could parallel Andy's always abortive development – making the same tentative moves towards adulthood without ever being entirely transformed. As Ilana Nash (2010: 35) argues, 'teen-centred comedies' of this period 'frequently portray their heroines as lively, good-hearted, and fundamentally innocent, but also as constant sources of aggravation and anxiety to their long-suffering parents.' Shary (2005: 9) suggests that 'teens of the late 1940s were quite likely eager to move

beyond their parents' notions of youth, which Temple had represented to them.' But Temple did become a moderately successful actor in 'bobby-soxer' movies like *Kiss and Tell* (1945) and *The Bachelor and the Bobby-Soxer*. These films contain highly recognizable teen characterization and plot devices, including misrepresentation of sexual reputation, the new kid at high school, and the teenager's endeavours to construct an image of maturity through both sex and personal style. Such films, and Figure 1.1, foreground a distinctive contemporary youth culture through clothing, music, language, and practices like basketball, cheerleading, 'malt shops', and jukeboxes. As Scheiner (2000: 6) puts it, the bobby-soxer 'had her own language, mannerisms, fashions, concerns, and style.'[8] These films map a teenage world construed as alien to a parent culture (Scheiner 2000: 3).

 The Bachelor and the Bobby-Soxer parodies teenage aspirations while stressing the appropriateness of youth culture. The moral thrust of this film is about acting one's age. Older sister Margaret (Myrna Loy) is a judge who doesn't realize she's missing out on love, Dick (Cary Grant) is an immature playboy who is unaware what kind of woman he really wants, and Temple's Susan doesn't realize she is still a child. Susan is moody, dreamy, and desperate to be an adult even while she sulks in her bedroom. Her characterization stresses the idealism and ennui of adolescence and also the importance of sexual development in comparison to other forms of education (although Susan is a high-achieving and articulate student). This film presents a theory of adolescence through references to psychoanalytic and other developmental theories supplemented by the visualization of fantasy. It is with reference to bobby-soxer and j.d. films that Considine (1985: 33, 42) argues adolescence emerged in the 1940s 'as a fact and phase recognized by the motion picture industry.' But if Gish and Pickford did not make teen film in the same way it is important to ask what changed, and what transitional figures appear between *Birth of a Nation* and *The Bachelor and the Bobby-Soxer*.

'The Orchidaceous Clara Bow': *The Plastic Age* and the Flapper Star

If Temple and Rooney's adolescent roles are teen roles, Doherty's taxonomy of teenpics would call them 'clean teens'. Indeed, in the heyday of the Production Code there were delinquents and there were clean teens and little in between. Both figures worked by presenting adolescence as a problem of what one could and should do and both were in effect produced by the Code itself. The Code forced US film to search for ways to represent transgression indirectly, producing strategies like the shadows of film noir and the new filmic uses for the uncertainty, vulnerability, and impulsiveness of adolescence. The cleanness of many successful 1940s screen teens can distract us from the diversity of youthful roles before the 1950s and make it worth looking back at the scandalous films which inspired the Code.

 While the pre-Code roles of Jean Harlow are never discussed as teen films they were crucially girl roles, dominated by the question of who Harlow's characters

would become. Harlow was just nineteen when she played her first major role as the promiscuous Helen in *Hell's Angels* (1930), declaring: 'I wanna be free. I wanna be gay and have fun. Life's short. And I wanna live while I'm alive.' Considine stresses that there were not many girl j.d. films during the first period of the subgenre's popularity (Considine 1985: 172–3, 182–3). This is partly because girls' risky behaviour was more clearly linked to sexual reputation than crime. We could compare Harlow in *Hell's Angels* to Clara Bow's nineteen-year-old performance as Orchid in *Grit* (1924). Orchid is a street gang-member trying to go straight, but the reference points for her morality are principally sexual rather than criminal. It matters to the sexual dimension of bad girls rather than bad boys in pre-Code films that *Grit* was written by 'jazz age' chronicler, F. Scott Fitzgerald. *Grit* might be better understood as a flapper than a gang film, and it is the flapper ethos that links it to *Hell's Angels*.

As a popular pre-Code genre that combined representation of current social issues and a focus on adolescent identity formation, the flapper film is an excellent test case for the claim that there were teen films before the Code.[9] These films, exemplified in the promotional image for *The Wild Party* (1929) reproduced as Figure 1.2, centred on the shockingly unregulated behaviour of modern girls. They

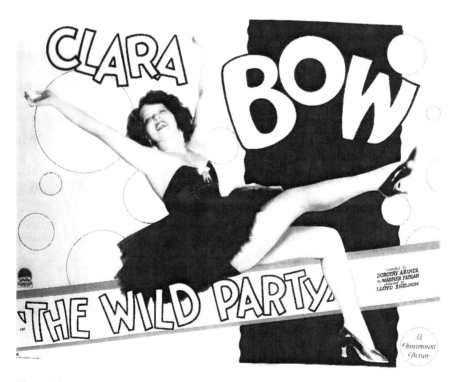

Figure 1.2 Promotional poster for theatre lobbies, featuring Clara Bow. *The Wild Party* (1929). Director, Dorothy Arzner. Courtesy of Paramount/The Kobal Collection.

shared an ethos opposed to the ingénue and efficiently summarized as pleasure by the character Diana Medford (Joan Crawford), heroine of the flapper series beginning with *Our Dancing Daughters* (1928). 'It feels so good,' Diana says, 'just to be alive'. Film perfected rather than invented the flapper image, which was established by the press and popular fiction as uniting ambivalence about contemporary life, spectacular generational difference, and disrupted gender norms. Colleen Moore had some of the most famous flapper film roles, including in *Flaming Youth* (1923), which inspired Fitzgerald to declare that Moore was the torch which burned a spark he had lit (Curnutt 2004: 158). But *Flaming Youth* was based on a Warner Fabian novel that itself drew on media panic over 'flappers', tying it to both longstanding social debates and what were represented as new challenges to gender norms.

The heroine of flapper films often first appears to be a rebel and is discovered to be an ingénue; or else she understands herself as a rebel only to discover her desire to conform. The ambivalent relationship between rebellion and conformity so important to teen film is clearly established as a youthful characteristic in these films, and one which is so predictable as to form an implicitly necessary stage of psycho-social development. Despite Moore's fame, Bow is my example for considering flapper films. As Figure 1.2 indicates, publicity stressed her blend of vulnerability and action. In 1930, Leonard Hall described her as 'Dashing, alluring and cinematically untamed, she was flaming youth incarnate – the personification of post-war flapperhood, bewitching, alluring and running hog-wild. All the old taboos and thou-shalt-nots were knocked dead by the new freedom for adolescents' (Hall 1971: 275).

Bow's most famous film was *It* (1927), one of several adaptations from the sensational romance novels of Elinor Glyn (Driscoll 2010: 79–80). As 'it', Bow was a particularly adolescent version of feminine glamour and explicitly commodified: 'IT can move mountains and cash registers. IT is sought, sought, sought. Students of IT have found manifestations most frequently in members of the feminine sex, sized about five feet two, red-headed and aged eighteen' (*Photoplay* 1927: 109).

In uniting flapper films as teen films I disagree with Scheiner's distinction between college-aged flapper roles and films of this time about school-aged youth (Scheiner 2000: 30). The lack of clear distinction between teenagers and young adults in the flapper films is in fact a recurring feature of teen film. To consider this claim I will focus on a Schulberg production directed by Wesley Ruggles and starring Bow: *The Plastic Age* (1925).

Hugh (Donald Keith) is a high-school athletic star, beloved and trusted by his parents, who send him off to college at the beginning of the film with high expectations. Hugh's college peers lack the serious application he is used to, and he is soon dragged into fraternity hazing and meets the popular party girl, Cynthia (Clara Bow). Hugh's hazing challenge is to sing a love song to Cynthia, and this is a neat summary of the plot as a whole because Hugh's adolescent trial produces Cynthia's. Hugh is instantly in love and Cynthia is touched by his innocent sincerity.

They commence an affair which leads Hugh into Cynthia's party lifestyle and away from his commitments to sports and study. His disappointed father disowns him. After they narrowly escape arrest during a raid on a nightclub where Hugh has wound up fighting friend-turned-rival Carl (Gilbert Roland), Cynthia decides to push Hugh away for his own good. He regains his success on and off field and his family's approval, while unbeknownst to him Cynthia pines for him at a distance. They are finally reunited as Hugh is leaving college for the last time, when Carl reveals Cynthia's constancy and newfound virtue.

Though Bow has more respected and more famous films, *The Plastic Age* exemplifies how flapper films developed the concerns of later teen film. It opens with a dedication addressing contemporary life, which became a minor refrain for teen film while it became obsolete in other genres. It is

> Dedicated to the Youth of the World – whether in cloistered college halls, or in the greater University of Life.
> To the Plastic Age of Youth, the first long pair of pants is second only to – the thrill of going to college.

From extant reviews and promotion we know that Bow's *The Wild Party* (Figure 1.2), based on another popular Fabian novel, also tells the story of a college party girl who realizes the importance of virtue through the love of a good man. *The Wild Party*'s plot is equally familiar, centred on girls competing for their teacher's romantic attention. But *The Plastic Age* offers a narrative which is as much about the boy as the girl, even if Bow shines in comparison to Keith. Hugh's story about struggles with parental expectation and the conflict between reputation, aspiration, and temptation in an athletic star's life are just as relevant to later films as the moral makeover of Cynthia.

For contemporary teen film, Hugh might be a 'jock' and, typically, the emphasis is on his personal rather than sporting development. He begins the film sure that he is already a man, while his mother in particular feels otherwise. She urges his father to give Hugh advice about girls before he leaves, foreclosing, it seems, on the pregnancy narrative common in flapper films. But the sex education Hugh's father can offer doesn't equip him to deal with Cynthia. For contemporary teen film, Hugh might also be a 'geek'. He is teased by other boys for being studious, clumsy and a 'great gink', and for having the wrong underwear. Either way, Hugh is the good boy whose athletics are fun enough for him in counterpoint to the smooth girl-catching sophistication of his room-mate Carl. Hugh's confrontations with new ideas of manliness are central to his college experience. Hugh is an ingénue with no useful skills for coping with college life despite the value credited to his virtuous self-deprecation and romantic good intentions.

Sex and drug use are often implied in the flapper films. In *The Plastic Age*, smoking and drinking are represented as commonplace parts of college life, despite

(or because of) the reigning US Prohibition laws (from 1920–33) and other illegal drug use is also apparently common. There's a typical reference to marijuana in one dance-hall scene as characters come and go from behind a heavy curtain amid clouds of smoke and the direction and camera work imply the effects of drugs. This curtain also represents and conceals sex, as kissing and fondling clearly progress to something more affecting off screen. It's important to the flapper film that such risky behaviour is entwined with the dominant expectations of adolescence – school or college, career choice, and developing independence and romantic attachments – and in this way the flapper film was a contributing factor in the debates that led to the Code.

Cynthia is as wild as any boy and, if her sexiness is fun-loving, it is also somewhat jaded. Her makeover plot, then, is centred on falling in love. One of the key differences between flapper films and girl-centred teen film in later decades is that they might feasibly end in marriage, which was gradually removed from the realm of films about adolescence while romance stayed central. For centuries across different media, plots where girls played central roles have closed with a romantic couple, but the teen film belongs to the extension of adolescent development and thus delay of the full social maturity with which marriage is associated. *The Plastic Age* closes with a couple who have suffered in order to be together in the right way, but marriage is only a possible future, however clearly the importance of their love gestures to it. Extracting marriage from the girl-centred film is not only a reflection of changed models of girlhood but also a new generic distinction between adolescent and adult romance on screen.

In these ways *The Plastic Age* clearly foreshadows the high-school film. While it shares many narratives and motifs with later college films, the mesh of close monitoring by parents and institution with experiments in identity and transgression is especially apparent in high school films. And many recognizable high school film types and tableaux appear. Alongside the good and bad boys and girls we find the cool teacher who understands what kids are really like; the fat boy and the clever boy as the butt of popular boys' taunts; love triangles that depend on reputation for girls and prowess for boys; and even the recurring motifs of the locker room and the big dance. If the gap between institutional expectations and the real life of adolescents in those institutions belongs to many teen film genres, the stress on this gap makes some college films seamless extensions of the high-school film.

The example of Bow also raises more explicitly commercial dimensions of the teen film. Like Pickford and Temple, Bow's celebrity was dominated by an irresolvable story about her growing up.[10] However, it was not only that her image stayed trapped in girlhood (Scheiner 2000: 51). Bow fell from stardom in the wake of 'the talkies', and yet talking itself was also not the whole problem. As distinct from the players of Pickford's reign, the flapper stars were not 'little girls'. The tendencies of the characters they played to vivacious, impulsive sexuality extended into their public images as stars – on and off screen they were exciting party girls.

But they were also supposed to represent the self-interrogating every girl. The ideal adolescent Bow playcd had to be widely accessible, and both the public scandals that marked her career and her strong Brooklyn accent revealed in talkies made her a too particular kind of girl. The visibility of scandals around Bow contributed to the debates foreshadowing the Code (Lewis 2002: 92–6) and in the production culture of the time there were few ways to exploit her class background. Bow thus exemplifies how the teen star commodity seeks contradictory effects from youth.

Flapper films were not only adapted from stories by writers like Fabian, Fitzgerald and Glyn, but interacted with other fields, such as popular music, dance, and cartoons. As partial synonyms for 'teenager', terms like flapper and bobby-soxer point to a nexus of adolescence, commodity culture, and governance. They are social problems and fashionable styles at once. Teen film generically engages a broader field of youth culture, and tends to be characterized by the cross-promotion of commodities, including of stars (Chapter 8). *Flaming Youth*'s promotion, for example, was characterized by publicity tours, commercial tie-ins and myth-making around Moore's personal life. Teen film stars, as much as the characters they played, dramatized the problem of maturity through the circular trap of youthful glamour and through public dramatizations of a clash between innocence and experience.

Teen film emerged as cinema developed into a set of industries distinguished by genres as modes of production and distribution. The industrialization of cinema involved the development of coherent film genres as structures for appealing to expectations, producing novelty, and repeating success. Hollywood's establishment as the premier film industry in the world during the studio era is anything but incidental to a history of teen film. Its dominance in fact grounds the strong association between teen film and Americanness given that Hollywood and teen film emerged at the same time and I have thus allowed Hollywood full sway over this chapter. But the ideas about adolescence to which these earliest teen films referred were no more exclusively American than their component parts – such as psychoanalysis, sociology, high school, fandom, and cinema.

–2–

The Teenager and Teenage Film

Mildred: 'What are you rebelling against?'
Johnny: 'Whatta you got?'

The Wild One (1953)

This chapter focuses on the popular idea that teen film is an invention of the 1950s; part of the Western emergence of youth culture after the Second World War. Jon Savage (2007: 18) puts the argument this way: after the War, 'the spread of American-style consumerism, the rise of sociology as an academic discipline and market research as a self-fulfilling prophecy, and sheer demographics turned adolescents into Teenagers.' Thomas Doherty's *Teenagers and Teenpics: The Juvenilization of American Movies in the 1950s* is a highly influential example of this argument, analysing an extensive archive of films and the media circulating around them. Doherty claims that the decline of the Hollywood studio system in the 1950s, and related threats to the profitability of cinema, produced a flood of films in which teenagers were central in order to cater to a market newly identified as 'teenagers'. He links this to changed economic relations between studios and theatres but also to forces more intimately connected with adolescence, such as post-war suburbanization and the rise of television, which extended the significance of the family home (Doherty 2002: 18–19). Amidst these influences, the teenager appeared as both exciting film content and reliable filmgoer.

The Wild One: Youth as Problem

From Doherty's perspective, the pre-Second World War conjunctions of adolescence and film I discussed in Chapter 1 are not 'teen film'. One important difference lies in what he sees as the emergence of a more strictly *teenage* version of adolescence in the 1950s, displacing forms of cinematic adolescence that stretched from pre-teen/pre-puberty years through to the mid-twenties. From my perspective, this range and flexibility remains importantly characteristic of the 'teen' named by teen film and we must look elsewhere for what might be new about 1950s teen film. For this reason my key film example in this section is one in which the 'teen' is probably not a teenager, although we cannot be entirely sure: László Benedek's *The Wild One* (1953). But before turning to *The Wild One* Doherty's argument warrants further attention.

Doherty's association between the decline of glamorous Hollywood and the expansion of teen film is important to teen film's status as *genre* film, and he convincingly details links between 'B grade' or cheap formula movies and the teenage audience. Doherty's emphasis on audience research establishing teen film's commercial necessity downplays other cultural forces in favour of a film industry history. He is undoubtedly right that audience studies became newly important to Hollywood in the 1950s as it tried to adjust to declining audiences (Doherty 2002: 19ff). However, marketing discourses and cinema actually emerged together over decades, intersecting through an increasingly transnational commodity culture in which adolescence was an important conceptual category.

The importance of youth-centred stories and a youth market to the cinema of the 1930s and 1940s documented by David Considine certainly undermines some of Doherty's more emphatic claims about the invention of youth culture and teen film in the 1950s, and in the last chapter I tried to reinforce and extend those claims. But Doherty's scholarship does give us a multilayered picture of how the film industry addressed youth at this time. This chapter builds on his analysis, elaborating connections between cinematic and other ideas about the teenager in the 1950s while extending these connections towards a further claim. That is: if Doherty's (2002: 34) insistence that '1950s teenagers' were something new because 'There were more of them; they had more money; and they were more aware of themselves as teenagers' remains convincing, it is largely because film represented them that way. Teen film itself is a crucial factor in the newly coherent forms of youth culture and teenage life in the 1950s.

For Doherty (2002: 9), the 'teenpic' is an 'exploitation' film, and 'The more enduring furores of the 1950s, like rock 'n' roll and juvenile delinquency, spawned whole exploitation cycles, historically bound clusters of films sprung from a common source.' In the field of cultural studies this relation between public 'furores' and popular culture is often discussed using the term 'moral panic'. Moral panic, discussed further in Chapter 6, describes the mutual benefits for media outlets and political voices in seeing contemporary cultural change as producing social crisis – and youth are an especially effective focal point for moral panic because adolescence lies metaphorically between the values of a parent culture now in control and a future which might be different. The teenager was a concept that engaged popular culture with expert discussion of adolescence as a crisis, and in the popular media and the 'public sphere' it was used to discuss a range of perceived social challenges. This repeated patterns discussed in Chapter 1, but with a difference that partly depends on scale. There seemed to be more youth culture in the 1950s. And this scale largely depends on teenpics themselves – there were more, and more differentiated, forms of teen film representing more broadly a field of youth culture.

Doherty (2002: 2) claims 1955 as the concrete birthdate of 'the teenpic'. His choice is specifically tied to landmark American films that year – *Rebel Without a Cause* (1955) and *Blackboard Jungle* (1955). In choosing these films his analysis

overlaps with that of many others. *Rebel Without a Cause*, directed by Nicholas Ray, is a staple of histories of teen film and one of few such staples to be critically acclaimed. The three themes I want to focus on in this chapter as linking teen film in the 1950s with the films about adolescence that preceded and followed it are all evident in *Rebel Without a Cause*: youth as a social problem, the institutionalization of the teenager, and youth as a celebration of present pleasure and future potential. Each of these themes is considered by Considine, Doherty, and Shary, if in different ways. They are implicit, for example, in each of Doherty's four categories of 1950s teenpics: rock movies, j.d. films, monster movies and the 'clean' teenpics.[1]

Both the flapper film and the early j.d. film focused on youth as a problem; on youth as a danger to themselves and others. Several key conventions for the 'problem' film thus arose before the 1950s, including the pre-title preface which disclaimed the possibility that the drama on screen was there for salacious rather than educational value. If clarifying a film's moral in this way became redundant in most film genres with the shift to 'talkies' this was not because films became more or less moral but because film-scripts could make so much more story explicit, which is part of why the Production Code appeared in the wake of the talkies. If declarations that a film exposes a problem are always ambivalent – both salacious and judgemental – in the case of the youth problem film they addressed audiences that could identify with the problem youth on screen as well as those who did not, translating the intimacy between moral panic and the thrill of witnessing illicit behaviour into glamourized violence.

Films such as *The Flaming Teen-age* (1956) were advertised as offering 'the naked searing truth' to parents who don't know about their teenage children 'living it up and doing things they can't live down' (ModModWorld). Many such 'B grade' films have scant plot beyond displaying problem youth. This is what Doherty (2002: 5–6) means by describing teen film as an exploitation genre – that it exploits a particular audience's responses with 'The implicit corollary ... that it does so in a particularly egregious and manipulative way through subject matter that is particularly accessible or disreputable.' There's an important difference between 'accessible' and 'disreputable', however, on which Doherty does not reflect. The link forged between these ideas by the figure of the teenager – so that what is familiarly 'teen' is also disreputable – is what makes 'moral panic' still an important concept for thinking about teen film (Chapter 6).

Joe Austin and Michael Willard see in contradictory 1950s discourses on youth a pattern that continues in contemporary media narratives about youth. They argue that concerns about mass culture, cultural dispersal, hedonism, and delinquency were always entwined with the complementary certainty that 'most young people' were 'traditional, clean-living, hardworking' kids 'unfairly maligned by the actions of a few disturbed members of their generation' (Austin and Willard 1998: 2). As the 'bifurcated social identity of youth as a vicious, threatening sign of social decay and "our best hope for the future"' (Austin and Willard 1998: 2, quoting B. Davidson)

is 'obviously not limited to the late 1950s' (Austin and Willard 1998: 2), it is worth considering in what ways 1950s j.d. films differed from those before them.

For Doherty, films like *Blackboard Jungle* and *Rebel Without a Cause* abandoned an 'environmentalist' model for explaining youth crime and turned instead to psychology and particularly to the 'Freudian' drama of parent-child conflict (Doherty 2002: 93ff). The ungrateful children of earlier dramas were displaced, he argues, for 'reasons that have as much to do with the popular dissemination of Freudian psychology' as with attempts to appeal to a teenage marketplace. For what Doherty (2002: 101) calls 'softie j.d. films', parents are almost always responsible.[2] A similar argument is made by Considine (1985: 118–19) and Shary (2005: 18–20) despite Considine understanding the psychologization of delinquency as an earlier development. The 1950s j.d. film turned the problem of delinquency into a question, and in this sense *The Wild One* is a crucial filmic influence on Doherty's films of 1955.

In *The Wild One*, Johnny (Marlon Brando) is the leader of the Black Rebel Motorcycle Club, which blows into a small town after a bike rally, followed there by a rival gang led by Chino (Lee Marvin). Johnny is attracted to Kathie (Mary Murphy), daughter of the town sheriff, and, while she detests his uncouth violence and purposelessness, there is clearly attraction on her side too, fed by apparent frustration with her small-town life. Romantic and sexual tensions between them build in parallel with tensions between the gangs and the townspeople, but Kathie cannot overcome her contempt and Johnny can hardly express anything but anger. When a man is accidentally killed, Johnny is arrested, and only Kathie's distress inspires the locals to concede he is innocent. Despite the moral lessons stressed in Johnny's interrogation his reform is doubtful and it remains unclear whether Johnny has a choice about that. While he makes a grateful gesture to Kathie as he leaves, on his departure everyone remains, at least on the surface, much as they were.

The Wild One is often referenced in discussions of teen film as a precursor text. As Shary (2005: 21) puts this, 'Even though many people remember *The Wild One* as a youth film, virtually all of the characters are clearly in their twenties or older (Brando himself was nearly thirty when he made the film).' But *The Wild One* reminds us that we shouldn't confuse the chronological specificity of teenage years with the broader idea of 'adolescence' centring teen film. Johnny is treated as a boy and called a boy, both by the girls he interacts with and by authority figures. More importantly, the film stresses a generational divide, and when the gang takes over the town bar only the young gather to dance and jive along. The elderly bartender can't even understand what the kids are saying in an argot (specialized language) explicitly linked to popular music, and the gang members tease his incomprehension between cuts to the spinning be-bop record.

This scene additionally associates youth and pleasure, and the violence the gang perpetrates is not the whole story about adolescence told by this film. Gang members dance and flirt and race down the street on pogo sticks. The film also makes a

gendered distinction between ways of expressing the urgency of youthful desires that crosses the distinction between gang and town. While they have different dating rituals, both the good and bad girls want something more than the one night stand Johnny is used to offering. The gang molls appear resigned to settling for a party, however, while good girl Kathie pines for a life with some sort of direction for herself. 'I wish I was going some place', she tells Johnny. 'I wish you were going some place. We could go together.' For Johnny, however, the importance of 'going' is not about the destination: 'you don't go any one special place. That's cornball style. You just go.' Johnny's famous declaration that he will rebel against whatever's available – quoted as an epigraph to this chapter – doesn't actually explain Johnny at all. In context it's a joke – a teasing aside to a girl who's flirting with him. But the continued currency of that line as a summary of the film does speak to its context. The theatre trailer makes the generic exploitation of moral panic stressed by Doherty very clear, promoting the film as 'the story of a gang of hot-riding hot-heads who ride into, terrorize, and take over a town – led by that "Streetcar" man <u>Marlon</u> BRANDO as "THE *WILD ONE*."' The more subtle plotlines about Johnny and Kathie are irrelevant to this sales pitch, but the eroticization of Brando is central, with the trailer insisting that 'You'll thrill to the *shock-studded* adventures of this hot-blood and his jazzed-up hoodlums'.

The questions surrounding 1950s delinquency are made poignant in this film by Johnny's inarticulateness. It is not only that he refuses to answer the interrogating authorities but that he cannot represent himself in any way. When trying to respond to Kathie's concerned interest the alternatives available to Johnny are clearly silence, anger and sex; and even when he wants to thank her in the closing scenes he struggles to find any words at all. The gesture of leaving his trophy with Kathie and his smile are given intense significance by the difficulty Johnny has finding any other means of expression.

Despite consensus about the psychologization of the j.d. in 1950s films, *The Wild One* still suggests a causal relationship between environment and delinquency. Johnny mocks the townspeople attacking him with 'My father hit harder than that.' And he ridicules Kathie's attempts to understand and explain him. The problem of why Johnny does what he does, and what choice he has, aligns him with the difficult management of adolescence at the forefront of 1950s j.d. films. And at this level the iconic status of 'Whatta you got?' is also justified. Several elements of the film stress that there is nothing behind what drives Johnny and his peers, or at least nothing that can be articulated. Chino jokes that the trophy over which he and Johnny fight is a 'beautiful object signifying absolutely nothing'. And the Sherriff who finally interrogates and then releases Johnny represents him similarly: 'I don't get you. I don't get your act at all. And I don't think you do either. I don't think you know what you're trying to do or how to go about it. I think you're stupid. Real stupid. And real lucky ... I don't know if there's any *good* in you. I don't know if there's *anything* in you.'

While Johnny became an iconic representation of young male angst, Kathie's frustrations are rarely incorporated into the afterlife of the film. But Kathie is crucial to the way *The Wild One* suggests that 'good' youth are not only tempted by the delinquent image but partly defined by its romance. The fascination with the 1950s rebel that Doherty (2002: 161–2) notes among later critics and audiences was already apparent in the 1950s. Johnny is clearly more attractive than the men of the town, who are uniformly much older. And the attractiveness of Johnny is given substance by his opposition to Chino, who is less angst-ridden than uncontrollable and presents a more genuine threat. In Chino, *The Wild One* indirectly points to the immanent arrival of the youth-centred horror film, and particularly to its crossover with the j.d. film.

As Doherty (2002: 146) puts the case for a special analogy between teens and monsters to which I will return in Part II, 'The sudden swellings and shrinking of adolescence, the inhabitation of a body with a mind of its own, beset all sorts of screen creatures.' But the analogy between adolescence and monstrosity was part of the j.d. as well, and especially in this sense of concealing some force which might dangerously emerge without warning. Sometimes the genres were literally blended, as in *I Was a Teenage Werewolf* (1958), where Tony (Michael Landon) begins the film fighting in the schoolyard, already driven by forces he can't control. But seeking help from the authorities, whose help he resists with a smart mouth and 'jive talk' in the beginning, is what makes Tony a literal monster (Doherty 2002: 131ff). Doherty's account of the pervasive extension of adolescence as a metaphor for social turmoil encompasses both the inexplicable and yet familiar gang behaviour in *The Wild One* and the alien invasion narratives of the new teen-oriented science fiction films. As Mark Jancovich's (1996: 207–13) account of *I Was a Teenage Werewolf* suggests, like sci-fi and horror films the j.d. film spoke to an image of adolescents as the aliens among us.

The question of who 'us' refers to here is a contentious one. Doherty's discussion of 1950s teenpics is entirely focused on America, but he acknowledges the impact of imported films on US film genres, particularly the relation between imported British horror and science fiction films and the decline of the Production Code. Despite the primacy of examples like *Rebel Without a Cause* and *Blackboard Jungle* in discussion of the j.d. film this genre is not intrinsically American. The j.d. narrative about youth and the law, equally concerned with the loner and the subcultural, links *The Wild One* to a contemporary Japanese conjunction of 'youth' and 'gangster' films in the 1950s and 1960s (see Chapter 9), and to contemporary British films like *Serious Charge* (1959). The trade between UK and US j.d. films at this time is particularly telling. Titles like *Lost, Lonely and Vicious* (a 1958 US release) and *Violent Playground* (a 1958 UK release) responded to and conjured the same image of youth at the same time. If the US release *Young, Willing and Eager* sounds rather more sensational that its original UK title, *Rag Doll* (1958), the storylines were cross-culturally accessible in relation to a shared story about adolescence,

its problems, and the institutions for managing them. It is possible to talk about the increasing production of films centred on adolescence in many countries in the 1950s as a product of post-World War Two American cultural imperialism but, as the importance of film imports to Doherty's story about 1950s teen film suggests, this would be a careless simplification.

Blackboard Jungle: the Teenage Institution

Rebel Without a Cause takes up the 'whatta you got?' motif in quite a different way from *The Wild One*. The hero Jim Stark (James Dean) asks his rival Buzz, immediately before they race to Buzz's death, why he wants to risk it. Buzz replies, 'You gotta do something. Well, don't ya?' While Jim concedes this, he also thinks there must be people with answers. This is both a j.d. film and a film about the range of institutions that manage adolescence, including the law, family, and school. *Rebel Without a Cause* opens with Jim lying on his stomach, playing with a wind-up cymbal-clanging toy monkey. While we later discover he's out on the street drunk, framing suggests he could be under a childhood bed despite being dressed in a suit with patent-leather shoes, and when he curls up as if to sleep he establishes a potent symbol of child-manliness that permeates the film. The second scene has Jim dragged into a police station where he meets two other troubled teens: Judy (Natalie Wood), brought in for wandering the streets unsupervised in the middle of the night, and Plato (Sal Mineo), brought in for killing puppies.

The Dean characters in general, Considine (1985: 185) points out, are neither 'misunderstood teenagers struggling against economic hardship nor the victimized working class delinquent spawned by city squalor and political corruption.' Instead they are middle-class boys failed by their parents (Considine 1985: 59). Even Plato's passing fantasy that Jim and Judy are his parents is a grim one, with children drowned 'like puppies'. For Considine and Doherty, *Rebel Without a Cause* belongs to a context in which the idealized fatherhood of a Judge Hardy (discussed in Chapter 1) who 'effortlessly solved all his son's adolescent crises with one "man-to-man" talk per picture', now seemed redundant (Doherty 2002: 105). When Ray (Edward Platt), the Juvenile Division officer, is assigned to help 'kids in trouble' like Jim, Judy and Plato, the clear implication is that many families are not up to this task. Jim's father, dressed in a frilled apron to stress the failure of his own masculinity, cannot answer Jim's desperate demand to know what one does when he has to be a man.

The school was crucial among institutions for management of the teenage problem as well as a site where that problem was detected and represented. High schools grouped adolescents according to age, often forming dramatic situations that proved the need for more high school-style training and discipline. And the movies brought young people together to watch spectacular dramatizations of what happened when young people came together. The importance of high school in the 1950s was not

because high school was something new or because of a staggering increase in enrolments. But in a range of countries in the 1950s high school became an expected component of popular representations of cultural and personal development. This shift was driven in places partly by the need to keep 'kids' at home so that soldiers could return to vacant jobs, but more widely by the need for training in new kinds of work, including new kinds of citizenship and consumption. Doherty (2002: 75) can only claim that neither *Rebel Without a Cause* nor *Blackboard Jungle* is properly a teenpic because neither high school nor the nuclear family are very important to his industry history.

The *Wild One, Blackboard Jungle*, and *Rebel Without a Cause* foreground respectively the streets, the school and the home as scenes in which delinquency resists appropriate management. While the action of *Rebel Without a Cause* does spread to places outside the home it is chiefly a private drama (Considine 1985: 90). Direction encourages alignment with Jim's private perspective on the world. At the height of his distress we watch Jim's mother come down the stairs from the upside-down perspective he has lying on the couch. As Doherty (2002: 86) says, this locks 'the audience into Jim Stark's upside-down viewpoint' as 'a critical perspective on an adult world far less exhilarating or rewarding.'[3] *Blackboard Jungle* takes a more sociological line, expressly focusing on the problem of education. Shary locates it within a shift in images of high school away from its importance for 'proper cultural assimilation' and towards the problems high school might produce. As Considine notes, the bobby-soxer films already presented high school as a social rather than educational venue (Considine 1985: 147). This was not, however, a failure of realism, as Considine suggests, because high school had been this cultural space for a long time.

Doherty quotes Robert and Helen Lynd's first 'Middletown' study:

> The high school, with its athletics, clubs, sororities and fraternities, dances and parties, and other 'extra curricular activities' is a fairly complete social cosmos in itself and about this city within a city the social life of the intermediate generation centers ... In this bustle of activity young Middletown swims along in a world as real and perhaps even more zestful than that in which its parents move. (Lynd and Lynd 1929: 211; in Doherty 2002: 33)

We can usefully contrast this image of high school as its own cosmos with Jurgen Herbst's (1967) essay 'Highschool and Youth in America'. This very different account of the interplay between adolescence and high school opens with the claim that twentieth-century youth had been stranded by loss of the certainties around which their education was designed and goes on to tell a story about ever-increasing enrolments in a school system with ever-decreasing certainty of purpose.

High school enrolments in the US, Herbst records, increased from 6.7 per cent to 73.3 per cent of fourteen to seventeen year olds between 1890 and 1940 (Herbst

1967: 168), making high school an inevitable part of the life cycle whether or not any individual needed what it taught.[4] Herbst aligns himself with G. Stanley Hall's turn-of-the-century opinion that high school should be designed around the needs and nature of adolescence. Counter to this need, Herbst claims, high school has become 'a custodial system ... for the non-penal accommodation of the young' (Herbst 1967: 166, quoting Robert Hutchins). He sees the social dimensions of high school discussed by the Lynds as a product of this failure to consider what adolescents were in school for (Herbst 1967: 169). And by the time Herbst's short history reaches the 1950s, film itself becomes part of his analysis of the meaning of high school – populated by 'juvenile delinquency and blackboard jungles' (Herbst 1967: 178).

Blackboard Jungle was a smash hit, directed by Richard Brooks from his own screenplay. New teacher, Mr Dadier (Glenn Ford), arrives at a working-class inner city school where the teachers are all resigned to their students' disinterest and frightened of them with good cause. The plot follows Dadier's attempts to engage the students in literature and their own futures by appealing to their current tastes and lives, and follows his struggles with the power plays of a classroom, which seems pointless to the students he's teaching (Figure 2.1). His key antagonists are the cool black student Gregory Miller (Sidney Poitier), who confronts Dadier with

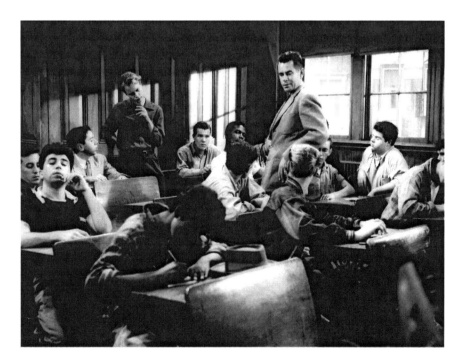

Figure 2.1 'Daddy-O' (Glenn Ford) strives to manage his class. *Blackboard Jungle* (1955). Director, Richard Brooks. Courtesy of MGM/The Kobal Collection.

his own unacknowledged racism, and the thuggish thief Artie West, who leads the students in attacking Dadier both directly and indirectly. Although tempted by the chance to teach at a more congenial school, Dadier finally elects to stay where the students seem to need him more. His sincere interest in teaching, and his students, finally reaches Miller and inspires him to aim for greater things than his job as a mechanic, and in a final showdown with West the students take Dadier's side.

Like *The Wild One*, *Blackboard Jungle* opens with a pre-title preface urging the importance of exposing dangerous delinquent behaviour so that such problems might be addressed. For Doherty (2002: 109) these prefaces were a 'prefatory publicity campaign'. Although his crediting this convention to *The Wild One* is a little off the mark, as it is both indebted to silent pictures like *Birth of a Nation* and was added, along with the Sherriff's lecture to Johnny, at the insistence of the PCA (Lewis 2002: 110). But drawing on the effectiveness of this frame for *The Wild One*, publicity for *Blackboard Jungle* was addressed with veiled salacity to 'an aroused public' (Doherty 2002: 111).

The school in *Blackboard Jungle* is the prison Hutchins invoked, and the teachers are wardens, antagonists and entertainment but not guides – a sensational image that remained just as effective when *Blackboard Jungle* was loosely remade as a teen horror film in *Class of 1984* (1982). One of Dadier's colleagues despairs to him that 'They just get to be eighteen and they throw 'em out to make room for more of the same kind.' A war metaphor pervades the plot, and Dadier's ability to make a difference is aligned with his past military service. As with this warzone image, *Blackboard Jungle* contains many elements that became common in later high-school films. The victim of bullying runs from the smokers in the toilet. The smart-mouthed rebel calls the new teacher on his attempt to negotiate: 'You're holding all the cards, Chief. You wanna take me to see Mr Warneke, you'll do just that.' And immanent threat laces through every scene with a collection of students in it: 'Ever try to fight thirty-five guys at one time, Teach?' There's an explicit sexual dimension to this violence as well and one teacher's comment that all the students know is how to 'multiply themselves' is followed by sexual assault in the next scene.

West's resentment echoes J. D. Salinger's Holden Caulfield in rejecting Dadier's attempt to expose the boys to critical skills as 'a phony'. But Dadier persists. This formation establishes a now highly recognizable story that Considine labels 'the teacher-hero'. As Considine suggests, this story is premised on the failure of teachers in general:

> in order for the teacher to emerge as hero, it was necessary for other teachers, and in particular for principals and administrators, to be depicted as villains. At its most simple level, this format led to a formula in which teacher meets class, teacher wins class, teacher loses class, teacher wins class back. (Considine 1985: 113)

This teacher-hero scenario not only confirms that high school is a social space, organized first of all by the currency of respect, but it emphasizes the generation gap at the foundation of high school at the expense of the generational cohort that is its dominant experience.

The school film as j.d. film has had a long life not confined to the US, sometimes with the teacher-hero in the foreground, as with *To Sir With Love* (1967) or *Stand and Deliver* (1998), and sometimes not, as in *If* (1968) or *Heathers* (1988). These stories are continually responding to popular narratives about the youth problem of the time, from *If*'s story about armed protesting students (Considine 1985: 135) to the racialized ghetto images circulated around *Dangerous Minds* (1995). *Dangerous Minds* is a particularly interesting comparison to *Blackboard Jungle* because its teacher-hero is another ex-soldier teaching poor kids literature. The comparison also foregrounds the fact that school delinquency films are often dominated by race, or by race and class, as factors in the proper management of youth and as distinctions between groups of youth. This packages the problem of youth as the problem of *different* youth – and as a difference that must be overcome in order to get a chance to grow up.

To Sir With Love's explicit reference to *Blackboard Jungle* is not confined to casting Poitier as the black teacher Mark Thackeray rather than the black student he had been twelve years before. Poitier's portrayal of Thackeray takes up Miller's coolness, now to expose the shared currencies of youth style in 'A story as fresh as the girls in their minis ... and as cool as their teacher had to be!' Coolness was not enough in 1955, and Dadier is contrasted with his friend, the new maths teacher Josh Edwards (Richard Kiley), who aims to reach the kids with his beloved 'swing' collection until they destroy it. Josh's optimism is represented as foolish. The question of whether delinquency is caused by environment is raised again in these films but not answered. In another school, happy contented teenagers harmoniously sing the national anthem. But with some authority a police detective insists this school's problems occur on 'both sides of the tracks'. The film's diagnosis is broadly that teachers are unprepared for a generation whose home and church lives were destroyed by the war, but the delinquents also have a voice in this story. Dadier has to acknowledge some validity in West's anger that people who condemn him will still expect him to join the army next year and get his head blown off.

The music in *Blackboard Jungle* also uses racial difference to both link and distinguish the boys. The diegetic music (not yet something we could call a soundtrack) juxtaposes the overt racial significance of slave folk songs prepared by the black students for a school concert and the implied racial mixing in both Edwards's passion for jazz and the kids' passion for rock and roll. If Bill Haley and His Comets' version of 'Rock Around the Clock' playing under the opening sequence is dislocated from the music focused on inside the school – jazz or spirituals – that is part of the story. Rock and roll is as alien to Dadier as the drums beneath the pre-title preface are to the urban landscape. This dislocation is emphasized by the

mismatch in the opening scene between the gritty industrial town and the euphoric lyric – 'we'll be riding seventh heaven' – to which the school kids are nodding along or jive-dancing. This scene also quickly confirms the realism claims of the pre-title preface, filled with extras cast from a Manual Arts Highschool. The fact that Poitier in particular was no teenager doesn't disrupt these youthful authenticity claims based in music, clothing, and language (Dadier is quickly nicknamed 'Daddy-O').

Although credited as the first 'rock-and-roll' film theme, 'Rock Around the Clock' was a 1954 B-side recording taken up to flesh out the youth culture credentials of the production. The excited popular response that greeted it is a piece of the history of rock and roll's rapid expansion. In the wake of *Blackboard Jungle*, 'Rock Around the Clock' returned to the charts and spawned *Rock Around the Clock* (1956), featuring Haley and his band in a dramatization of the discovery of 'rock and roll'. The rock movie subgenre may well have appeared independently of *Blackboard Jungle* (Shary 2005: 30) but 1950s teen film as a whole produced a new relationship between teen film and popular music that has continued to be crucial.[5]

When Doherty claims the conventions of teen film were all established by 1959 this new relationship with popular music is a powerful piece of supporting evidence. Shary's (2005: 31) claim that the 'rock movie' had disappeared by the end of the 1950s thus only makes sense if teen film very rapidly changed its generic mix, making films like The Beatles' *A Hard Day's Night* (1964) and the whole subgenre of 'tour films' something other than a 'rock movie', whether fictional, documentary, or, like *A Hard Day's Night*, a combination of the two. The rock movie mixed 'real life' bands in performance and a scant dramatic plot centred on celebration of the musical form, but these conventions were quickly adapted to more polished narrative forms, including musicals centred on recording stars like Elvis Presley, Pat Boone, and Cliff Richard. If neither the tour film nor the musical is a rock movie then the rock movie's life cycle probably was very brief. But the question has added importance when returned to Doherty's argument. For Doherty the teenpic itself emerged in 1955 and disappeared in 1959. To consider this claim I want to turn to an undisputed teen film from 1959 that exemplifies both the fate of rock-and-roll for teen film and rapid shifts in the genre itself.

Gidget: Youth as Party

The films I've discussed in this chapter are predominantly about boys. There are key girl characters in both *The Wild One* and *Rebel Without a Cause*, but the famous iconography of these films reveals their focus. This is a good place to consider Roz Kaveney's definition of teen film, which I mentioned in the introduction as starkly differing from that of Doherty. For Kaveney (2006: 4) the j.d. film is never a teen film because it 'considers teens as a social problem to be understood and solved, rather than the teen years as a transitory phenomenon to be enjoyed and celebrated.'

Such films are too 'serious' and 'not so much for teenagers ... as in favour of them.' This is a very restrictive definition, ignoring the popularity of j.d. films among adolescents and their significance to shaping ideas about adolescence. However, the value of this argument as a provocation is in shifting the focus of discussions of teen film away from the spectacle of youth problems and towards celebratory and often girl-centred narratives. I'll discuss Kaveney further with reference to 1980s teen film, but one 1950s film her discussion touches on is *Gidget* (1959).

Gidget, directed by Paul Wendkos, is, as every critic who cites the film comments, a revealing example of the girls' role in 1950s teen film. If the beach party films faded from popular view during the 1960s, *Gidget*'s refinement of girl-centred narratives about individuation through romance did not. The components of Gidget's story – the tomboy who discovers her femininity, the geek whose prettiness is revealed by a makeover, the outsider girl whose sporting rather than sophisticated attitude wins the boy's heart – continue as popular elements of teen film. Doherty positions Gidget as both typical in its middle-class 'clean teen' narrative, complete with tie-in pop theme and conventional narrative closure, and as exceptional in its focus on 'the invisible girl' of 1950s film (Doherty 2002: 161, 197).

Frances (Sandra Dee) is a sixteen-year-old tomboy whose friends have discovered sex (which means flirting, dating, 'making out' and 'going steady') and want her to join in chasing boys. Frances's pleasures mostly come from her studies, her music, and her close relationship with her parents. In fact, she is a girl geek. She tries to play along, however, only to find that trying to attract surfer boys is silly while catching waves is fun. Gidget decides to learn to surf, despite initial resistance from both her father and the surfer boys who are the only available teachers. As she proves her daring and becomes proficient, the surfers christen her 'Gidget' (girl midget) to mark her as a child rather than a love interest. But during her lessons she develops a crush on Moondoggie (Jimmy Darren) and decides to turn her learning skills to attracting him. Moondoggie, however, doesn't want a girlfriend, which he associates with being tied down.[6] Aided by his friends, including the too-cool-to-be-true jaded veteran 'The Big Kahoona' (Cliff Robertson), Gidget strives to display her femininity and make Moondoggie jealous. After several comical failures Gidget gives up, just as he is realizing he cares about her. The happy resolution arrives when Gidget discovers that, off the beach, Moondoggie is the blind date she has been trying to avoid her father arranging for her. Their misunderstandings are revealed as they discover that Kahoona too has learned from Gidget to want a normal (adult) life.

Allison Whitney (2002: 55) describes Gidget as 'free of drugs, alcohol, and other vices, sexually inhibited and respectful of [her] parents.' But Gidget is often at odds with her parents and often flirting dangerously with forbidden behaviours. Shary's brief reference to the first two Gidget films notes that they were split by *Where the Boys Are* (1960), implying that this film offers a context for them. This seems a worthwhile connection. *Where the Boys Are* is an image of Easter vacation in Fort

Lauderdale that presages contemporary images of 'Girls Gone Wild' at 'Spring Break'. This is youth as party to which, the opening voiceover tells us, 'The girls come very simply because this is where the boys are'. Every girl at this party is waiting impatiently, as the title song puts it, for love and marriage. Miss Andrews (Dolores Hart), with an IQ of 138, is the girl geek in this story and, like Gidget, she takes her scholarly skills to the question of sex (via such theories as Alfred Kinsey, Freud and Margaret Mead).

The plotline of *Where the Boys Are* largely belongs to the college party film subgenre. The opening scenes function as the pre-title preface from the j.d. films, combining the admonishments of teachers with a preparatory address by the police chief. Spring break is, for him, a 'war against higher education' in which 'the students of America are gathering to celebrate the rites of spring. And if you'll pardon a pun, they have that right. They are our future voters, they're citizens of our fair country and they are our responsibility. But how the hell to handle 'em?'

With students directing traffic in pyjamas, leaving sharks in swimming pools, and attempting to scam free meals, this war is more comic than in *Blackboard Jungle*. But the battle between the sexes waging between the lines of this generational conflict has dire consequences. Extramarital sex and its consequences comprise the drama, and the chaste girls win their men while sex robs the other of her youth and happiness.

In the same year as *Gidget*, Dee starred in the drama *A Summer Place* as the girl at the heart of a plot about the honesty of youthful love in comparison to married adult hypocrisy. *Gidget* and *A Summer Place* refine some important conventions for teen film romance, presenting comedic and dramatic versions of the claim that youthful love is defined by authentic response and genuine pleasure. But as Whitney points out, sex in *Gidget* is a complex arrangement of social strictures and dangerous quantities. Sex is, first of all, for girls, a presentation of the body; and Gidget, her friends, and the boys all agree, has nothing to display in that sense (Whitney 2002: 60–1). But Gidget has a well-crafted sense of self, which is in fact on display, when she means it to be and when she doesn't, and her romantic victory rests on the fact that she is the right kind of girl. Gidget's mother notoriously tells her not to be anxious because, whatever she does or wants, the boy must choose. However, Gidget chooses to do, not do, want, and not want, many things in this film. In the end both Moondoggie and Gidget must learn to choose compatible sexual positions, and part of what makes the sequels to *Gidget* less engaging is that sex becomes a simple comedy of errors rather than this educational drama for both.

Because *Gidget* is a 'nice girl' film about sex, Doherty's definition of the 'clean teen' is worth considering here. The clean teens inherited a place from Andy Hardy and the commercial power of teen film stories that articulate a moral mainstream by showing whom one should grow up to be. Doherty sees *Gidget* as exemplifying the importance of gender conformity to this moral mainstream. Despite 'the occasional reform school girl and hot rod hellcat' (Doherty 2002: 196), girls mostly featured in

1950s teenpics as victims of crime or horror, or as romantic encouragement. Judy in *Rebel Without a Cause* is a little of each. With reference to the last chapter, Judy demonstrates that reaching sixteen doesn't solve any of the 'in between' problems of adolescence Betsy Booth dreams it will but may do quite the reverse. Judy's parents reassure one another that sixteen is 'just the age when nothing fits.' Nevertheless, in films that intersect the j.d. and clean-teen films, like the 1957 drama-musicals *Jailhouse Rock* (an Elvis vehicle) or *April Love* (a Boone vehicle), the girl is a moral compass reminding the j.d. of what he really wants.

If the pop-star vehicle films quickly appropriate the exciting aura of rock-and-roll without any social transgression (Doherty 2002: 188ff) then, as Shary (2005: 31) points out, 'The teen beach movies essentially picked up where the rock movies left off, with an emphasis on music and opportunities for more sexual stimulation.' One of the most compelling sections of Doherty's history is his discussion of how neatly the clean teen was bound to commercial tie-ins and to the production of film franchises. I will return to more contemporary versions of this formation in Chapter 8, but one thing Gidget and the pop-star vehicle have in common is 'the franchise'. Gidget was a mass-produced ideal adolescent commodity, which flexibly took very different forms reflecting the changing lives of adolescent girls in the 1960s. *Gidget Goes Hawaiian* (1961) centres on quite a different Gidget (Deborah Whalley) with a very different family that is just as central to the plotline as Gidget herself. *Gidget Goes to Rome* (1963) has another new Gidget (Cindy Carol), this time travelling without parents and far from the beach, exploring a desire for European sophistication. This trilogy was succeeded by very different short-lived television series in the mid-60s and mid-80s, split by two equally distinct made-for-television movies. Each iteration featured an updated Gidget and updated gender challenges. *Gidget* is not only interesting because it inspired a wave of beach-party movies; taken as a whole the Gidget story is a fragmented picture of girls' rapidly changing expectations.[7]

While Gidget's girl identity drama moved to Europe, and television, the beach-side party expanded through a range of scantly scripted musically oriented forms – not only the Annette Funicello/Frankie Avalon 'Beach Party' films but also the series of 1960s Elvis beach films. The musical genre was particularly good at inter-secting contradictory ideas about adolescence because it could mix, for example, the rebellious connotations of rock-and-roll with romantic and euphoric musical possibilities, providing a selection of styles or tastes without committing to any of them because it was all 'performance'. Thus Elvis was remade in *G.I. Blues* (1960) as a clean teen, reflected in the soundtrack's mix of lullaby, folk-song, ballad, and concert numbers as well as rock and roll (sans swivelling hips and in demure military uniform).[8] Across his prolific film career Elvis specialized in sampling teen film styles. In the early films he often played roles in which his adolescence was marked by race and class and thus invoked the threat of delinquency. But he was also the generic teen film hero: handsome prince, sensitive rebel, secret romantic

and angsty outsider. As Doherty (2002: 76) argues concerning *Jailhouse Rock*, Elvis films 'consistently [assume] an indigenous attitude toward its target' audience: 'In narrative content and visual presentation, the film does not simply recognize teenage [culture] ... but displays the insider knowledge and tacit respect that is the mark of the informed observer.'

The teen party films focused more often on a boy star than a girl. And girls-only parties are also hard to find. But if we step outside Doherty's taxonomy of 1950s teenpics there are some other images on the margins. Before *Gidget*, and even before *Blackboard Jungle*, there are, for example, the girls of St Trinian's. The St Trinian's series blends the school party story, the school delinquency story and the girl-teen story. Its strange difference from the other examples in this chapter is partly its intense Britishness – although I have deliberately connected UK and US examples in each section – but largely the way it comes to teen film from outside the link between adolescence and youth culture. The St Trinian's films are a parody of gender norms, class decorum, and the role of the British public school in reproducing them. As much as the j.d. films, these films draw on public concern about contemporary youth, based on cartoonist Ronald Searle's satire (1948–53) on alternative education, but with very different tone and story.

In *The Belles of St Trinians* (1954) and three sequel films released by British Lion until 1966, a boarding school full of girls educated without rules causes social havoc. The consequences of their delinquency are, however, highly ambivalent: they both prevent crime and commit crime; they are anarchically dangerous and yet capable of loyal self-defence. There are no individually angst-ridden characters, no quests for sexual knowledge (they seem to know it all already) and no moral development. But excluding 'St Trinians' from teen film is too hasty. These films depend on the institutional governance of adolescence, which identifies youth as a problem for which society should be responsible, and on an image of youthful pleasures that cannot be contained by it. The vaudevillean cross-dressing role of the headmistress/her brother (Alistair Sim in 1954 and 1957) does not prevent the series being revived amidst the new attention to teen film in 1980, and loosely remade in 2007 with a contemporary pop soundtrack and its own sequel in 2009. Each iteration of this series increases focus on individual girls' development, including the makeover trope and parent-child conflict, but if it was always different to *Gidget* it always depended on adolescence.

Doherty's and Shary's certainties about teen film in the late 1950s may try to contain the volatility of the genre as a whole, but they also foreground some clear consistencies. We can see youth as problem, institution, and party reconfiguring each other in the dance/musical conjunction of delinquency and romance in *West Side Story* (1961; Figure 2.2) in ways that herald more changes in the years to come. While the film is a very loose adaptation of William Shakespeare's *Romeo and Juliet* (see Chapter 8), Jerome Robbins's choreography focuses the story on what the boys do on the street: showing off, hanging out, negotiating space and identity.

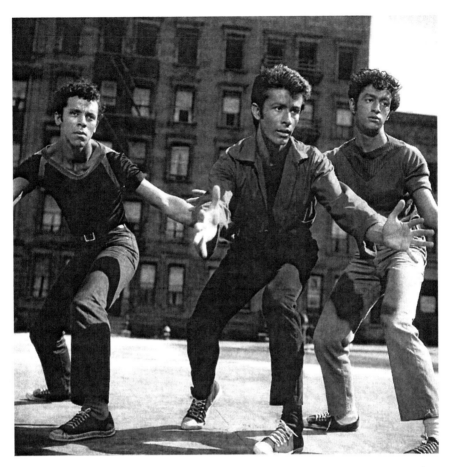

Figure 2.2 The Sharks, led by Bernardo (George Chakiris). *West Side Story* (1961). Director, Robert Wise; choreographer, Jerome Robbins. Courtesy of Mirisch-7 Arts/United Artists/The Kobal Collection.

And the drama emerges jointly from the thwarted love story, from tensions between the 'white' Jets and the Puerto-Rican Sharks, and from clashes with the institutions monitoring youth. But in this story the girls also have a separate voice. On the side of the Jets we only see one girl, 'Anybodys', who wants to be a boy. But the Puerto Rican girls demand celebration rather than conflict, 'to be in America' with its commodities and pleasures, and to enjoy life.

The famous 1950s j.d. films have a highly recognizable iconic afterlife. Jim's style in *Rebel Without a Cause* and Johnny's in *The Wild One* have become synonymous with the teen rebel. Stylistic cues from these looks are used to signify 'delinquent', sensitive, misunderstood, or just 'cool'. And they bring with them their less easily named counterparts of the troubled teenage girl, the beach girl, and even the schoolgirl horde. The meaning of the 1950s teenager is anchored in cinema

history; a certainty about what the experience and difficulties of adolescence *look* like. Doherty (2002: 193) argues that 'The paeans to 1950s and 1960s pop culture that so dominated film production in the 1970s and 1980s made perfect demographic sense. Teenpics about past teenagers could speak jointly to the teenage audience of the moment and their nostalgic elder siblings and parents.'

This seems indisputable, except that the iconic power of the 1950s teenager has not faded with the aging of these nostalgic parents. It remains installed in film history as both more specific (to adolescence) and more general (to all adolescents) than its predecessors. And it has not been displaced by subsequent generations of teen film because of its monumentalization as the moment where film first named the teenage market.

−3−

Inventing 'Teen Film'

Jake's grandfather: 'He's plenty old and people don't mature anymore. They stay jackasses all their lives.'

She's Having a Baby (1988)

Turning to teen film after the 1950s, Thomas Doherty (2002: 190) summarizes the next forty years as 'a series of postclassical phases retreading, revamping, and reinventing the generic blueprints of the original teenpics of the 1950s.' Timothy Shary's *Teen Movies* presents quite a different view, locating teen film's infancy in 1895–1948, its early adolescence in 1949–67, its later (rebellious) adolescence in 1968–79, supplemented by a rebirth in 1978–95, and a coda of new teen film speculations in 1994–2004. It is only possible to reconcile Doherty and Shary's claims if they are talking about different types of teen film, and they differ on the question of whether 1980s teen film is part of the genre or a reply to it. For Shary, teen film in the 1980s became sophisticated and self-conscious, for Doherty (2002: 196) this is a 'double vision', which betrays these films' address to adults (perhaps as well as teenagers) and makes them not teen film at all. For Roz Kaveney (2006: 3), however, teen film has 'a specific time and place and origin' and this is the US in the 1980s. This chapter approaches 1980s teen film framed by these disagreements, considering what is supposed to be phenomenally coherent or spectacularly self-conscious about 1980s teen film.

John Hughes: Teen Film 1984–1987

Shary's study identifies six 'subgenres and cycles' of teen film: slasher film, sex comedies, techno-youth, 'revisionist' teen film, 'the African-American crime cycle', and 'Youth by John Hughes' (Shary 2005: 56–87). These have varying degrees of recognizability outside his analysis. For example, the 'African-American crime cycle' could be discussed as a type of j.d. film, which had long found drama in the difference of race (Chapter 2), and the slasher film can be traced back to teen horror in the 1950s (Chapter 5). But as Shary describes them these cycles all cohere around the 1980s, especially when he stretches the decade to 1978–95 to incorporate key texts. But only one is actually specific to the 1980s, aptly demonstrating how Hughes came to represent 1980s teen film.

Hughes is Shary and Kaveney's central common ground, Kaveney describing teen film as 'a body of work which is in large part a creative response to the 1980s John Hughes films and to a lesser extent other films that appeared at roughly the same time' (Kaveney 2006: 3). Between 1984 and 1987 Hughes wrote and/or directed, and sometimes also produced, six teen films: *Sixteen Candles* (1984), *The Breakfast Club* (1985), *Weird Science* (1985), *Pretty in Pink* (1986), *Ferris Bueller's Day Off* (1986) and *Some Kind of Wonderful* (1987). Although recognizing that this dominance might be 'a matter of there being six films by the same writer/director that appeared in cinemas over a three-year period', Kaveney (2006: 3) defines teen film by these films' emphasis on suburbia, high school, and adolescent identity formation.

Leaving *Ferris Bueller's Day Off* for later discussion, brief accounts of the other five films show evident narrative coherence. In *Sixteen Candles*, Sam's (Molly Ringwald) sixteenth birthday has been forgotten by her family but a series of accidents make the day a turning point by bringing her into new proximity with two boys from school: The Geek (Anthony Michael Hall), who desires her, or at least desires a girl; and the popular Jake Ryan (Michael Schoeffling) on whom she has a crush. In *The Breakfast Club*, five kids (Figure 3.1) share Saturday-long detention in a classroom scenario shot to echo schoolroom dramas like *Blackboard Jungle* (Figure 2.1). Across the course of the day they discover they have important things in common despite being distinguished as a j.d. (Bender – Judd Nelson), a princess (Claire – Ringwald again), a geek (Brian – Hall again), a jock (Andrew – Emilio Estevez), and a 'basketcase' (Allison – Ally Sheedy). In *Weird Science*, the geeky Gary (Hall again) and Wyatt (Ilan Mitchell-Smith) accidentally create the superwoman Lisa (Kelly LeBrock), who proceeds to give them lessons in self-confidence. In *Pretty in Pink*, the artistic working-class individualist Andie (Ringwald again) is pursued by the wealthy Blane (Andrew McCarthy) and adored by her equally artistic and individual best friend Duckie (Jon Cryer). Following conflicts over both class-identity and ethics, Andie chooses Blane with Duckie's blessing. In *Some Kind of Wonderful*, the artistic working-class individualist Keith (Eric Stoltz) adores the upwardly mobile beauty Amanda (Lea Thompson), not noticing that his equally artistic and individual best friend Watts (Mary Stuart Masterson) is in love with him. Following conflicts over class-identity, gender-identity and ethics, Keith chooses Watts with Amanda's blessing.

Despite these consistencies, Shary praises Hughes's ability 'to convey the contemporary adolescence experience ... from a wide variety of perspectives', claiming that after Hughes teen characters had to be portrayed with a greater 'depth of understanding' (Shary 2005: 67–8). Kaveney also claims that, 'After Hughes, teen movies would always be knowing, had lost that blandness of affect, and lack of recursiveness and reference, which is often termed innocence.' (Kaveney 2006: 12) But even critics who praise Hughes's sensitivity to adolescent drama acknowledge that his is a very partial picture of adolescence. The Hughes teen is white, suburban, and normatively middle-class. Working-class characters like Andie, Amanda,

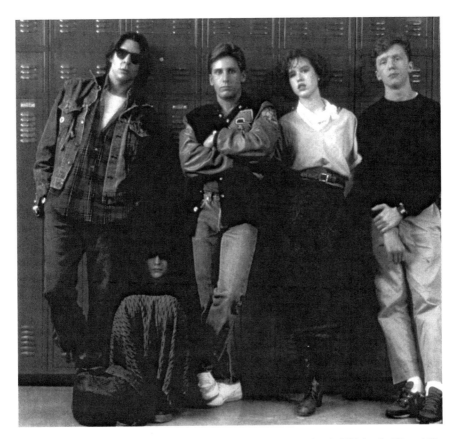

Figure 3.1 Promotional photograph for media coverage featuring Bender (Judd Nelson), Allison (Ally Sheedy), Andrew (Emilio Estevez), Claire (Molly Ringwald), and Brian (Anthony Michael Hall). *The Breakfast Club* (1985). Director, John Hughes. Courtesy of Universal/The Kobal Collection.

and Bender reinforce the normal desirability of middle-classness and non-white characters appear in the background or are crass caricatures like *Sixteen Candles'* Long Duk Dong (Gedde Watanabe).

Popular histories (for example, Bernstein) and tributes to Hughes after his death in 2009, widely equate Hughes and teen film. Hank Stuever representatively insists that Hughes's films offer an index of 1980s teen culture:

> On the wavy matrix where popular culture and one's time in highschool intersect, Gen Xers can often feel like they were born too late (post-Beatles) or too soon (pre-'American Pie'). But with John Hughes's cycle of five [sic] high-school movies that he wrote and/or directed in the 1980s, it simply felt like perfect timing. What were meant to be larky, cheaply made teen comedies remain fixed in memory as documentary accounts of that time, that place, that music, those clothes, those people, that angst. (Stuever 2009)

Partly because of this availability to nostalgia, Hughes's focus on adolescent alienation and its redemption has come to represent not only teen film of this period but in general.

Sixteen Candles introduces many of the conventions of the Hughes teen oeuvre but does not arrive unheralded. Its focus on adolescent drama that is equally banal and intense, equally comic and angst ridden, is apparent in *Fast Times at Ridgemont High* (1982), although that film is grittier than any by Hughes. *Risky Business* (1983) is a key precursor to its use of popular music. And celebration of the outsider is equally apparent in *Revenge of the Nerds* (1984), in which difference is a unifying force against persecution. *Sixteen Candles* differs from these films chiefly in its celebration of teen romance and of adolescent girlhood, although films like *Little Darlings* (1980) had already unfolded the comedy and pathos of girls' contradictory ideals of sex and love (Chapter 4). But *Sixteen Candles* also presents an optimistic portrait of suburban adolescence in which there is no obstacle of any significance that being true to yourself and empathetic with others will not counter. Sam gets her ideal man, Jake, and his penitence over exploiting Sam's trust allows The Geek to get a girl as well.

This is the first of three Hughes's films to star Ringwald as teen ideal. Ann deVaney (2002: 204) argues that this Hughes teen princess is overwhelmingly guided by fathers and invested in heterosexual romance in his image, offering girl viewers 'the promise of insight but giving them only the smallest kinds of rebellions within safe geographies of school and home.'[1] However, the Hughes family is not a uniform ideal. In fact, no family in the Hughes oeuvre is as positively useful as Sam's, who forget her birthday. As Andrew puts it in *The Breakfast Club*, 'everyone's home life is unsatisfying.' The Hughes film belongs to everyday suburbia but this is a tendency of the period. Even the Hughes film's embrace of moral pluralism was broadly characteristic.

The elements used to single out the Hughes teen film are not always narrative. Hughes's use of popular music is often emphasized, and characterized less by narrative functions than by a taste regime. Sam's first appearance on screen in *Sixteen Candles* is accompanied by Paul Young's 'Love of the Common People' and in *Pretty in Pink* Andie's appearance is accompanied by Nik Kershaw's 'Wouldn't it be Good'. The selection of UK singles for these moments locates these characters in an expert relation to contemporary music. Reaching outside the US pop music scene emphasizes Sam, Andie and Duckie's outsider cool. Andie works in a record store where her musical taste is affirmed by her 'alternative' boss Iona, but even popular boys can tell Andie and Sam are more 'interesting' than most girls. They are the resourceful creative girls routinely figured in 1980s teen film as cool in terms of what the film values and uncool in terms of high-school politics portrayed in the film. But *Pretty in Pink* is not, in fact, an outsider romance, but a reparative one that brings the outsider and the mainstream together. Commentary now often remarks that there was a mooted alternate ending in which Andie chose Duckie, but

the existing ending resists sentimentality precisely because Duckie's devotion goes unrewarded.

Duckie marks a turning point for Hughes' teen characterization in being more complex than the geek characters of earlier films and the later films abandon the geek type. Criticism often stresses Hughes' identification with the geek but this figure belongs to the locker-room jokes and house-trashing parties of the early films. This is most true of *Weird Science*, which centres on the realization of adolescent male fantasy, primarily in 'success with women' (Kaveney 2006: 24–7). Gary and Wyatt produce Lisa from a conjunction of computer wizardry, adolescent hormones, and a fashion doll, but just as she is more summoned genie than computer product, she is more moral guide than sex toy. Appropriately for the kind of transformations she comes to work, Lisa commands all things stereotypically male – cars, guns, club argot, party life – and she confronts male authority figures, like Gary's father and Wyatt's brother, who have failed to nurture the boys. Lisa apparently ascribes to a more traditional image of masculinity than do the boys, for whom the 'bravery and courage' she wants them to prove 'are outdated concepts.' Kaveney (2006: 28) quite rightly refers to her as a 'phallic fantasy woman'. *Weird Science* is both a Frankenstein narrative in which the (virtuous) monster makes the man, and a story about the skills that really comprise a man. The Hughes geek knows who he wants to be, but he needs the fortunate intervention of someone paying attention to him in order to make it happen.

In this sense *Revenge of the Nerds* offers a crucial context. Here too, the geeks seek recognition of their masculinity through the authority of sexual partners. The geek is associated with the rise of new technologies, such as the domestication of computers as tools and as leisure spaces (videogames appeared in the 1970s). But the geek is also a new variation on old questions about how one becomes a man. Like *Sixteen Candles*, *Revenge of the Nerds* contains a key late scene in which the sensitivity of the geek as a lover is revealed to the popular girl who would never have sex with him if she was able to say no (in *Revenge of the Nerds* he is disguised as her boyfriend and in *Sixteen Candles* she is too drunk to decide). This is as important as the fact that these films draw on the success of *WarGames* (1983), in which the technical proficiency of youth enables critical perspectives on established power (Shary 2005: 73–4). This set of films appear so closely together that they evidence a cultural moment rather than speak to each other. And the Hughes–Hall geek that develops across this period culminates in Brian's intelligent empathy in *The Breakfast Club*.

The Breakfast Club is one of the most discussed teen films of the 1980s. Celebration repeatedly claims that it is 'new', as *Juno* (2007) scriptwriter Diablo Cody puts it, because it was 'a serious film about young people's emotions' (in Lehmann 1988). The film does work like 'a group therapy session' (Shary 2005: 68), but Principal Vernon (Paul Gleason) is a crucial additional perspective. Vernon acts as immaturely as any of the kids, relishing his power to intimidate and losing

his temper when meeting any limit on his power. But Vernon has real authority in his capacity to close off the potential that still seems alive in the students. He finally makes Bender submit by representing him as having no future: 'You go and visit John Bender in five years,' he taunts. 'You'll see how God-damned funny he is.' Bender recognizes Vernon's immediate power over him but he understands this future as the more substantial threat.

The Hughes teen film celebrates and critiques both high school and the nuclear family. Vernon's dismissive attitude is established as generally representative of the school, and if the students' desires and characters go unacknowledged at school they don't fare better at home – parental ignorance and disinterest is efficiently signified by the way they are dropped off and picked up (or not) and by their packed lunches (or absence thereof). To engage with the institution of high school it deploys and reverses several strategies evident in *Blackboard Jungle*. In place of the pre-title preface the film uses an epigraph from David Bowie's 1971 song 'Changes' – 'They're quite aware of what they're going through.' This twists the public address to moral panic into a reflection on adolescent self-consciousness, but still marks a generation gap. In place of 'Rock Around the Clock' signifying the energetic attitude of kids offered few opportunities, *The Breakfast Club*'s theme is heavily ironic: Simple Minds' 'Don't You (Forget About Me)'.

Despite appreciating aspects of *The Breakfast Club*, Kaveney (2006: 22) reads the transformation of the central characters as 'superficial and entirely reductive'. Shary (2005: 70) also questions Claire's sudden interest in both Allison and Bender late in the film. But the relationships within the group are always characterized by a mix of fascination, contempt and caprice. Even Brian's letter uniting them as 'the breakfast club' doesn't separate them from the stereotypes by which they were first defined but embraces these as shared characteristics of adolescence: 'each of us is a brain, an athlete, a basketcase, a princess, and a criminal'. These are images of adolescence drawing on the history of teen film. Bender, for example, is a screen j.d. by both his styling and his story. Kaveney sees him as referring to *The Wild One*, *Rebel Without a Cause*, and the hoods of *West Side Story*, 'depraved on account of he's deprived' (Robbins and Wise).

The class difference Bender suggests, is even more central to the Hughes films directed by Howard Deutch. *Pretty in Pink* and *Some Kind of Wonderful* are narratives about class mobility that situate adolescence within a class-specific parent culture and then bring it into contact with class difference through high school and youth culture. They tell this story about class mobility differently, first of all because of the gender reversal of the central love triangle. Both Kaveney and Shary see *Some Kind of Wonderful* as rewriting *Pretty in Pink* from a male perspective, with a reversal of its conclusion (Shary 2005: 71–2; Kaveney 2006: 32–7). But there are some further differences. Across Hughes's literal use of 'the other side of the tracks' motif, Keith in *Some Kind of Wonderful* has power to determine a class trajectory for himself, via college and his college fund, that Andie doesn't have in *Pretty in*

Pink. And he is also more able to recognize love, giving his future into the control of Amanda and then Watts and recasting the diamond earring Claire gives Bender in *The Breakfast Club* as a serious commitment. The consequence of this combination of mobility and trust, however, means that it matters what kind of girls Amanda and Watts are in a way that's not applicable to Blane.

The Hughes teen film is spectacularly coherent, but not simple. There is a moral tenor to his films that sets definite limits, but within that range no one way of moving through adolescence is the singularly right one. Hughes brought the youth as problem, as institution, and as party themes in more or less equal measure into narratives about negotiating social limits and cultural stereotypes. The context for Hughes teen film in this sense is not only the mythical terrain of suburban American teenage life but also an international field of images of adolescence. If models of gender and class in the Hughes teen film seem highly specific they participate in the transnational cultural flows that allow Hughes to take up UK music and that mean high school is just as important to adolescence in countries all across the world.

Ferris Bueller's Day Off

In *Ferris Beuller's Day Off*, written and directed by Hughes, cool, popular Ferris (Matthew Broderick) skips school on a beautiful day. He convinces his neurotic best friend Cameron (Alan Ruck) to come along, and they steal his father's car and trick the Dean of Students, Edward Rooney (Jeffrey Jones), into releasing Ferris's girlfriend Sloane (Mia Sara) from school. Their adventure in Chicago moves between their houses, the Sears tower (then the tallest building in the world), the stock exchange, an expensive restaurant, a baseball game at Wrigley Field, the art gallery and a downtown parade. Throughout this day Ferris's adventure wends around those who might catch him out: his parents, his resentful sister Jeannie (Jennifer Grey), and Rooney on an increasingly manic quest to prove Ferris is not ill at home.

Ferris commands a wide array of forms of knowledge that allow him to manipulate his parents, Cameron, his fellow students, the school's computer system, the restaurant staff and a parade's organizers, cast and audience. He even knows about and addresses the film audience. But Ferris's day off particularly relies on his knowing how to perform different and at times contradictory images of youth. To reassure his parents, Ferris declares 'I want to go to a good college so I can have a fruitful life.' But he knows that his parents have a highly ambivalent picture of him in which he is not only responsible almost-adult Ferris but also sweet little boy Ferris. In class, Ferris's fellow students are dazed with boredom as the teacher drones on about American politics. But Ferris has no need for such training and the skills to avoid it; he is dancing to the television. He commands that eclectic taste regime and personal creativity which threads through Hughes films as an index of individuality, uniquely combining characteristics of the nerd and the popular boy.

As Rooney's assistant Grace (Edie McClurg) puts it, 'he's very popular, Ed. The sportos, the motorheads, geeks, sluts, bloods, wastoids, dweebies, dickheads … They all adore him. They think he's a righteous dude.'

Given 1980s teen film's focus on segmenting school types this mix of abilities is highly unusual. The fact that Ferris fits no 'type' is intimately linked to the fact that he has, and constitutes, no problem. His every resistance remains compatible with the successful progress of adolescence and so Rooney's determination that Ferris be punished for not being in school does make him, as Grace suggests, 'look like an ass'. Rooney is a slapstick version of *The Breakfast Club*'s Vernon, spitefully determined to destroy the life of a student who defies him. In *Ferris Bueller's Day Off* this determination is comedic because it seems so improbable that he could succeed. The narrative closes around Rooney's humiliation, forced to take the school-bus with children who ogle his injured and filthy state. Ferris in this context is a kind of superhero.[2] While without Jeanie giving up her petulant determination to expose her brother's lies Ferris might have been caught by both his parents and Rooney it seems possible Ferris would have found another way out. Ferris occupies an untyped middle-ground of adolescence – a typicality transformed into an ideal. His whiteness is crucial here. The parade Ferris interrupts is a German festival but in the surrounding streets many black people dance in synchronization to Ferris's song.

The whiteness of 1980s US teen film is not confined to Hughes. Responding to this context, Shary singles out 'the African-American crime film' as 'the dominant style of American teen film' in the early 1990s, from the success of *Boyz N the Hood* (1991) until 1995, when a 'saturated' market confronted with more diverse popular images of African-American youth undermined the subgenre's influence (Shary 2005: 82). But Shary's emphasis on this subgenre in some ways obscures a history of race narratives in US teen film that his longer study (Shary 2002) gave more space to. It downplays other subgenres, including films about young black athletes (Regester 2005: 333–49) and comedies like *School Daze* (1988) and *House Party* (1990). While ethnic difference was often embedded in whiteness, diversity threaded through 1980s teen film, including the teen dance-musicals like *Fame* (1980), the teacher-hero genre films like *Stand and Deliver* (1988), and family-oriented films like the 'Karate Kid' series (beginning in 1984). While *National Lampoon's Animal House* (1978) exposes racial segregation, *Revenge of the Nerds* uses the same conventions to incorporate a wide array of differences – black, gay, Jewish, geek, Asian youth, etc. – as those marginalized by a vicious mainstream youth culture typified by white jocks and cheerleaders.

If these kinds of difference are set aside by Ferris, his privilege remains clear. Confidence, luck, and charisma are Ferris's special resources, but he has access to more than sufficient tools, toys, and money. Home, school and street as key locations for teen film are always marked by class, but teen film's forays into working life are relevant here. Both Andy Hardy and Miller in *Blackboard Jungle* a decade later had after-school garage jobs, but by the time Keith has a similar job in *Some Kind of*

Wonderful this raises the spectre of failure. The US image of adolescence had become more symbolically middle class and more normatively applied regardless of class. In this context 1980s teen film has been strongly associated with 'Reaganomics'. Ronald Reagan's pro-business, low-tax policies and the economic recovery linked to them is understood to have enthused teen film with entrepreneurial spirit. This image of comfortable 1980s adolescence is, in fact, particularly American. In the UK, for example, decline and restriction rather than prosperity marked the images of youth culture in teen film of the time, as with *Gregory's Girl* (1981) and *My Beautiful Laundrette* (1985). In Australia, from the beachside drama of *Puberty Blues* (1981) to the rural drama of *The Year My Voice Broke* (1987), teen film in the 1980s was predominantly interested in working-class life outside that of a putative suburban audience. Certainly for Ferris, as in *The Secret of My Succe$s* (1987), 'business' is the only promising career. He visits the stock exchange, imitates a businessman at lunch, and his day is paralleled with his father's corporate working day. However, films like *Fast Times at Ridgemont High* demonstrate that the 'slacker' culture now usually associated with the 1990s is equally part of 1980s teen film's response to US prosperity (Chapter 4).

Ferris's adventures are not typical youthful thrill-seeking but explore the border between adolescence and adulthood. The adult characters with whom he clashes understand this and Ferris and his friends directly confront the question of what will happen after the immanent end of high school. While Cameron believes that 'School, parents, future. Ferris can do anything,' Ferris confesses to the audience that he doesn't know what the future holds. He suspects that he and his friends will drift apart and the film suggests he is right. The musical motif of Wayne Newton's 'Danke Schoen', which Ferris sings in the shower and in the parade and Rooney hums as he pursues Ferris, underlines this: 'Though we go on our separate ways / still the memory stays, for always, my heart says / Danke Schoen.' But splicing older music like The Beatles and Newton into a teen's late 1980s escape from high school is also suggestive in other ways.

When Ferris addresses the camera, and audience expectations, he positions teen film as a genre too familiar to work anymore. Teen film in the 1980s sometimes seemed to be either mourning for or sceptical about narratives of maturity and development. At least it no longer positioned maturity as inevitably desirable or even always possible. Teen film in the 1980s was largely produced by people born during the escalation of bobbysoxer and teenybopper culture after the Second World War: the so-called 'baby boomers'. By the 1980s, history had moved the spectacular wave of 1950s youth culture into the position of parent culture and teen film treated this progression ambivalently. In the 'Back to the Future' films, Marty (Michael J. Fox) goes back to 1955 (in 1985) and forward to 2015 (in 1989) to find that adolescents have the same problems and adults are equally constrained by the frustrations of their youth. But, as with the tribute to the 1950s built into *Grease* (1978), this story suggests that nothing important about youth today is new. Teens in

the audience and on screen are referred back to the 1950s as a place in which their ideals about adolescence are true but their experiences are not. Doherty (2002: 196) sees 1980s teen film as abandoning investment in rebellion for this reason: 'The adult villains in teenpics such as *Risky Business* and *Ferris Bueller's Day Off* are overdrawn caricatures, no real threat; they're played for laughs. Since the 1960s, the most fascinating trend in teenpics has been their palpable desire for parental control and authority, not their adolescent rebellion and autonomy.'

This is a strange reading of *Ferris Bueller's Day Off*, but scholarship on teen generally agrees that 1980s teens were uninterested in the social. They were, instead, 'lulled into expressing their politics through consumption' (Shary 2005: 54).

For Shary, the 1980s renaissance of teen film is a product of the multi-screen movie theatre. The multiplex clarified a returning adolescent demographic to whom more and more varied teen films should be addressed. He attributes to this some changing conventions for teen film, including the 'complexity of moral choices and personal options' built into the variety of the multiplex (Shary 2005: 55). For Shary (2002), the multiplex represents an adolescent quest for social space that recalls the significance of early picture theatres but with more demographic coherence. And the techniques by which the film industry exploited this audience also recall the commodified youth culture Doherty identified in the 1950s but, again, with less demographic coherence.

While Ferris was partying on one screen and the disturbing protagonist of *River's Edge* (1986) passed around his dead girlfriend's corpse on another, Lawrence Grossberg published an essay called 'The Deconstruction of Youth'. Acknowledging that youth is a constantly changing field, Grossberg nevertheless argues that a resistant spirit he calls 'antidomesticity' – the refusal of institutionalizing parent culture – was being lost in the 1980s (Grossberg 1992: 188–91). Like Jon Lewis and Shary, Grossberg sees in the 1981 arrival of MTV and other changed circuits of youth culture, including malls and video games, a dispersal of 'youth culture' into niche markets. And he claims this fragmentation demands the 'rearticulation' of youth, 'not only as a cultural category but as a social and material body as well' (Grossberg 1992: 199). For Grossberg this reconstitution tended to promote conservatism by displacing the association between youth and resistance into irony. Grossberg relates this to ambivalent generationalization discussed above: 'Youth today is caught in the contradiction between those who experience the powerlessness of their age (adolescents and college students) and the generations of the baby boomers who have attached the category of youth to their life trajectory, in part by defining it as an attitude ("You're only as old as you feel")' (Grossberg 1994: 183).

Grossberg (1992: 189) describes *Ferris Bueller's Day Off* as a victory for youth in the struggle to claim 'youth', a struggle in which 'Never has youth talked so much, nor had so much expertise and knowledge' (Grossberg 1992: 190).

Another example that brings these ideas together is *Risky Business*. The title invokes that image of 1980s youth as newly invested in material success but also

invested in seeking independence and pleasure (Bernstein and Pratt 1985). Joel Goodsen (Tom Cruise) is a senior high school student left alone in his family home while juggling an 'Ivy League' college application, a high school entrepreneurship project and dreams of losing his virginity. Through a comic obstacle course of extortion, accident and naïveté, Joel's entrepreneurial spirit is turned to running a brothel, which eventually convinces the Ivy League interviewer of his talent. The scene for which this film remains famous, with Cruise dancing around the living room in socks, shirt, and underpants miming to Bob Seger's 'Old Time Rock and Roll', captures many of the film's themes. His costume and performance blend signifiers of business, teen, and child life and the music is both contemporary (a 1979 single) and nostalgic ('today's music aint got the same soul'). Joel's narrative simultaneously ridicules and validates the necessary achievements of adolescence. Thus *Risky Business* is one of Doherty's (2002: 196) examples of 'postclassical teenpics': 'teenpic-like in their target audience and content, but their consciousness is emphatically adult, the artistry in their double vision unmistakeable.'

One term for this ambivalence is 'postmodernism'. 1980s teen film is often thought to be particularly self-conscious. The sheer proliferation of teen film across the multiplex format demanded, in terms we should refer back to Siegfried Kracauer's discussion of the audience's awareness of fantasy (Chapter 1), that films acknowledge the genre of teen film and its repetitions. Teen film has always been a self-conscious genre because it is so concerned with articulating what belongs to the present, but in the 1980s it was surrounded by theories about self-consciousness that provided new terminologies for this. Ferris appears in the same context as Fredric Jameson's 'Postmodernism and Consumer Society' (1983).[3] The two elements of 'postmodernism' Jameson develops in this essay stress loss of certainty. The first is the loss of certainty that one can become a unique, autonomous person, so that for postmodernism people seem more like a collection of roles and fantasies than individuals (Jameson 1983: 113–14). And the second is the loss of linear historical progress as an explanation of the world, so that for postmodernism all histories are just texts (Jameson 1983: 116–18). Ferris has been widely discussed in this sense as an image of ideal youth talking about images of ideal youth that does not suggest any meaningful adolescent development.

The historical specificity of Ferris's life includes this uncertainty about the relations between adolescence and adulthood. In the late 1980s a range of teen films told stories about young adults' problems with maturity – what Shary (2002: 153) calls 'the "20-something teenager" emblematic of '90s films.' Although I took the epigraph for this chapter from *She's Having a Baby* (1988), I omitted that film from my list of Hughes's teen films. But it does belong with these post-high-school films about adolescence that I now want to suggest are also teen films. Beginning with marriage and ending with childbirth, it focuses on an apparently impossible quest for certain maturity. If, as Jake (Kevin Bacon) puts it, 'College is like high school with ashtrays', life after graduation offers no new certainty. In

their twenties, the characters in *St Elmo's Fire* (1985) are also struggling with adult careers and relationships without resolving the problems of adolescence – parental expectations, anxieties over image and popularity, the burden of the future, and the imminent loss of a certain kind of freedom. While this deferred if not impossible adulthood continues older themes, in the 1980s it became associated with claims about 'postmodern' adolescence for which there is no developing maturity but only proliferating youthful styles.

We might also see the problem 'postmodernism' tries to describe in the art gallery scene in *Ferris Bueller's Day Off*. The camera focuses on Cameron's aghast expression as he stares at a detail of Georges Seurat's post-impressionist painting *A Sunday Afternoon on the Island of La Grande Jatte* (1884–6). Seurat's 'pointillist' style makes fragments into something that only has coherence at a distance (a suggestive analogy for 'youth'). But from the poised figures in the painting Cameron focuses on the smallest and most indistinct; the only figure looking directly from the painting at the observer. While Ferris, taking the day off to look around and see what's there, moves rapidly from place to place and seems always to be performing on the surface of things, Cameron stops. But it turns out that beneath the surface nothing is clear. We do not know if Cameron sees himself or a challenge to himself in the way the little girl disappears as he looks more closely. But we know he cares and it is thus Cameron who transforms Ferris's day off into something significant because when, in the very next scene, he denies having seen anything special today we share Ferris's disbelief.

The Exhaustion of Teen Film: *Heathers, Clueless, Mean Girls*

The tight conventionality of 1980s teen film is easily exaggerated. There were 1980s monster/adolescence allegories, like *An American Werewolf in London* (1981) and *Lost Boys* (1987). There were youth problem films, like *The Outsiders* (1983), party films, like *Revenge of the Nerds*, and musical romances, like *Dirty Dancing* (1987). Instead of looking for the distinctiveness of 1980s teen film in this section I want to think about its continuity with what followed. For this I'll focus on a subgenre Shary (2005: 76) calls 'revisionist teen film' to distinguish films like *River's Edge, Say Anything ...* (1989), and *Heathers* (1988) for 'their understanding of their generic heritage and, more so, their ability to transcend the typical concerns of subgenres dealing with delinquency, romance and schooling' (Shary 2005: 76). This revisionist 'cycle' appears during the 1980s proliferation of teen film rather than as an after-effect and the sequence *Heathers, Clueless* (1995) and *Mean Girls* (2004) points to a continuity in which teen film is repeatedly represented as exhausted – as saturated with clichés.

These films all also focus on the powerfully popular high-school girl. Given her command of the adolescent mainstream it is ironic that the teen queen film should be

such an effective tool for revisionism. *Heathers*, *Clueless*, and *Mean Girls* use the teen queen to represent the conventionality of adolescent fears and ideals but also of teen film itself. This sequence also represents the diversification of girl characters in teen film since the 1980s and the impetus for this does not come from Hughes films, where relationships between girls are generally negative or peripheral. The decline of idealized fatherhood in teen film responded in part to women's changed working lives (Considine 1985: 76–7), and the dialogue with institutionalized feminism evident in these films is as new to 1980s teen film as music television. Kimberley Roberts sees in Michael Lehmann's *Heathers* 'a direct precursor of the 1990s popular feminist groundswell known as *girl power*' (Roberts 2002: 217). But rather than a girl-centred feminist politics, *Heathers* represents an individual girl hero who is ruthless by necessity. She survives at the cost of her romanticism rather than her idealism but she has more in common with the final girl of teen horror film (Chapter 5) than with the Hughes princess.

In *Heathers*, Veronica Sawyer (Winona Ryder) is infuriated by the attitudes and behaviour of the girls who are currently her closest friends – Heather Duke (Shannon Doherty), Heather McNamara (Lisanne Falk), and Heather Chandler (Kim Walker) ... 'the Heathers'. Her anger is encouraged by the new boy in school who catches her eye; the tellingly named J.D. (Christian Slater). J.D. manipulates Veronica into accidentally poisoning Heather Chandler and then helps her conceal the death as a suicide. It soon becomes apparent that J.D. is happy to kill everyone in the school he doesn't like, which means everyone except Veronica. He sets up the subsequent 'suicides' of Heather McNamara and two football stars, compromising Veronica in each of these as the school gets caught up in melodramatic popular discourse on teen suicide. Veronica finally discovers J.D.'s plan to blow up the school leaving behind a mass suicide note and has to kill him to stop him.

Veronica herself is and is not a Heather. She dresses like them, spends her time with them, and is included as one of them by the school population at large. But Veronica is also always singled out, and not only because her name is not Heather. While the others reach quick verbal consensus, Veronica keeps her opinion to herself and her scathing diary. We could bluntly summarize *Heathers*' contribution to the revisionist teen queen subgenre using this diary: 'My teen angst bullshit has a body count.' *Heathers* plays with stereotypes and exposes the reliance of popular and public discourse concerning adolescence on cliché. J.D.'s full name is Jason Dean, but the shooting script introduces him this way: 'She's suddenly captured by the sight of a JAMES DEANESQUE GUY sitting stark in a long, tan gunslinger coat, behind a Rebel Without a Cause lunchbox' (Waters 1988). Styled as the angsty teen rebel, J.D. is revealed to be something more chaotic. If he has a target it's the 'phoniness' of the world, exemplified by the way Heather Chandler's death is exploited by self-help rhetoric, by 'current affairs' television, by knee-jerk religious opprobrium about youth culture, and by the hit pop song, 'Teenage Suicide, Don't Do It'.[4] While Veronica saves the school, as a moral victory this remains ambivalent. She coolly

lights a cigarette on the explosion she knows will kill J.D., and although critics have seen her final embrace of the persecuted 'Martha Dumptruck' as renouncing everything 'Heathers', Veronica also declares that she now runs the school.

Heathers influenced later films about the violence of high-school cliques and the cruelty of girls' popularity contests. *Jawbreaker* (1999) and *Mean Girls* are direct responses but Kaveney (2006: 85–108) claims *Clueless* is a fluffily likeable inversion of this 'mean girls' trope. *Clueless* has merited a great deal of critical attention for its success at translating a literary canonical hit, Jane Austen's *Emma* (1815), into teen film (Chapter 8). But *Clueless* also had fresh appeal amidst an array of cinematic representations of adolescent difficulty. As Gayle Wald (1999: 51) points out, *Clueless* was released the same year as the grim moral panic tale *Kids* (Chapter 6), and it was surrounded by popular and award-winning youth problem films like *Dangerous Minds* (1995) and *The Basketball Diaries* (1995). In comparison to such films, *Clueless* did not take itself seriously, promoted with tag lines like 'Sex. Clothes. Popularity. Whatever.'

In *Clueless*, Cher Horowitz (Alicia Silverstone) lives a luxurious Los Angeles lifestyle with her wealthy litigator father, her mother having died in a freak liposuction accident. At school, Cher is queen of all she surveys, with a court including her best friend Dionne (Stacey Dash), Dionne's boyfriend Murray (Donald Faison), and a wider popular crew. Cher is superficial and vain but also generous and creative. Wanting to please her father and impress her ex-stepbrother Josh (Paul Rudd), who teases her for being an ignorant 'space cadet', but also to gratify her own self-image, Cher embarks on a serious of projects – matchmaking teachers, making over the 'clueless' new girl Tai (Brittany Murphy), attracting the handsome new boy, and finally charity work. This sequence of projects eventually makes over Cher herself, and she realizes that she is 'clueless' about many things, including her love for Josh. Cher's moral education is complete with that realization and the film closes on their happy romantic union.

Heckerling began directing teen film with *Fast Times at Ridgemont High*, based not only on Cameron Crowe's script but on her own observation of LA teenage life adapted to something she says was more 'colourful' and 'specific'. *Clueless* is often praised for its clever take on youth culture, but commentators like Doherty (2002: 204) criticize it for erasing problems like 'ethnic animosity and homophobia'. Set in Los Angeles in the mid-1990s, in the wake of the visible racial tensions of West Coast 'gangsta rap' and the 1992 LA riots, the easy race relations in *Clueless* are particularly notable. Slight and evasive references bleed into the plot. Debating the mesh of gender and race in black 'street slang', for example, Murray quips that 'Most of the feminine pronouns do have mocking, but not necessarily misogynistic undertones'. But despite its cool pop soundtrack, the laid-back backing vocals to Coolio's 'Rollin' With My Homies' are the only part of contemporary rap's narrative about youth, music, race, sex, and crime that makes it into a rich white girl's world.

Doherty (2002: 203) includes the 'post-AIDS' erasure of sex in *Clueless* as part of this disingenuous 'gentrification' (Doherty 2002: 204). There is no on-screen sex,

despite the tagline quoted above, but sex is a crucial plot element precisely because Cher is 'saving herself for Luke Perry'.[5] *Clueless* is smartly ironic about this hypcr-clean image. Backed by Kim Wilde's 'Kids in America' (1981), the film begins with a pool party that Cher knows makes her life look like an anti-acne 'Noxema commercial'. It's a purified, commodified teen world but one that, as Lesley Stern puts it, is 'at once utopian and comic'. As Wald (1999: 60) argues, *Clueless* conflates 'consumption with cluelessness' using an opposition between the commodified girlhood of advertising and the angst-filled struggles established as the natural state of the girl in 1990s teen film. *Clueless* thus invites pleasure in recognizing Cher's cluelessness (Wald 1999: 61), but it also invites admiration of her. However 'clueless' she turns out to be, Cher's knowledge and taste are not dismissed. In fact, as Wald (1999: 65) suggests, Josh just as clearly articulates his identity and preferences through consumption. His 'complaint rock', beret, or copy of Nietzsche produce the identity he wants others to see in the same way as Cher's extensive and immaculate wardrobe.

This recognition suggests another useful critical tool for thinking about teen film. In 1979, French sociologist Pierre Bourdieu coined the term 'cultural capital' to describe how taste and knowledge combine to locate a person's competencies as belonging to a particular class. Cultural capital, which can be inherited or acquired (Bourdieu 1986: 80–8), is central to the makeover trope and education in *Clueless*, and in teen film more widely. It is a way of explaining how taste 'functions as a sort of social orientation, a "sense of one's place," guiding the occupants of a given ... social space towards the social positions adjusted to their properties, and towards the practices or goods which befit the occupants of that position' (Bourdieu 1986: 466).

Every character in *Clueless* works to develop and evaluate cultural capital. And if Cher and Dionne's shared sartorial style can be passed on to Tai, not everything can be so easily taught. Tai wonders that the Beverly Hills kids all 'talk like grown ups' and is assured that 'This is a very good school.'

In *Fast Times at Ridgemont High* and *Clueless*, Heckerling differently deploys one of her key contributions to teen film – the guided tour of high-school groups that Kaveney (2006: 3) calls 'the anthropology shot'. In *Fast Times at Ridgemont High* this tour names class and ethnic diversity as well as leisure groups, and in *Heathers* it labels highly recognizable but only superficially coherent cliques. But in *Clueless* the cliques are a mix of the surreally specific and by now utterly generic: the 'TV station crowd', the 'Persian mafia', 'popular boys', 'loadies'. These distinctions lack the angst of a Hughes film or the savagery of *Heathers*, but the point of the teen queen remains that she is somewhat outside such groups because she can define them. In comparison to Cher, the cruelty of the Heathers is more intentional, impersonal, and strategic and in this *Mean Girls* is the film more indebted to *Heathers*. However, *Mean Girls* is also directly adapted from a guidance manual on the problems of teenage girls. Kaveney stresses the fact that *Mean Girls* is directed by Mark Waters, brother of *Heathers*' scriptwriter Daniel Waters, but the more telling influences are comedian Tina Fey, who wrote the screenplay adaptation, and her source, Rosalind

Wiseman's *Queen Bees and Wannabes: Helping Your Daughter Survive Cliques, Gossip, Boyfriends, and Other Realities of Adolescence* (2002). Wiseman's text is written, as Kaveney (2006: 98) puts it, 'from the point of view of anxious parents and concerned educators.' *Mean Girls*, unlike *Heathers* or *Clueless*, is thus sentimentally hopeful about the goodness at the heart of every girl if she can overcome a culture of cruel competitiveness. But it maintains some ambivalence by suggesting that this culture reasserts itself repeatedly no matter how many girls overcome it.

In *Mean Girls*, Cady Heron (Lindsay Lohan) arrives at high school after being homeschooled by her parents – field zoologists who raised her in Africa. Although high school is a puzzling foreign land that Cady christens 'Girl World', she quickly meets a couple of guides. Janis (Lizzy Caplan) and Damian (Daniel Franzese) are artistic types interested in rather than alienated by Cady's difference. They introduce her to the school's social system, including its predators, 'The Plastics', led by popular cheerleader Regina George (Rachel McAdams). As Cady gets to see how villainously Regina treats everyone, she's also attracted to Regina's boyfriend, and so she agrees to Janis's plan to undermine The Plastics by using her 'new girl' credibility to become one of them. Cady undermines Regina's power, but the plan goes awry as Cady becomes more and more like a Plastic herself. In a climactic confrontation Cady is both trapped by Regina's revenge and herself exposed as a mean girl. Cady finally redeems herself by sharing her prom queen crown with all the other girls, including Regina, now crippled (*deus ex machina*) by a truck accident.

The opening joke in *Mean Girls* is that Cady is effectively a little girl because she hasn't gone through the socialization of school. But the skills necessary for successful teenage life have nothing to do with what's taught in class. In *Mean Girls* the anthropology of high-school tribes is given added reflexivity by positioning Cady as a trained anthropologist, but if Cady brings analogies between adolescence and animal behaviour or primitive tribes to her analysis of Girl World, what she discovers is a fine map of transient distinctions. *Mean Girls* plays with some familiar teen film conventions while challenging others. Cady's makeover to look like a 'plastic' doesn't code her as suddenly more attractive and if her pursuit of the nice boy succeeds then fails quite conventionally, it never comes around to a happy conclusion equal to Cady dividing up her prom queen crown. Kaveney (2006: 106) dismisses this prom scene as 'mawkish', and Ms Norbury's (Tina Fey) exercises designed to teach the girls to value and forgive one another other are undeniably cheesy. But this sentimentality is parodied at the same time. Even Cady's moral triumph is made less simplistic by a tag scene in which she recognizes in the easy hauteur of a trio of younger girls the new 'junior plastics'.

Heathers, *Clueless*, and *Mean Girls* pose very different reasons for the teen queen's competitiveness. In *Heathers*, girls directly seek power over other students. In *Clueless* girls compete to be popular, a pleasure teen film often portrays as a mark of immaturity and exclusive to adolescence. *Heathers* is a satire of teen film

because maturity is beside the point; no one will ever be mature, including the ludicrously inept parents and teachers. But *Mean Girls'* therapeutic premise is that girls compete because they are insufficiently self-aware. They are damaged by a girl culture that is inevitable because it is embedded in the institution of high school. *Mean Girls* undermines the idea that girls' conformity is a form of safety and yet suggests that society is not responsible for the mean girl's behaviour because she can be defeated by public exposure. Neither *Heathers* nor *Clueless* is invested in such public redemption: in *Heathers*, because the public is as flawed as any high school, and in *Clueless* because the mean girl is only changed by growing up.

Heathers, *Clueless* and *Mean Girls* all stress the conventionality of teen film in order to stress their overcoming of that conventionality. What they do with the genre's association with pop music is exemplary. *Heathers'* satire of teen film conventions extends to its use of popular music, replacing contemporary pop songs with covers of the 1956 Doris Day hit 'Que Sera, Sera' and the exploitative 'Teenage Suicide (Don't Do It)' by the fictional band Big Fun. The *Clueless* soundtrack uses a mix of 1980s and contemporary tracks to reinforce its ironic repetition of teen film conventions. In *Mean Girls*, however, the convention of using contemporary pop song fragments to supplement the narrative also returns to cite Lohan's current visibility as a popstar and thus the older convention of pop-star vehicle teen films.

From the 1970s to the 1990s the close relation between pop-stars and teen films after the reign of Elvis discussed in the last chapter was overshadowed by pop-stars on teen-directed television, from David Cassidy (*The Partridge Family*, 1970–4) to Will Smith (*The Fresh Prince of Bel Air*, 1990–6). Teen film stars as celebrities no longer played themselves on film (like Elvis) but specialized in generic adolescence. The US media referred to the most famous as 'the brat pack', a tribute to the 1950s Hollywood 'rat pack' that tellingly conjoins immaturity and public license. These teen stars moved across the expanding network of 1980s teen films, providing crucially recognizable promotional links to which I will return in Part III.[6] They were brought together by the new visibility of the genre label 'teen film', which is the most distinctive aspect of this type of film in the 1980s. What Shary (2005: 2) calls the 'more codified approach' of 1980s teen film relies less on any difference in content than on the way movies for and about teenagers were pervasively talking to each other. If my central examples in this chapter have been American this conversation is not confined to the US. I want to close Part I by foreshadowing the importance of both the 1950s and the 1980s to teen film in countries like Japan and India to which I turn later in the book, and in Part II I want to engage more directly with the premise, based on the international visibility of these examples, that teen film is particularly American.

Part II
Film Teens

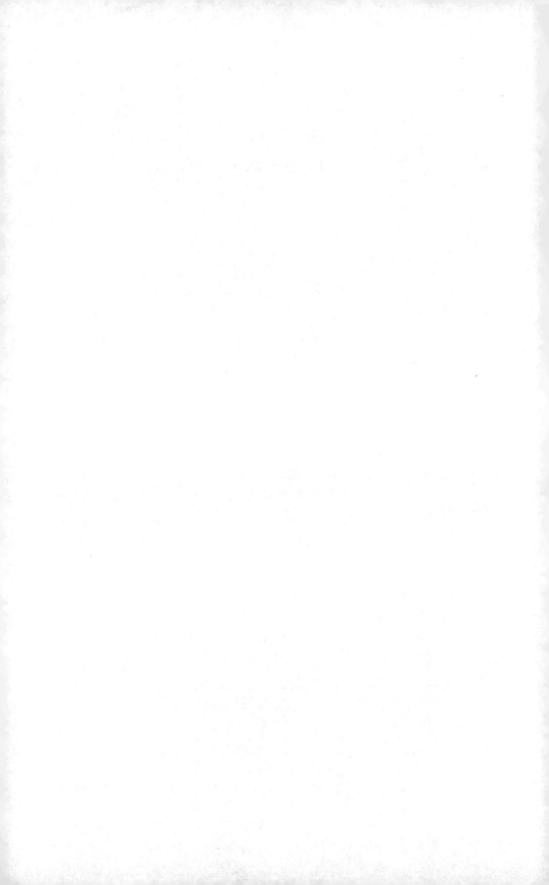

–4–

Rites of Passage

Kumar: You might think this is just about the burgers, but this night is about the American dream

Harold and Kumar Go to White Castle (2004)

Genre is always historically defined – connecting films to existing genres – but it is also defined by the set of films being compared at a given time. One teen film may be more *teen film* than another. Every film includes a range of components selected from those available at the time: including choices between shots, characters, settings, and script or soundtrack elements. Rick Altman (2004: 684) calls these 'lexical choices'.[1] Particular components and arrangements of components, can be chosen to say, or not say, *teen film*. The second part of this book considers how the conventions of teen film signify adolescence. It also considers teen film's reputation as specially generic or conventional. Jane Feuer (2004: 230) discusses teen film as a genre that can be defined either in Altman's terms or in Thomas Schatz's as 'a community of interrelated character types'. But she follows Altman to distinguish between films belonging to a genre semantically (because they have teen-film components), and those that belong syntactically (because they tell teen-film stories but with perhaps varied components) (Feuer 2004: 230).

Criticism generally talks about why teen films exist rather than analysing how they work. The most subtle historical approach to teen film will tend to think of the genre in *mimetic* terms, understanding changes in the genre as reflecting changes to the lives of adolescents in the audience. In the case of teen film this approach furthers the tendency for discussion of films to especially evaluate them according to how well they produce this reflection and what effect they have on their audience. For these reasons it is important to not only think about teen film in historical context – but without, of course, forgetting that context.

Genre is popularly understood as a checklist in which few components are absolutely required but others are very common indeed. So teen film requires adolescents, but it is very likely to include high-school, parents, popular music, peer groups, and sexual or romantic interest. It will often include less central components like drug use, virginity, parties, dances, or makeovers. Across this second part of the book I am interested in what these components and their arrangement say about the adolescent experience at the heart of teen film. In this I'm indebted to John Frow,

who understands 'genre as a form of symbolic action: the generic organization of language, images, gestures, and sound makes things happen by actively shaping how we understand the world' (Frow 2006: 2). For Frow (2006: 9), genre is a 'frame' that entails a particular 'structure of address', a 'moral universe', and a set of 'truth effects'.

The three themes organizing images of modern adolescence that I outlined in Part I – youth as problem, the teenage institution, and youth as party – are populated by a range of tropes and strategies that I will sketch in Part II. These possible components for teen film are assembled around a central narrative trajectory, 'coming-of-age' and, just as importantly, a key narrative obstacle, 'maturity'. Maturity is a question and a problem within teen film rather than a certain set of values. This chapter argues that teen film is less about growing up than about the expectation, difficulty, and social organization of growing up.

American Graffiti and *Stand By Me*: **American Frontiers**

Despite teen film's reputation for triviality, adolescence is, as Timothy Shary (2002: 1) insists, frequently used to represent 'our deepest social and personal concerns'. The films flagged in my subtitle explore the transition from boy to man through an encounter with mortality. One takes place in an urban setting and one in a wilderness setting but both are dramatically outside the institutional frames for adolescence emphasized in previous chapters. Such institutions imagine adolescence as a long transition in need of guidance and discipline. This is crucial to the modern idea of adolescence but it was always accompanied by an idea of adolescence as dramatic transformation associated with the anthropological concept 'rite of passage'. Running parallel to influential work on rites of passage as separating, transforming, and then reincorporating social subjects by anthropologists like Victor Turner (1967) is a long debate about whether adolescence is fundamentally the same for all people everywhere.

The rite of passage operates in two ways for teen film. The first is as a ritual marking passage between different social states, like graduation ceremonies, or indicating an immanent change of this kind, like 'the prom'. And the second does not depend on any literal 'rite' and might be more properly called an 'experience of limits'. The former is always a cultural rather than merely personal marker, but the key difference lies in whether the rite of passage belongs to one of teen film's principle narrative structures, 'coming of age'. Both *Halloween* (1978) and *Bill and Ted's Excellent Adventure* (1989) are examples of the rite of passage, which is an experience of limits rather than coming of age. Some films, like the ones foregrounded in this section, involve both, and in both the rite of passage requires separation from the banal practices of life. And for teen film in practice, I want to stress, rites of passage are often thwarted by the complexity of coming of age, when they are not entirely disappointing.

In George Lucas's 1973 *American Graffiti*, four friends – Curt (Richard Dreyfuss), Steve (Ron Howard), Terry/Toad (Charles Smith), and John (Paul Le Mat) – spend the night driving around the Californian city of Modesto. Newly graduated from high school, Curt and Steve are facing the prospect of leaving Modesto for college – Curt with trepidation and Steve with excitement. In the course of the night, the boys' endeavours to mark this occasion and move on to a future life all centrally involve girls. Steve breaks up with his high-school sweetheart Laurie (Cindy Williams). Curt gets distracted by a beautiful girl in a beautiful car and spends the night looking for her, impeded by 'The Pharoahs', who drag him into robbing a store then pranking the local police, and assisted by star rock-and-roll dj Wolfman Jack. Terry is caught up in a comedy of disasters trying to impress an unconventional stranger and John accidentally picks up a girl, Carol (McKenzie Phillips), far too young to interest him, whom he can't get rid of for hours. The plots meet up as Steve and Terry watch John drag race the arrogant interloper Bob Falfa (Harrison Ford). Falfa's car crashes, bringing Steve and Laurie back together in their shock, and it's finally Steve who stays in Modesto and Curt who leaves. The film closes with captions telling us the boys' futures. John is killed in a car accident the next year; Terry disappears in Vietnam the year after that; and, in 1973, Steve is still in Modesto, selling insurance, while Curt is a writer living in Canada (importantly a destination for young men evading the Vietnam draft).

American Graffiti is set in 1962 but opens with a radio tuning in with improbable clarity on the song 'Rock Around the Clock'. This is a double-layered historical reference, drawing on the successful 1950s teen films that song represents (Chapter 2) and foregrounding the film's period setting. This film can justly be described by its director as 'a ten year reunion with myself, or rather with my teenage fantasies' (Lucas in Considine 1985: 112). Jon Savage (1994: 20) sees even in its ambivalent closure 'an almost luminal immanence: America is still rich and still hopeful.' And within this nostalgic reference, *American Graffiti*'s teens are also teen types. John is 'a regular j.d.', Terry is the unattractive dork, and Curt the smart boy. Steve is last year's class president and Laurie this year's head cheerleader. They are bound together by their high-school experience, by youth-directed media, and by geographies of youth culture. Cars are mobile teen spaces moving between partial or temporary teen spaces (like the drive-in, parks, the dance, or homes). And in various sites, including in cars moving around Modesto, people are listening to the radio. Music is a space for youthful engagement and a system of distribution and exchange mediating youth and their experience – both cars and music are policed by various authorities and it is popular music that makes Wolfman an authority on youth that can, more credibly than his teacher, advise Curt to move on.

This question of moving on is the central narrative tension in *American Graffiti*. Steve can't believe that, despite having won a scholarship, Curt is considering staying: 'We're finally getting out of this turkey town, and now you wanna crawl back into your cell, right? You wanna end up like John? You just can't stay seventeen

forever.' At the same time they're already nostalgic for how much bigger everything seemed when they were children. Shary (2005: 45) reads *American Graffiti* as a last night of escapism, but the night is punctuated by rites of passage: the Pharoahs' initiation of Curt; Terry's struggle to buy alcohol; John's encounter with loss and Steve's with mortality. The boys are being tested against their own ideal self-images, and all of them fail. Yet the film closes around Curt's departure framed as a victory because John's claim that leaving doesn't make him anything special is undermined by the film as a whole.

Despite background plots, like Laurie's counter-narrative about her relationship with Steve as something she has had to guide, the named girls are almost as peripheral as Curt's fantasy woman. Unlike the other boys it is not immediately apparent that Steve has been removed from his usual life in order to undergo any particular trial. His trial is encountering the fact that Laurie doesn't understand what Steve wants from leaving home. She establishes a stable heterosexual relationship as the expected consequence of his staying. Steve's projected future with Laurie is finally selling insurance, underscoring that he has opted for safety. The dynamic between Carol and John reinforces this association between girls, home, safety, and stagnation, because while driving around town is an audacious experiment for Carol it is merely the same old routine for John on a night when the future declares it has nothing new to offer him. John and Terry are not facing the prospect of college as a ritual that effectively prolongs adolescence. But they also finally embrace an extension of life at the limits – Terry by going to war and John by remaining on the road even if he isn't going anywhere. *American Graffiti* reminds us that leaving home always appears in teen film as a question about maturity.

Rob Reiner's 1986 *Stand By Me*, based on a story by Stephen King, represents the rite of passage to manhood in ways that importantly differ from *American Graffiti*. *Stand By Me* focuses on the beginning of high school rather than the end, and high school rather than college is the looming change that threatens to separate friends. The catharsis which offers these friends transformation is also different, removing them from everyday life not by the pressure of time but by both desire for and fear of growing up.

In the summer of 1959, Gordy/Gordon (Wil Wheaton), Teddy (Corey Feldman), Chris (River Phoenix), and Vern (Jerry O'Connell) set out to find a dead body. Chris overhears his brother and Ace (Kiefer Sutherland), the toughest boy in town, discussing their discovery of a body in the woods. It had apparently been hit by a train but they fear telling anyone because they'd been driving a stolen car. Chris and his friends decide to be the ones who 'discover' the body, but the quest is full of obstacles, including locals hostile to the boys and the environment itself – the sheer distance without enough food, leech-filled swamps, and the train lines along which they're following the dead boy's trail. But the greater dramas are personal and interpersonal. Teddy's relationship with his insanely violent father and own possible madness (he wears dog-tags representing his father's military heroism throughout

the journey) is juxtaposed with Chris's fear that his family's reputation has already allotted him the life of a minor criminal, and Gordy's sense that he has become an 'invisible boy' at home since his beloved older brother's death. The bonds of their friendship are strained to breaking point over questions about shared and separate identities and futures. When they find the body only to be overtaken by Ace and his gang, Gordy draws the gun Chris brought along and faces Ace down.

There are important parallels between *American Graffiti* and *Stand By Me*, beginning with their representation of the same generation, gender, and even the same US state. In 1959, the twelve year olds in *Stand By Me* are singing rock and roll that's a backing track for *American Graffiti*'s seventeen year olds in 1962. Although the soundtracks only include two common singles, music in both expresses the boy's bonds to each other as well as acting, for these period films, as a nostalgic historical marker. *Stand By Me* is narrated by Gordy as an adult, played by *American Graffiti*'s Dreyfuss, and in both films this narrator is also a writer. The summer he is recalling, Gordy says, was 'A long time ago. But only if you measure it in terms of years.' As with the remembered narrative of *American Graffiti*, this moment is represented as a crucible in which future identity is formed. And both films end by summarizing the boys' futures. Vern still lives in town, married with kids and a working-class job; Teddy has returned, after failing to join the army and spending time in jail; and Chris is recently dead. Having struggled through high school and college to become a lawyer he was killed while trying to help a stranger. Chris's death makes him the key to the film – the reason for telling the story. And noticing this reminds us to pay attention to both rather pointless deaths foreshadowed in *American Graffiti* – John in the service of his very local image and Terry in the service of America's.

As in *River's Edge* the same year, the dead body in *Stand By Me* is overloaded with symbolism, uniting the deathlessness of youth, the threat of mortality and the immanent transitions of adolescence. But the body in *River's Edge* is different in almost every respect: because it is a girl, because one of the friends murdered her, and because despite their having known her the body doesn't generate any feeling for the adolescents who go to see it. In *Stand By Me*, the boys say they're searching for the body because it'll make them famous, but this is also an encounter with mortality to which being famous is a kind of reply. While in memory the story has them suspended in a moment when anything seems possible, from superheroic virtue to living on cherry-flavoured pez, the dead boy represents closure, and closure threatens them far more than Ace, the junkyard dog, the ridicule of peers, or the burden of family. Life seems to be demanding they make decisions about the future: that they choose between 'shop' and 'college' classes and determine how far their families and friends define them. The wilderness narrative takes them out of this demanding context and offers them a new experience of limits which represents the border between childhood and adolescence as a frontier – a limit of knowable experience where all the social rules are suspended and strength of character alone enables survival. A well-known American myth of the frontier as a place of self-determination is here associated with a question about maturity.

Like *American Graffiti*, *Stand By Me* takes place in the 'summer holidays', a transitional space between school years and thus between one age and the next. The summer is frequently employed in US teen film to engage with what happens outside the shared space of compulsory schooling. Outside North America and its particular form of 'summer holidays', however, school still widely functions as a normal social order for adolescents and being out of school can similarly invoke freedom from social constraint. *Stand By Me* pushes this metaphorically towards the limits of the social itself, invoking an association between adolescence and 'savagery' through narratives about bodily change and psychological 'drives' that need to be managed before adulthood is possible. *Lord of the Flies* (1963) is a comparable UK text, with the boys literally lost outside the social and driven to try and replicate it.

Many teen films symbolize coming of age with a formal ritual, but this is rarely a literal passage to adulthood. Ceremonies like the Jewish *bar mitzvah*, which draw on older relations between puberty and maturity, do not mark entrance to adulthood for modern adolescence. Teen film focuses rather on ceremonies marking the achievement of some limited independence which, at the same time, does not produce adulthood: high-school graduation/completion, for example, or 'the prom'. The prom is worth further consideration because it foregrounds questions about the American-ness of teen film's rites of passage and because it makes explicit the gendering of such rites in framing its narrative of maturity around a dialectic of sex and romance. The significance of this rite is reinforced by many films but, as Roz Kaveney notes, the term 'prom' has little literal relevance outside the US. This is not the case, however, if we pay attention less to the name than the function of the prom. 'Prom' is shorthand for a nexus of sexual coming-of-age, ritual display, school and family, rather than representing a wholly American cultural sensibility. The UK film *Angus, Thongs and Perfect Snogging* (2008), for example, has no prom. But its romantic coming-of-age narrative in which school features centrally does climax with a club/party scene that has the same narrative function as the prom. Like the other rites of passage in which teen film specializes, the prom offers no transition to adulthood because the protagonists of teen film must remain adolescent. Social markers like the right to vote, which has little ceremony attached to it, and marriage, which does, are rarely referenced in teen film. Instead, teen film uses and further ritualizes markers that remain internal to adolescence and yet open up new possible experiences.

Little Darlings and *American Pie*: The Problem of Virginity

Virginity exemplifies the ways in which rites of passage are central to coming-of-age in teen film as a narrative that cannot be completed. Virginity is a complex conjunction of social, cultural, and psychological limits. It does not mean the absence of sexual activity so much as the restriction of certain culturally agreed-upon sexual

activities, so that Dionne in *Clueless* (1995) can joke about being 'technically' a virgin despite being sexually active. As Greg Tuck (2010: 158) argues, 'the virgin/ nonvirgin boundary is not traversed in a single moment through a single act.' Virginity is a question of knowledge and experience rather than a physical transformation (Tuck 2010: 159). Neither is the culturally established set of prohibited activities defining virginity the same as legal limits that restrict sexual activity. Most age of consent legislation, for example, leaves ample room for caveats about reasonable awareness and individual situations, exemplifying the complexity of the borders negotiated by modern adolescence.

Virginity is an important recurring element of teen film for several reasons. It is one place in which to see the negotiation of individual choice and socially established norms. It intersects historically specific and highly gendered experiences of adolescence with the political opposition between tradition and change. It is a psychological marker that remains internal to adolescence, referring to its origins in ideas about puberty and its destiny in images of adulthood (and potential parenthood). It is worth also stressing, however, that teen film is crucial to contemporary understandings of virginity. As the pervasive reference to teen film in Tamar McDonald's collection on 'Representing Sexual Inexperience in Film' suggests, virginity has become incorporated into modern ideas about adolescence, and ideas about modern adolescence are disseminated and debated through teen film.

Adolescent rites of passage rely on starkly differentiated images of 'becoming a man' and 'becoming a woman'. Because puberty, gender and sex are crucial to adolescence there is no such thing as a teen film that does not include sex, even if there is no sex on screen. This is even true of *Stand By Me*, which is why a leech on Gordy's testicles is more horrifying than it would be anywhere less sexually loaded. And there is no teen film that doesn't centrally discuss gender. Neither *American Graffiti* nor *Stand By Me* could become stories about girls without drastic renovation. And adolescent *sexuality* (meaning not just physical capacity for sex but an identity defined by attitudes to sex) is defined by this gendering, meaning that a wide range of ideas about femininity and masculinity have been understood to have sexual functions. In this context, virginity is about both gender and sex and it is also a social position, establishing opportunities for negotiating what sex is wanted, available, and means.

Shary (2002: 226) claims losing virginity was 'The most common plot of youth sex films throughout the early 1980s', but this plot takes many forms. *The Breakfast Club* (1985) is one example of teen film openly reflecting on the gendered negotiation of virginity (Shary 2002: 72–3; Kaveney 2006: 13). Alison acknowledges to Claire that 'It's kind of a double-edged sword, isn't it? ... If you say you haven't ... you're a prude. If you say you have ... you're a slut! It's a trap. You want to but you can't but when you do you wish you didn't, right?'

In teen film, as elsewhere, this sword is different for boys and girls. As Henry Giroux points out, in the John Hughes teen films 'it is clear that the only men

who remain virgins are nerds and even they can be transformed into real men by sexual experience ... there is no ambivalence at all about the importance of sexual experience for men' (Giroux 1991: 131).

But we shouldn't reduce the virginity trope in teen film to the famous 'double standard' in which sex adds value to boys and removes it from girls. Virginity in teen film is a platform for statements about sexual identity and values attached to it.

This section focuses on films that feature virginity wagers – a bet between girls as to who can 'lose it' first and a pact between boys to 'lose it' by prom night. As is generally the case across the long history of sexual wagers in teen films as varied as *G.I. Blues* (1960) and *Cruel Intentions* (1999), those making such wagers are taught that sex must have emotional content. Many teen film subgenres emphasize virginity as something to be traded – whether for love, pleasure, knowledge, or the ownership of bodies or other forms of power – but the sexual wager films are generally comedies. They downplay the ethical problem of what can be traded for sex by staging the wager as one between peers too immature to realize their mistake. The sexual wager in teen film usually ends well for the central protagonists. It might be argued that comedy is thus used to avoid exposing something too telling about the system of unequal power in which adolescent sex appears, and certainly critics like Shary and Kaveney are very critical of such films. But the sexual wager film overwhelmingly insists on the cost of treating relationships like tradeable objects. That's one of the reasons these films have traditionally been addressed to girls.

In Ronald Maxwell's *Little Darlings* (1980), rich girl Ferris (Tatum O'Neal) and poor girl Angel (Kristy McNichol) join girls from diverse backgrounds at summer camp. Vying for authority among strangers, Ferris and Angel, both fifteen and thus importantly below the age of sexual consent for the film's main audience, stake their peer-group credibility on a competition to see who can lose their virginity first. The other girls, some of whom claim to be sexually active (but are later revealed to be lying) and some of whom declare themselves virgins, form support teams. As this is a girls' camp the options for male sexual partners are few. Ferris decides on one of the camp counsellors, the suave older Gary (Armand Assante), and Angel on Randy (Matt Dillon), a boy from a neighbouring camp. Gary rejects Ferris but she allows the other girls to think they had sex anyway thus threatening his job. Angel and Randy, after some awkward scenes in which neither know how they should behave, do have sex, but Angel finds it an emotionally affecting experience and tells the other girls it never happened. The bet is cancelled, camp ends and Ferris and Angel return to their lives apparently more mature but certainly still not adults.

Sex itself takes on ritual dimensions learned from popular culture in this film. *Little Darlings* particularly associates girls' sexual knowledge and fantasies with film: one girl exclaims that she 'saw *Grease* six times!' while others extol the simultaneously educational and pleasurable qualities of art films like *Last Tango in Paris* (1972). Ferris takes her model of seduction from an idealized reading of *Romeo and Juliet* that is indebted more to Franco Zeffirelli's 1968 film than to

Shakespeare. And popular music is clearly also instructive, offering images of ideal boyhood and scenarios for love and seduction forming, as in *American Graffiti* and *Stand By Me*, a common ground for adolescents. For Chuck Kleinhans, *Little Darlings*, along with *Foxes* and *Times Square* the same year, captures 'a social and historical moment, a liminal space for female teens' (Kleinhans 2002: 73) shaped by the women's liberation movement but not comprehended by it (88–9). Like Lisa Dresner, however, I am more interested in the film's portrayal of virginity as a negotiated sexual identity. As Dresner notes, *Little Darlings* distinguishes between male and female relations to sex but it also suggests, in comparison to the more critically praised *Fast Times at Ridgemont High*, that sex has a negotiable and thus unstable meaning for adolescent girls (Dresner 2010: 174–5, 180).

Little Darlings relies on a stark narrative about class difference broadly popular in teen film, in this case removing the girls from their classed contexts as from the rest of their lives. In practice no summer camp would ever include as diverse a cultural mélange as 'Camp Little Wolf', but this diversity enables a central drama concerning what all girls want to know. The bet allows girls to express sexual ideals, fantasies and fears to each other and they uniformly understand sex as transforming 'little girls' into 'women'. This doesn't mean the girls are eager for sex. If they lie about having had sex for fear of the cultural meaning of virginity, sex is as frightening as it is fascinating. Despite its blunt moral lesson that sex without emotional attachment is a bad thing, *Little Darlings* suggests that adolescents must learn about sex. Both Ferris and Angel learn that, whether or not they have had sex, they're not women yet. But there is a sense in which sex make Angel more mature. She parts from Randy with the sad reflection that 'We started in the middle. We never even had a beginning.' While Ferris merely seems embarrassed by her own immaturity, Angel now has sufficient wisdom to correct her mother's negative attitude to sex (Considine 1985: 73; Dresner 2010: 177–8).

Virginity is one way in which teen film girl identities are explicitly defined by the social appearance of the body. Sex, like dating, like personal style in clothing, is a social experience in teen film and a question of reputation. One of the reasons 'the prom' is such a potent trope in teen film is because it brings together so many of these social opportunities to be made over – as more stylish, or popular, or sexy. In this social field, sex and romance are tied together as opposing but complementary forces – as a dialectic that exposes a fraught contradiction in the meaning of both for adolescent development. In the case of *Little Darlings*, sex is, in the end, about romance, but there are many other teen films for which romance is about sex. This raises questions concerning Doherty's claim, supported by Shary, that AIDS awareness led to 'a marked shift in the [late 1980s] teen sex film from promiscuity to romance' (Shary 2002: 142).[2] While public discourse on sex and health addressed to youth at this time certainly impacted dramatically on teen film, it encouraged existing tendencies in the tight sex/romance nexus which was always central to the genre.

American Pie (1999), directed by Paul Wietz, launched a trilogy of successful films based on the same characters. Jim (Jason Biggs), Finch (Eddie Kaye Thomas), Oz (Chris Klein), and Kevin (Thomas Ian Nichols) make a pact to lose their virginity by prom. Although Kevin has a steady girlfriend, Vicky (Tara Reid), this doesn't make his task easier because Vicky is not eager to have intercourse even though they have other kinds of sex. Kevin must seek apparently esoteric knowledge about female sexuality from his older brother in order to seduce her; but in the end the experience is disappointing and, despite some attachment, they break up. Finch bribes a friend to spread rumours about his sexual prowess but, after a school prank exposes him to ridicule, it seems he will fail until their friend Stifler's (Seann William Scott) dissatisfied mother seduces him. And the insensitive jock Oz fakes interest in jazz choir in order to meet girls who don't detest him, only to fall in love and choose not to reveal whether he has sex or not. But the central narrative belongs to the hapless Jim, caught in a series of embarrassing experiments trying to comprehend what sex is, let alone experience it, often being consoled afterwards by his earnest and affectionate father. Jim settles on the unpromising 'band geek' Michelle (Allyson Hannigan) as the only prom date he can get, only to find her eager to have sex him.

The sexual pact in *American Pie* is as explicitly about achieving masculinity as that in *Little Darlings* was about reaching womanhood, and the claim that the boys' 'manhood' is 'at stake' is as laughable as the girls' fantasies of womanly fulfilment. But if the boys barely believe their own rhetoric – going to college as virgins would simply be less desirable – they are genuinely pursuing the *question* of whether sex will make a difference to who they are. *American Pie* turns on the expected gendering of teen film romance, in which boys are innately interested in sex rather than romance, and girls innately the reverse. For *Little Darlings*, girls and women desire romance rather than sex, even when they don't know they do. Blending the conventions of teen sex comedy and teen romance, *American Pie* sometimes self-consciously reverses this model and sometimes fulfils it. This remains a delicate balancing act. Hesitations among the boys are emphasized by the uncertainty around whether Oz and Heather (Mena Suvari) have sex. Kaveney (2006: 143) believes they do not; Shary (2005: 105–6) that they do. While the visual codes for representing but not displaying sex in teen romance suggest they do, these codes are less explicit than for teen sex comedy, leaving space for doubt. But it almost doesn't matter. Because Jim is the identificatory centre of the film his pragmatic desire for sexual experience overshadows the more sentimental plotlines of Kevin and Oz, keeping *American Pie* a teen party film. Oz and Kevin's realization that sex is emotionally meaningful to them keeps *American Pie* close enough to teen romance that Jim's thrilled embrace of the idea that Michelle 'used' him is a deflation of Oz's romantic triumph but not a dismissal of it.

Gender differentiations around sex in *American Pie* are nevertheless clear cut. The film opens with the sound of a pornographic film Jim is using as a masturbation tool before he is quickly caught by his mother.[3] In the second scene, Vicky excitedly

learns of her acceptance to college. Together, these establish that girls are more mature than boys and do not require sexual experience for successful psychosocial development. But the reasons for this difference remain as mysterious as everything else about girl sexuality. The boys' sexual education requires a range of technologies, including a secret book, experiments with sexual tools from socks to apple pie, and a 'Mrs Robinson' figure (an older female sexual teacher) indebted here as elsewhere to *The Graduate* (1967). Both Kenneth Kidd's discussion of teen film as sex education, which focuses on many of the 1980s films discussed in Chapter 3, and Sharyn Pearce's more direct consideration of *American Pie* as a 'sex manual', stress the importance of such stories for teen film.

American Pie is often discussed as evincing a substantial change to the sexual ethics of teen film and, by implication, of adolescence more broadly. This kind of sea change in the sex of teen film has been announced many times. Both Jonathan Bernstein and Shary detail the increasing explicitness of teen sex comedies in the 1980s (Bernstein 1997: 7–33; Shary 2002: 235). Shary indirectly links this to a 'sexual liberation' history. But adding explicit sex to the other components of sex comedy may not produce a film paradigmatically different from the less graphic comedies of sexual manners like *Gidget* (1959). What is different about *Porky's* (1982) or *American Pie* is the addition of 'grossout' corporeal comedy and coming-of-age narrative to the sex comedy (Bernstein 1997: 7).[4] This is not specifically American. The 'Lemon Popsicle' series of Hebrew films directed by Boaz Davidson between 1978 and 2001 is exemplary. The first, *Eskimo Limon* (1978), set in 1950s Israel, uses similar virginity tropes as contemporary US films. When it was later remade as *The Last American Virgin* (1982), and set in contemporary America, it did not so much 'become American' as demonstrate the cross-cultural translateability of the teen film sex comedy.

The 'grossout' sex comedy represents the corporeal challenges of sex and identity for adolescents. For Kaveney, although she rejects 'easy' Freudian readings of teen film, these challenges are explicated in part by the Freudian concept of 'polymorphous perversity'. For Freud, this term described infantile sexuality, still unregulated by social norms and thus able to want anything at all, but Kaveney uses it more or less as a synonym for what Adrian Martin calls 'erotomania'. In teen film, she argues, anyone can *potentially* be paired with anyone else. In this, Kaveney does not deny the privileging of heterosexuality in teen film because she excludes films which centre on gay or lesbian sexuality. While emphasizing the importance of homoerotic possibilities in teen film she ironically deems the 'queer' film about adolescence insufficiently 'polymorphous' or subtextually perverse (Kaveney 2006: 5–6). Mainstream teen film does seem to be partly defined by heterosexual closure, with other sexualities marginalized as foils for that story. However, if 'queer' teen film is relatively new, and its incursions into US teen film few – examples include *But I'm a Cheerleader* (1999) and *Saved!* (2004) – hybrid queer/teen films are increasingly available. Shary and Seibel's collection *Youth*

Culture and Global Cinema (2007) includes three essays on 'Coming-of-Age Queer' focusing substantially on European examples. I turn now, however, to a subgenre where mainstream teen film routinely becomes perverse – the party film. This is the genre at work in *American Pie*'s story about Jim's unfocused desire (Tuck 2010: 157–8), when Michelle recalls the sexual utility of her flute, or when Finch's bowel movements are put on cruel display. In *American Pie* these elements are regulated by the romance plot, but there are many teen films where both sex and romance are in the service of the party gods.

From *Animal House* to Harold and Kumar: Where the Party Animals Are

Both *National Lampoon's Animal House* (1978) and *Harold and Kumar Go to White Castle* (2004) rely on a field of jokes about which adolescents are the right adolescents to be, and thus about American youth culture. But in order to tell those jokes they have to ask questions about the distinction between immaturity and maturity. The party dimensions of teen film are important to defining the genre because they relish immaturity. In fact, teen films that overtly address citizenship tend to be either party films or their inverse, military teen films, like *Taps* (1981) or *Red Dawn* (1984). The struggle between war and party that influenced the emergence of teen film conventions early in the twentieth century is a valid context here, but I want to emphasize the party film's engagement with discourses on citizenship, which is what demands the central reference to 'American' youth in *American Pie*.

As *Animal House* opens, first-year students Kent (Stephen Furst) and Larry (Tom Hulce) are looking to join a fraternity at Faber College. They attend a sedate party at Omega fraternity house where they are quickly tagged as 'a wimp and a blimp' by gloved hostesses Mandy (Mary Louise Weller) and Babs (Martha Smith) and herded by frat leaders Neidermeyer (Mark Metcalf) and Greg (James Daughton) into a corner with others who are not white clean-cut athletic types. Then they attend a party at Delta Tau Pi, where drinking, smoking, gambling, and debauchery comprise the welcoming celebration (Figure 4.1 shows Delta leaders at their later toga party). While at Omega the leaders are busy selecting the next generation, at Delta the leaders are barely present: Hoover (James Widdoes) fusses around earnestly and the spectacularly uncouth Bluto (John Belushi) sets a bad example but Otter (Tim Matheson) and Boon (Peter Riegert) are upstairs planning their own pleasures without reference to responsibilities downstairs, including Boon's girlfriend Katy (Karen Allen). The next day Larry and Kent are accepted for Delta on Hoover's insistence that they were all once that pathetic. This cast of characters and the vague proposition that everyone changes in college establishes the film's plot, which otherwise is minimal. The Machiavellian college Dean, in league with Omega, sets out to close the disreputable Delta. The usual hijinks at Delta are escalated by this

Figure 4.1 Hoover (James Widdoes) and Otter (Tim Matheson) at the toga party. *National Lampoon's Animal House* (1978). Director, John Landis. Courtesy of Universal/The Kobal Collection.

threat – 'They're going to nail us no matter what we do. So we might as well have a good time!' – and the Dean's determination increases. The frat is closed, the boys take revenge, and the film finishes with statements about their futures that play off the famous close to *American Graffiti*.

An 'animal house' is that part of a research institution that maintains animals as subjects for scientific testing, but as the 'animal' house Delta is also opposed to Omega as an institution for the training of future social leaders. This is explicit in the trial of Delta, which references popular scepticism about the US political system after Watergate.[5] Otter protests that if illicit individual behaviour can lead to the indictment of a fraternity then the whole fraternity system, the educational system, and 'our whole American society' must also be accountable. The boys march out in mock patriotic ire. Delta is nevertheless stripped of its charter and amenities and an outraged Bluto inspires his dispirited fraternity to band together for a final 'really futile and stupid gesture' – destroying a parade honouring the university.

This destruction centres on destroying images of American idealism previously mocked by the film. A women's rights float carries the slogan 'when better women are made, Faber men will make them.' This double entendre recalls the Delta boys' attempt to trick bereaved sorority sisters into having sex with them. The float marked as a civil rights float, with black and white hands shaking over the word 'togetherness', is ludicrous after the exposure of cultural segregation in the black club where the boys take their dates. And the 'Camelot' float, with a model President Kennedy surrounded by dancing girls dressed as his wife (in pink suits with pillbox hats) references the parade in which Kennedy was assassinated. As the film closes on chaos, each key character is captioned in freeze-frame by an equally cynical future life.[6]

The boys in *Animal House* are not teenagers, but their immaturity is palpable and their educational narrative a satire. From Larry's fumbling attempts at first sex with a girl he doesn't realize is only thirteen to Kent's being taunted into shooting Neidermeyer's horse, the 'freshmen' mature primarily in self-defence. The older Deltas presume themselves to have grown past freshman immaturity but evidently still have a lot to learn. Boon in particular negotiates what counts as desirable male behaviour with Katy. Leaving a party in annoyance she asks, 'Is this really what you're gonna do for the rest of your life? ... Hanging round with a bunch of animals getting drunk every weekend?' Boon suggests that he'll get drunk every *night* once he graduates. Later, Katy complains: 'Honestly Boon you're 21 years old. In six months you're going to graduate and tomorrow night you're going to wrap yourself up in a bedsheet and pour grain alcohol all over your head.' Their reunion at the end of the film, which also predicts their divorce, is framed by the impossibility of credible maturity in a social context which thinks Neidermeyer is a good citizen and would elect Bluto senator.

There are literal rites of passage in *Animal House*: fraternity initiations which align Delta with democracy (Figure 4.1 makes this reference as well) and Omega with esoteric monasticism. The Delta ceremony comically rewrites the Pledge of Allegiance and then baptizes each boy with a new name and a shower of beer while the Omega ceremony takes place in a darkened room, with candlelight and organ music and initiates on their knees ritually thanking cowled leaders for spanking them.

The frat houses' more routine rituals reinforce this equation of the putrid Deltas with 'liberty and fraternity' as well as pleasure. The Omegas are sanitized beyond feeling, symbolized by Greg's inability to form an erection while Mandy (and later Babs) masturbates him wearing rubber gloves. The Deltas' unity in physical pleasures like dancing, singing, and drinking, seems to extend from their opposition to such clean, paranoid obedience to the law. We could discuss them as abject (a term I'll use in the next chapter), and Bluto personifies this excess. We could also call him, after the critic Mikhail Bakhtin, 'Rabelaisian' or 'carnival'. Bakhtin stressed that celebratory excess was not simply suppressed in the interests of social order. Instead it continually reappeared in spaces enabled if not sanctioned by that law (Bakhtin 1984: 9–10). For the teen-party film, adolescence itself is a carnival enabled by orders like high school and college.

In several respects, *Animal House* is a reply to *American Graffiti*. Both films look back at 1962 – one at the end of college and the other at the end of high school. *American Graffiti* undoubtedly presents more complex characters but *Animal House* also explores limits on adolescent agency. *American Graffiti* clearly suggests that Curt's leaving for college will enable more opportunities and freedom. But *Animal House* represents college as another set of unevenly distributed limits and opportunities that still don't position the adolescent subject as 'mature'. There are decades of college and fraternity films before *Animal House*, but this film was influential in returning the youth as party theme to institutions after its wide-ranging journeys in 1960s films like *Easy Rider* (1969).

Shary aligns *Animal House* with the Canadian sex comedies *Meatballs* (1979) and *Porky's* as 'raucous comedies featuring goofy and/or hormonal youth pursuing pleasure, respectively, in college, summer camp and high school' (Shary 2005: 55). But *Animal House* is not a sex comedy. It brings sex to the foreground amongst the other 'normal qualities of youth' that Martin identifies with teen film: 'naïveté, idealism, humour, hatred of tradition, erotomania, and a sense of injustice' (Martin 1994: 67). However, *Animal House* suggests that we might read sex comedies like *Porky's* as narratives about what kind of citizen a boy should become.

Animal House asks whether the mix of freedom and surveillance characterizing this adolescence is 'American'. So does *Harold and Kumar*, directed by Danny Leiner. Harold (John Cho) and Kumar (Kal Penn) are ex-college buddies sharing a New Jersey apartment. After a bad day at work/university they get stoned on marijuana and decide they need to eat hamburgers from the chain White Castle. But the local White Castle has closed and they embark on what becomes an epic journey to find an open outlet via detours that are partly drug induced and partly the effects of nationality, class, race, gender and age. For example, a paranoid Harold throws their marijuana away and Kumar insists on going to a nearby university to find more. But the university is Princeton, and the people they know there are young, wealthy Asian-Americans who both define and undermine Harold and Kumar's equation of youthful freedom with pleasure rather than work.

As a stoner road trip version of the teen college party film the plot of *Harold and Kumar* is frequently disrupted by surreal accident, as when they ride an escaped cheetah, banter with a 'hillbilly' lifted partly from porn and partly from horror, or have their car stolen by an equally stoned semi-fictionalized TV star, Neil Patrick Harris (who famously played teen doctor *Doogie Howser, MD*, 1989–93). Eventually, they ride a stolen hang glider to an open White Castle and consume enormous quantities of fast food with happy satisfaction. Their return to the apartment also brings an exhausted Harold back to Maria (Paula Garcés), the Hispanic girl next door he admires. With Kumar's encouragement he finds the courage to talk to her and the film closes, or fails to close, on the boys deciding to follow her on holidays to Amsterdam.

Harold and Kumar are, respectively, Korean-American and Indian-America adolescents and their story is equally concerned with their non-whiteness and their adolescence, in the grey area between spectres of dependence and fantasies of independence. The 'stoner' film generally employs drug use as a comic eye on disenfranchised youth and on the hierarchized 'straight world' that frames and judges them. In *Harold and Kumar* this America is represented in conventional teen film terms through institutions at which both Harold and Kumar are failing. Harold fails to be the 'nerdy little Asian guy' his co-workers expect and fails to talk to Maria; Kumar fails a medical school interview and thus fails to keep his father committed to paying for his apartment. These narratives about the challenges of identity and independence frequently return. Harold strives to complete his work assignment despite travelling the night through various mad vignettes. And Kumar manifests both medical knowledge and skill despite deriding his family's expectations. His brother rants, 'God, Kumar, you're 22 years old. When are you going to grow up and stop this post-college rebel bullshit?'

Stoner films were entwined with 'slacker' films well before the characterization of Jeff Spicoli in *Fast Times at Ridgemont High* (1982). They belong with teen party films because of their shared emphasis on margins and excess and their discourse on immaturity, but they often stray beyond US teen film's common association with suburban white adolescence. They are very closely aligned with what Troyer and Marchiselli (2005: 265) call 'the dude film', their extensive list of which includes many stoner films and begins with the 'proto-dude films like *Easy Rider*'. The principle convention of the dude film, Troyer and Marchiselli (2005: 265) argue, is 'an epic quest', which is foundationally a quest to remain 'juvenile', 'free from the responsibilities of a self-conscious adulthood' (Troyer and Marchiselli 2005: 267). Since the irresponsible young adult 1960s films like *Easy Rider*, the stoner film has had a tendency to be 'on the road', even crediting the direct influence of Jack Kerouac's 1957 novel of that name. Mobility and drugs are combined in a world-view that closely relates staying in one place with settling down and growing old and which further detaches youth from literal chronological age. This association is less explicit in *Harold and Kumar* but it shares *On the Road*'s focus on outsider identities.

Although it also lacks the countercultural credibility of *On the Road* or *Easy Rider*, *Up in Smoke* (1978), starring the Chinese-Canadian and Mexican-American comedy duo 'Cheech and Chong', is another influence here. Less social critique than black comedy, *Up in Smoke* represents police and government treatment of immigrants as a farce that immigrants also exploit. Like *Harold and Kumar*, Cheech and Chong are constantly on the road, and the *Up in Smoke* plotline is also spurred by a combination of drug-addled confusion, social injustice, and surreal accident. The 'Bill and Ted' (1989, 1991) and 'Wayne's World' films (1992, 1993) are edited white suburban versions of this post-*On the Road* stoner buddy narrative, with Bill and Ted retaining mobility and implied drug use and Wayne and Garth retaining the social satire (as well as Cheech and Chong's unlikely rock-god aspirations). And like Harold and Kumar, Bill, Ted, Wayne and Garth are adolescent because they are unwilling and perhaps unable to take on mature social roles rather than because of age.

Harold and Kumar incorporates an array of references to other texts in relation to which it takes up meaning. Such referentiality is important to the stoner film as part of the subgenre's games with what is real. But among these references those to teen film do the most narrative work. The absurdity of Harris's role is accentuated by citation of Leiner's earlier film, *Dude Where's My Car?* (2000), and Harold's sentimental romanticism is made clear in his passion for John Hughes's films. His favourite film is *Sixteen Candles* (1984), which is additionally significant as the one Hughes film featuring an Asian teen character, the egregiously cliché Long Duk Dong. Outside a 'John Hughes Retrospective' Harold sees Maria queuing up to watch this film, and Maria herself is a reference to *West Side Story* (1961). Alongside Long Duk Dong, and Mr Miyagi from *The Karate Kid* (1984), she represents the homogenization of racial difference in US popular culture including teen film.

The obstacles to Harold and Kumar's quest are as cliché as the police sketches of a straw-hatted Chinaman and a turbaned Indian circulated to catch them.[7] And more than the violent cop, the threatening tow-truck driver, or the treacherously unpredictable Harris, the villains of this film are the recurring gang of white youth labelled and credited as 'extreme sports punks'. Early on they push Harold out of his parking space – 'this is America, dude, learn how to drive' – and they return to harass Harold and Kumar with cliché jibes. The difference of Harold and Kumar's American adolescence is a comic-serious web of power. The bullies feel entitled to attack them although, compared to Harold and Kumar, they seem stupid and unskilled. They stereotype and are stereotyped back – their leader has no clearer identity than 'Extreme Sports Punk Number One'.

Harold and Kumar exemplifies the way teen film circulates the components of cinematic adolescence as an endless rite of passage punctuated by generic motifs. They belong to teen film as a genre that produces broad cross-cultural knowledge of conventions for marking out the experience of adolescence. I would thus insist on what Considine (1985: 277) is only prepared to suggest: that 'in perpetuating

stereotypes of adolescence, the film industry, rather than merely mirroring reality, helps to create it.' In teen film adolescence is refined to a generic form, a fact that teen film itself self-consciously keeps in view.

–5–

Teen Types and Stereotypes

Benny: 'I still wanna know what happens!'
Buffy: 'Everyone gets horribly killed except the blonde girl in the nightie, who finally kills the monster with a machete. But it's not really dead.'
Jennifer: 'Oh, my God, is that true?'
Buffy: 'Probably. What movie is this?'

Buffy the Vampire Slayer (1992)

This chapter is not organized around a theme but around a dominant strategy for teen film: repetition. All genres repeat certain conventions – that's how we recognize them. But for teen film repetition is not only about production and distribution but also style, form and content. The sense in which the terms 'genre' and 'generic' can be used to denote 'the formulaic and the conventional' (Frow 2006: 1) is crucial to teen film. If the popular understanding of genre texts as repetitious 'obscures the extent to which even the most complex and least formulaic of texts is shaped and organized by its relations to generic structures' (Frow 2006: 1–2), for teen film something more is at stake. The central idea of adolescence on which it depends must be relevant to an already recognized category of experience. Teen film works largely by telling us things we already know about characters and situations that we are presumed to instantly recognize.

I will begin this chapter with teen horror, and the subsequent sections consider subgenres that intersect teen horror with other genres – respectively satirical comedy and the gothic. Teen horror is particularly useful for thinking about how recognition, familiarity and identification work in teen film because horror must operate on the border between what we know and what we don't or, in fact, what can never be known. While horror genres, and especially horror film, have been widely discussed, teen horror usually appears as subgenre that offers little new material for that discussion. The repetitiveness of teen film is indeed one of the things often found so appallingly bad (even horrifying) about it. Teen horror *is* repetitive, predictable, derivative and exploitative, although there are ground-breaking teen horror films and wide variations as to quality. But I want to use teen horror as a beginning point for discussing the importance of teen film's systematic use of repetition and stereotype, including in the way it twists repetition to new ends.

The Return of the Revenge of the Repressed: Why there are Thirteen 'Friday the 13th' Movies

Psychoanalysis is a popular, if sometimes overly blunt, tool for thinking about horror genres and given its simultaneous importance to theories of modern adolescence it seems important to start with it here. My subtitle is a reference to one of Freud's most famous summaries of how the unconscious mind can dramatically influence human behaviour. It represents the unconscious as a place where thoughts and feelings that cannot be consciously allowed are recorded, and from which they may come back indirectly to haunt or incite. The horror film genre is widely discussed using such psychological tools, looking for motivations that inspire people to consume representations of unpleasant experience. But, as Mark Jancovich observes, some difficulties arise from the dominance of psychoanalysis in discussing the horror genre, especially in its emphasis on the family unit and its specific model of gender produced by that family (Jancovich 1996: 225–7; see also Craig and Fradley 2010: 79). So I want to consider repetition in more literal terms before coming back to a psychoanalytic approach to the appeal of teen horror.

The most famous formation of teen horror is the wave of slasher films associated with the 1980s which soon became dominated by franchised series (Shary 2002: 141). Two historical notes about these series seem important. First, while this subgenre is spectacularly coherent, it depends on earlier cinematic associations of horror and adolescence, including *Carrie* (1976) and *The Exorcist* (1973), as well as proto-slasher films like *The Texas Chainsaw Massacre* (1974) in which the victims were adolescents. Looking further back, it also relies on the importance of horror to 'B grade' or low production-value formula films in the 1950s, amongst which, as Thomas Doherty (2002: 115) argues, teen horror was 'the most prolific and durable' such genre. Second, despite changes to the film industry these series are ongoing, although some criticism that claims that there was a decline of teen horror at the end of the 1980s (Bernstein and Pratt 1985: 34–51; Shary 2002: 137–78). An overview of key series and their general plot parameters will be useful here. While lists of films usually offer little analysis, in this context lists can reveal not only regularities but also cycles of renovation, closure, and regeneration (I will also include directors in these lists in order to foreground production investments).

Halloween (Carpenter 1978, subsequently *Halloween1*) centres on Michael Myers, who kills his older sister and then, years later, a set of teenagers associated with his younger sister Laurie (Jamie Lee Curtis). Both Laurie and the psychiatrist tracking him, Dr Loomis (Donald Pleasance), survive his killing spree. Because Laurie defeats Michael in the end, the slasher convention of the 'final girl' discussed below is sometimes said to begin with her (although other critics begin this convention with *The Texas Chainsaw Massacre*). Across the following series (Shary 2002: 149–51), Michael's violent obsessions focus on his family and his victims' families: *Halloween II* (Rosenthal 1981), *Halloween III: Season of the Witch* (Wallace 1982),

Halloween 4: The Return of Michael Myers (Little 1988), *Halloween 5* (Othenin-Girard 1989), *Halloween: The Curse of Michael Myers* (Chapelle 1995), *Halloween H20: 20 Years Later* (Miner 1998), *Halloween: Resurrection* (Rosenthal 2002), *Halloween* (Zombie 2007), *Halloween II* (Zombie 2009).[1]

Friday the Thirteenth (Cunningham 1980, *Friday1*), centres on Camp Crystal Lake, where counsellors preparing for the arrival of children for summer-camp are murdered by a stalker eventually revealed to be a mother avenging the death of her son, Jason Vorhees. Over subsequent films (Shary 2002: 151–4), Jason returns to avenge his mother and then pursue adolescents more generally: *Friday the 13th Part 2* (Miner 1981), *Friday the 13th Part III* (Miner 1982), *Friday the 13th: The Final Chapter* (Zito 1984), *Friday the 13th Part V: A New Beginning* (Steinmann 1985), *Friday the 13th Part VI: Jason Lives* (McLoughlin 1986), *Friday the 13th Part VII: The New Blood* (Buechler 1988), *Jason Goes to Hell: The Final Friday* (Marcus 1993), *Jason X* (Isaac 2001), *Freddy vs Jason* (Yu 2003), *Friday the 13th* (Nispel 2009).

The ninth and eleventh films in this series cross over with the last of the famous 1980s teen slasher serics: *A Nightmare on Elm Street* (Craven 1984, *Nightmare1*). The killer, Freddy Krueger (usually played by Robert Englund), here appears in the nightmares of troubled teens with real effects. Subsequent films (Shary 2002: 154–7) refine Freddy's personal history as the reason for his supernatural murderous abilities: *A Nightmare on Elm Street Part 2: Freddy's Revenge* (Sholder 1985), *A Nightmare on Elm Street 3: Dream Warriors* (Russell 1987), *A Nightmare on Elm Street 4: The Dream Master* (Harlin 1988), *A Nightmare on Elm Street: The Dream Child* (Hopkins 1989), *Freddy's Dead: The Final Nightmare* (Talalay 1991), *Jason Goes to Hell: The Final Friday*, *New Nightmare* (Craven 1994), *Freddy vs Jason*, and *A Nightmare on Elm Street* (Bayer 2010).

These lists indicate that if the teen horror series declined in the 1990s it was quickly followed by another revival of remakes and new instalments. It might even be better to call these series serials, as it hardly seems possible that they could narratively close at this point. When Wes Craven, who directed *Nightmare1* and wrote, produced, and directed some of its sequels, moved on to another series this did not end the franchise any more than did sending the villain to hell. Craven's new series was entirely directed by him, beginning with *Scream* (1996) and followed by *Scream 2* (1997) and *Scream 3* (2000), with a revival instalment *Scre4m* scheduled for 2011. *Scream* incorporated satire of teen horror as teen horror and for this reason I will return to it in the next section. But in both *Scream* and *I Know What You Did Last Summer* (1997, *Summer1*) the key teen slasher expectations are both fulfilled and reversed.[2] These films rely on the familiarity of teen horror. As the genre expects, in *Summer1* the killer is defeated and returns multiple times, and the film closes on another return – a note left for the final girl saying 'I still know.' Such 'knowing' is pivotal for teen horror – adolescents knowing about the threat, of course, but also the audience and even the characters knowing the genre. From the success of teen slasher films in the 1980s, Shary claims,

certain popular beliefs and assumptions emerged: the youth horror film was excessively violent and gory; the vast majority of its violence was perpetuated against female characters; characters engaging in sexual activities paid for their indiscretions by being killed. Like all clichés, these perceptions were partially based in fact. (Shary 2002: 137)

The recognizability of teen slasher conventions also depends on the way the films themselves internally use repetition. In *Friday1*, for example, the cinematic cues for threat and attack are quickly established and never varied, using sonic motifs to repetitiously signal the presence of the killer: a reverberating 'ch-ch-ch ha-ha-ha-ha' sound effect when the killer is looming and a sharp high slice of sound when they attack. Thus the viewer's expectation of immediate attack is lengthened and surprise can only enter at the level of *how* someone is killed.

More famously, however, teen horror makes blunt use of stereotypes and recognizable cinematic shorthands to efficiently signify characters and settings – like the babysitter, who captures a range of ideas about the family, domesticity, gender, and adolescence in a single label (Forman-Brunell 2002). The opening shot of *Halloween1* is exemplary, as a carved pumpkin on the veranda signifies childhood, family, and the supernatural all at once. The victims of teen horror are also *typical*: both ordinary and types rather than individuals. And they are types specific to adolescence: baby sitters and camp counsellors, virgins and promiscuous youths, beauty queens and prom queens. They are the types from high-school films pursued through their streets, thrust into the wilderness, or even trapped in their beds. For Shary, the horror film represents

youthful fears of being different, becoming sexual, and confronting adult responsibility ... and which themselves may not have changed much in the past few generations. These fears take on a strikingly wide variety of manifestations – there are more types of horror movie 'killers' than varieties of teen characters themselves – and are thus confronted in a number of ways, making the youth horror film far more complex and significant in its representation of young people than popular belief would generally allow. (Shary 2002: 138)

Whether teen horror represents fears of the adult world or the dangers of the adolescent's in-between world, similar stories about it are told across many decades.

I will frame the rest of this section with two well-used concepts from psychoanalysis that offer interesting approaches to teen horror: the uncanny, based on Freud's 'The Uncanny' (1919); and abjection, drawing on Julia Kristeva's *Powers of Horror: An Essay on Abjection* (1982). The web of repetitions, revivals, and rewritings characterizing teen horror should satisfy any historian of Frankenstein and Dracula movies. That is, some of this repetition characterizes horror in general, and that is where psychoanalysis first becomes relevant.

Freud (2003: 123) identifies, 'within the field of what is frightening', something he calls 'the uncanny'. His recognition that some frightening things are closely embedded in the familiar helps makes sense of the way teen horror blends the monstrous with the banalities of family life, high school, generic youth venues, and neighbourhood streets. He stresses that the known and the strange (the *heimlich* and the *unheimlich*) are tied together: '*heimlich* is a word the meaning of which develops in the direction of ambivalence, until it finally coincides with its opposite, *unheimlich*' (Freud 2003: 148). And the uncanny is always both 'belonging to the house or the family' and 'what is concealed or kept from sight' (Freud 2003: 126–7). The uncanny evidences a 'compulsion to repeat', which is 'powerful enough to overrule the pleasure principle' (145). Freud relates this to instinct and childhood,[3] but he also concedes it does not characterize the fantasy world of fairytales but rather confrontation between reality and what defies rational explanation. Repetition is both threat – it can and will happen again – and preservation – everything starts over, no one is singled out.

In Freud's essay this is all about the family drama of repressed desires (the 'Oedipal' family). But Freud acknowledges that he has selected examples of '*psycho-analytic* interest' and that the additional qualification for transforming the familiar into uncanniness is not the family per se but a combination of threat and repetition. In *Halloween1* the murders in the present tense of the film are telling repetitions of the first (familial) murder, but Michael is also playing out a less familial trickster role in his mask and repetitions across these series multiply and vary the family drama so many times that it hardly seems convincing any longer. But whether its significance is more psychological or social, and whether or not psychoanalysis explains it correctly, modern adolescence is significantly defined and managed by the family.

Across many teen horror films the outsider is revealed to be an insider, or the other way around, and this reversal depends on strange familial dramas. The killer turns out to be the victim's unknown brother (*Halloween1*); the helpful neighbour turns out to be the killer avenging her son (*Friday1*); the dream-murderer seeks vengeance on parents (*Nightmare1*); the boyfriend/friend is really the killer, seeking revenge for family shame (*Scream*); a helpless victim is really assisting their adoptive parent murder (the 'Saw' series). Vivian Sobchack (1996: 150) claims:

> These films abstract and ritualize adolescent isolation, rage, and helplessness, and it is particularly interesting to note how they rigorously repress the presence of parents and families, the latter's impotence and failure an absence that necessitates and structures the violence of the narratives.

Families are often present in these films but as a problem. Craven describes Krueger as 'the ultimate bad father' (Williams 1996: 175), and Shary (2002: 152) describes Jason as 'the ultimate oppressive, abusive parental authority figure, a teenager's true nightmare.'

In *Halloween1*, the lengthy shots comprising the opening sequence begin with a house. With the unsteady movements of an outsider watching through a window, the camera frames a young couple kissing. When they go upstairs together, the camera moves into the house. As Steve Neale suggests, this is a game with point-of-view. Framing, shot content, and camera movement resolve into clearer personification as the figure collects a knife and picks up a clown mask (Neale 1984: 359–62). We are looking through the killer's masked eyes as he climbs the stairs. The girl gives him a name, 'Michael', before he attacks (Neale 1984: 358). A shot of the raised knife precedes the film cut standing in for his first cut. We see enough – after the style of Alfred Hitchcock's *Psycho* – to know that he murders her. The sexualization of this scene is clear: not only has the killer waited till they have sex but his gaze on her naked body directly precedes his attack. This adds to the shock when, in the next scene, a re-establishing long-shot of the house shows the killer in the yard. He is a little boy in a clown suit.

Teen horror routinely splits and mirrors figures in order to complicate relations between victim, killer, and witness. Doherty notes that *I Was a Teenage Werewolf* (1957) manipulates point-of-view to stress 'identification of audience and victim', including with 'an upside-down point-of-view shot when the girl first sees the werewolf' (Doherty 2002: 134). In the film's opening fight sequence the camera is aligned sometimes with the delinquent and sometimes with the boy he's fighting. And it also foreshadows the slasher film, where the viewer is positioned as stalking the victims from just beyond the edge of their perception, as watching the victims suffer, fear, hide, flee, and struggle, and with the victims themselves. Craig and Fradley (2010: 87) describe this as 'the genre's enduring emphasis on heightened subjective experience and psychological perception, appealing to *emotional* rather than objective realism.'

One of the most widely cited analyses of teen horror is Carol Clover's (1992) discussion of 'the final girl'. Clover traces, across the slasher genre, the figure of a final surviving girl: 'She is the one who encounters the mutilated bodies of her friends and perceives the full extent of the preceding horror and of her own peril; who is chased, cornered, wounded; who we see scream, stagger, fall, rise, and scream again. She is abject terror personified' (Clover 1992: 35).

The final girl is not always a girl, as many critics point out, but the survivor figure that carries the audience through the story is usually a girl, a child, or a couple in which the main point of identification is a girl. She is also, for Clover (1992: 119), a boy – 'a male surrogate in things oedipal, a homoerotic stand-in, the audience incorporate', which requires an assumption that the audience is full of boys.

The boy-ness of the final girl, for Clover, explains how she survives by her resilience: 'The practiced viewer distinguishes her from her friends minutes into the film. She is the Girl Scout, the bookworm, the mechanic. Unlike her girlfriends … she is not sexually active.' (Clover 1992: 39) Clover thus raises the association

between sex and victimhood that Shary notes entered popular wisdom about the genre. While some teen horror films kill adolescents who don't have sex as easily as those who do (such as *Nightmare1*) many clearly punish sex with death. The 'Friday the Thirteenth' series is particularly unsubtle in this respect, even while it laughs at its own cliché. In the fourth film, Crispin Glover's character is taunted as a 'dead fuck', meaning not good at sex but also predicting that having sex will literally kill him. Overall, this link between sex and death is a version of the virginity trope discussed in the last chapter (Falconer 2010). The openness to sexual negotiation represented by virginity here becomes resourcefulness, in opposition to which sexual activity is metaphorically a failure of imagination, the closure of adulthood, and death. The final girl also raises the genre's overarching question of maturity, converting it into agency – action and responsibility conjoined – but this is a moment experienced at the limits and no more a transition outside adolescence than other teen film rites of passage.

While she discusses the uncanny, Barbara Creed's (1993) analysis of horror is more interested in limits, and in Kristeva's (1982) account of abjection into which she incorporates the uncanny (Creed 1993: 54). Abjection is 'whatever disturbs identity, system, order. What does not respect borders, positions, rules; the in-between, the ambiguous' (Kristeva 1982: 4). Like the uncanny, this seems a useful prompt for paying attention to how the in-betweenness of adolescence matters to teen horror. Doherty stresses a sympathy in 1950s teen horror between adolescents and monsters, but the genre developed an increasing focus on monsters with a human or almost-human appearance. None of the villains in the famous slasher series is entirely human – even if that means they are more than one person – and in fact they resemble their victims in insistent in-between-ness.

Abjection is an encounter with 'the real'; with bodily permeability, mortality, and decay. Kristeva clarifies that abjection is ambivalent:

> We may call it a border; abjection is above all ambiguity. Because while releasing a hold, it does not radically cut off the subject from what threatens it – on the contrary abjection acknowledges it to be in perpetual danger ... abjection itself is a composite of judgement and affect, of condemnation and yearning, of signs and drives. (Kristeva 1982: 9; Creed 1993: 8)

The horrifyingly abject describes something more dramatic than the difficult relations between identity, the body, and the social characterizing adolescence, but adolescence works as a symbol for this encounter. Teen film adolescence is also 'a composite of judgement and affect, of condemnation and yearning, of signs and drives', and teen horror is a place where failure to properly negotiate this composition is exposed.

Teen Film as Pastiche: *Scream, Scary Movie, Not Another Teen Movie*

The sequence of films in this subtitle maps a relationship between satirical comedy and teen film. It begins where the last section left off, teen horror, but that starting point also suggests that a certain aversion to the repetitiveness of teen film belongs to the genre itself. We might discuss the differences between these films by distinguishing between satire, parody, and pastiche, although assigning films to such a neat taxonomy is always risky. Generally, *satire* is critique in the form of comedy: satire can use generic components to expose a genre's foundations, implications, and effects. *Parody* is a type of satire, but depends on imitation: genre parody copies the genre in exaggerated form, but its mocking can be more affectionate than harsh. *Pastiche* is also imitative, but the specific contexts of the pieces collected in a pastiche are stripped away. As in a newspaper collage, the incorporated pieces remain recognizable, but their individual meanings are subordinated to the effect of the new text. A genre pastiche film flattens every reference into fragments of the same broader statement about the genre.

The increased repetition of a tight genre of teen horror in the 1980s meant the demand for something new in its spectacle of repetitions produced more self-reflexivity. Craven's *Scream* is usually offered as a turning point, but its parodic exposure of teen horror's conventions is evident in earlier texts, as in the epigraph to this chapter. In fact, as William Paul argues at length (1995), the responses of screaming and laughing are intimately related in cinema. Teen horror routinely represents youth as characterized by risky behaviour, including laughter in the face of mortality. In *Halloween1*, as in *Friday1* and *Nightmare1*, teenagers repeatedly joke about fear. Laurie teases her babysitting charge about 'the boogieman', although her rationality betrays her because the typical boogieman – a monster who attacks without reason from the shadows – turns out to be the same as the stereotype in which she does believe – the stranger who attacks without reason from the shadows. The 'Friday the Thirteenth' series features several scenes where new counsellors are told stories about the earlier murders at the camp which, while frightening some listeners, are more broadly dismissed as just the hilarious kind of thing you would expect to hear around a campfire. As they tease each other with images of danger, the on-screen adolescents inadvertently arrange themselves as the victims the audience already expects them to be. Knowing what will happen, the audience is offered teens who also know what will happen (but not to them), and this builds suspense of a novel kind – not focused on what will happen but on the style of its happening.

Jancovich (1996: 201) points out that 1950s teen horror films also 'often relished their own ludicrousness and artificiality even while dealing with strongly contentious or emotive issues.' *I Was a Teenage Werewolf* is already making fun of Halloween, including predictable scares like the box packed with springs, a surprise the audience anticipates more because the girls on screen do not. And because they

always imputed more sophistication to the audience than was evident on screen such films are particularly easy to recover as 'cult' films. This doesn't mean they are not intensely aware of their own comic potential (Jancovich 170; 282). The George Romero zombie films offer an interesting example here – two trilogies spanning 1968 to 2009, with the 20 year gap to 2005 being filled with remakes of the first three films by other directors. The very first victim in these films dies because he is 'acting like a child' rather than a young adult and in some iterations, like *Diary of the Dead* (2007) the zombies move directly into the standard plots of teen film. But it is as self-conscious repetitions about repetition that the Romero series has come to belong to teen film. Considering this series as teen horror, Shary (2002: 141) begins with the third film, but *Dawn of the Dead*'s (1978) satire on consumerism, with living zombies in a shopping mall being attacked by literal zombies, is equally apt.[4]

Scream's satirical eye differs from Romero's first of all in being genre parody. The film opens with Casey (Drew Barrymore) getting a phone call from a stranger, which shifts from flirtation to threat in the course of a quiz about scary movies. As soon as she is established as the audience's point of identification, Casey is brutally murdered by a figure in a ghost costume. Although this costume clearly references Edvard Munch's 1893 painting *The Scream*, the film presents it as a mass-produced Halloween costume that can be brought by other teens. 'Ghostface' next turns his threatening phone call and home invasion strategy on Sidney (Neve Campbell), who is identified as the final girl by her resourceful evasion of the killer. She has exactly the kind of past that should return in horror (a murdered mother), so Sidney only reluctantly sees the fun in her friends' jokes about the conventions of teen horror. When the killer is finally revealed to be Sidney's boyfriend Billy (Skeet Ulrich), working with his friend Stu (Matthew Lillard), their motives are not only sourced in teen horror but laughing at it too.

Billy and Stu undermine the institutions managing adolescence – confusing the police, abducting Sidney's father, killing the principal – but are defeated by a combination of final girl virtue and the power of the media. Sidney has sex only once, and only for love, establishing less the power of chastity than of responsibility. She is principally assisted by the ingénue deputy Dewey (David Arquette) and the scheming tabloid reporter Gale (Courtney Cox), although her victory is witnessed by film-obsessed friend Randy (Jamie Kennedy). While Randy claims he survives because he is a virgin his role is as tragic chorus, voicing the connections between film and genre that the audience is presumed to be making. Randy, Billy, and Stu all think movies have rules that life abides by and the film doesn't disagree. What goes wrong for Billy and Stu is that they don't understand their genre, seeing themselves as master criminals rather than psychos and failing to realize Sidney is the final girl even when she takes up their weapons and fights back. Sidney says she doesn't like scary movies because 'they're all the same. Some stupid killer stalking some big-breasted girl who can't act who is always running up the stairs when she should be running out the front door.' But her critique doesn't undermine the power of

popular media in this story. Sidney finishes off one murderer with a television to the head, and when the other attempts the generically expected resurrection she shoots him, insisting he won't do that in her movie.

Scream finally repeats teen horror conventions just as Ghostface's costume inevitably allows for resurrection in the sequels. It exposes some well-known teen horror tropes, tempting the audience to be certain what will happen only to tease it with other equally generic possibilities. Shary (2002: 165–7) claims the 'Scream' series grows weaker as it becomes more like the subgenre overall but he sees *Scream* and *Summer1* as having so undermined teen horror that it was unclear what could happen next (Shary 2002: 167–8). What followed the 'Scream' series was another set of resurrections: some imitative, like Samuel Bayer's remake of *Nightmare1*; some reinventing, like Rob Zombie's new 'Halloween' films; and some ridiculing, like the 'Scary Movie' series, which Shary refers to as 'exploiting and satirizing the subgenre's most visible elements' (2002: 141).

The 'Scary Movie' films rely on discomfort with the familiar as much as any teen horror film but it is a different kind of discomfort. They are, finally, not frightening at all because they are so packed with allusions and jokes as to leave no time for suspense. Generically, they meld teen sex farce and teen horror, with sex being inserted into the horror pastiche as another way of ridiculing the genre. But even the sex-farce dimensions of *Scary Movie* (2000) are stripped of context and particular meaning. Just as *Not Another Teen Movie* (2001) exaggerates the incest narrative from *Cruel Intentions* (1999), *Scary Movie* emphasizes possible homoerotic tensions between the boys in *Scream*. Both are pastiche films.

Some critics distinguish pastiche from parody by claiming the former leaves no room for critique because it erases context. For Fredric Jameson (1991: 17), pastiche lacks parody's 'satirical impulse' and 'that still latent feeling that there exists something *normal* compared with which what is being imitated is rather comic.' For Linda Hutcheon, however, the distinction between parody and pastiche is simpler: 'parody is transformational in its relationship to other texts; pastiche is imitative' (2000: 38). Teen pastiche films deride teen film for not representing anything of substance and yet without imagining the genre to be dead. And they may still have something to say.

There have been four 'Scary Movie' films since 2000. The plot of *Scary Movie* is largely based on *Scream*, with key elements of other films, principally *Summer1*, spliced in. The character names and plot turns mimic these films and large portions of the script are directly appropriated from them. Drew (Carmen Electra) is killed in the opening scene, and then Cindy (Anna Faris) and Bobby (Jon Abrahams) play out Sidney's bedroom scene from *Scream*. The killer wears the (by 2000 commercially available) Ghostface costume but has a hook hand lifted from *Summer1*. Deputy Doofy (Dave Sheridan) and TV reporter Gail (Cheri Oteri) strike up a romance while pursuing the killer and, after Cindy has sex with Bobby (in an indirect play on cross-generational familiarity with *The Brady Bunch*), he and his friend Ray (Shawn

Wayans) attack her. The denouement switches from *Scream* to *Summer1* when the boys reveal they are attempting a copycat murder. The real killer murders them both and is finally revealed to be Doofy, who is only pretending to be mentally retarded to enact a revenge that doesn't follow any narrative logic at all. But the murderer's escape is not what makes *Scary Movie* different.

The *Scary Movie* characters Ray and Shorty (Marlon Wayans) are directly indebted to the Wayans brothers' previous pastiche movie, *Don't Be a Menace to South Central While Drinking Your Juice in the Hood* (1996, *Don't Be a Menace*). This film explicitly satirizes the mesh of gangsta cool and uplifting social drama of the early 1990s African-American teen films discussed by Shary (Chapter 3).[5] While *Don't Be a Menace* assembles actors and stories that represent the 'hood' narrative as one of both obstructed development and partying on the margins, *Scary Movie* cites its stoner parody to insert a racial narrative into the unmarked whiteness of teen horror. Character is definitively sketchy in the pastiche film, but Ray and Shorty spectacularly do not belong among the character types of teen horror. For half the film Ray plays with codes that mark him as homosexual, only to refute that identification at the end. Shorty, however, is constantly stoned, and although the killer threatens to murder him more than once Shorty doesn't seem to notice and their mutual pleasure in getting high blocks all violence.

In this respect, while *Scary Movie* is a pastiche film, it differs from *Not Another Teen Movie*, which has no story to tell beyond how ridiculous teen movies are. Directed by Joel Gallen, *Not Another Teen Movie* cites many more films than *Scary Movie* because it needs no room for its own plot. The central romance mimics that of *She's All That* (1999). Popular boy Jake (Chris Evans) is dumped by his popular girlfriend and bets a manipulative friend that he can easily make another popular girl out of geek Janey (Chyler Leigh). While Jake grooms Janey for the prom, other teen films are brought into the mix. Although a full list would be unhelpfully long, the only way to account for the narrative of *Not Another Teen Movie* is by these loosely integrated subplots. Jake turns to his sister Catherine (Mia Kirshner) for help but she is lifted from *Cruel Intentions* and just wants to have sex with him. Janey's brother Mitch (Cody McMains) makes an *American Pie* (1999) pact with his friends to lose their virginity. He also pursues an idealized girl he barely knows with a *Can't Hardly Wait* (1998) letter declaring his love for her and he takes detention with his friends in a room styled to replicate the set in *The Breakfast Club* (1985), lifting lines from John Hughes's script for banter with the principal (even played by Paul Gleason from *The Breakfast Club*). And Jake plays out a twisted version of *Varsity Blues* (1999), aspiring to find himself on the football field.

Janey is made over as a prom queen and she and Jake fall in love. But the manipulative friend reveals the bet, Janey leaves, and Jake must learn a serious lesson about love. While this moral triumph is utterly deflated in the final scenes, even this deflation is lifted from *American Pie*. The vignettes, types, and other genre components compiled into *Not Another Teen Movie* are detached from sincerity –

from the semiotic context which claims they have meaning – and fill up the space in which viewers might come to care about these characters. While the film does centre on a couple, even their romantic crisis is undermined with an apparently random musical scene. The romance doesn't make bigger claims on the audience's identification than the recurring joke about a fat boy who keeps getting hit in the head. And if *Not Another Teen Movie* often reads the films it collects poorly – forgetting that *Bring it On*'s (2000) race narrative was explicit and that the heroine of *Pretty in Pink* (1987) was aware her best friend was in love with her – this hardly matters when the stories are never meant to be believed.

In the last chapter I noted that stoner films emphasize references to other texts. In pastiche films these references work differently. Rather than anchoring the film in a real world they clarify that the audience is separate from the film's diegetic world and in command of all its elements. The characters are types literally drawn from the 'anthropology shot' of high-school tribes (Chapter 3). In an early scene of *Not Another Teen Movie* a student guide assures newcomers that everyone can be themselves at 'John Hughes High', and then promptly divides them into jocks, 'slutty' girls, and geeks. The publicity materials for the film make this attention to stereotypes explicit, arranging the cast with labels identifying them as types like 'The Popular Jock', 'The Token Black Guy', 'The Nasty Cheerleader', 'The Beautiful Weirdo', 'The Desperate Virgin', 'The Sensitive Guy', and 'The Wannabe'. Janey, 'The Pretty Ugly Girl', is central to this. A range of critics have noticed the minimal effort used in concealing the beauty of girls teen film represents as plain and will make over as beautiful. *Not Another Teen Movie* parodies this trope by having Catherine simply remove Janey's glasses, release her hair from its ponytail and give her a new dress, nevertheless leaving everyone amazed.

This flattened-out pastiche is still capable of disruptive inclusions when it melds conventions across such generically structuring distinctions as gender. The opening scene in which Janey takes on Jim's masturbation story from *American Pie* is exemplary. It also has additional meaning for the film as a whole because Janey's pornography is teen film romance. When Jake begs Janey not to fly off 'to art school', repeating lines from *She's All That* and *Pretty in Pink* to convince her to stay, Janey is moved. When she is reminded by an eavesdropping airline assistant (Molly Ringwald) that the lines are lifted from films she knows by heart Janey initially claims to be outraged. But when Jake finally admits they probably won't last longer than the summer and his departure for college Janey inexplicably both believes he 'stole that from *Karate Kid*' and agrees to stay. The selection of material from teen films in *Not Another Teen Movie* both prioritizes teen film's use of stereotypes and repetition and suggests this is the value of the genre. But that might not be a value any different from pornography – a stimulating self-representation.

The Metaphor of Adolescence: *Akira* and Buffy

Both the uncanny and abjection inevitably refer to their effect on audiences. Kristeva (1982) takes the idea of abjection first of all from the anthropologist Mary Douglas (2002), who stressed the social dimension of what is horrifying, and if Freud thinks the uncanny in fiction works differently than in real life he also provides examples from lived experience. As Creed (1993: 10) suggests, abjection 'works on the sociocultural arena', so that 'when we say such-and-such a horror film "made me sick" or "scared the shit out of me," we are actually foregrounding that specific horror film as a "work of abjection" or "abjection at work" – in both a literal and metaphoric sense.'

It remains uncertain how culturally particular such affects are. Horror refers to a story about the body as something outside culture – as the object of actions that have cultural meaning – but the 'teen' dimensions of teen horror depend on stereotype and are thus clearly culturally specific. The use of stereotype also makes the personal, individual stories of adolescent protagonists comparatively unimportant. But what we could call 'teen gothic' is pre-eminently interested in horrifying personal stories – in what is now widely understood as the angst-ridden experience of adolescence.

Teen horror is usually discussed with reference to US examples, but as Doherty's history demonstrates, the British Hammer Film Productions were a key impetus behind the 1950s expansion of horror film (Doherty 2002: 122). And in Japan at the same time, sci-fi/horror films also proliferated. Ishirô Honda's *Gojira* (1954), adapted for the US as *Godzilla, King of the Monsters* (1956), is iconic but not singular. The significance of such films being made for audiences in the UK and Japan is not confined to their impact as cheap imports to the US. The story about teen horror beginning in the 1970s sketched above is also not exclusive to the US. Notable examples in this history include Canadian films like *Black Christmas* (1974) and *Prom Night* (1980) and British films like *Hellraiser* (1987) and its sequels. The fact that British horror in the 1970s continued to be dominated by revisions of famous gothic novels is important, however, and just one path to a discussion of what is culturally specific about horror, including teen horror. I want to consider some Japanese examples here.

While Jim Harper (2009: 21) claims 'Japanese teen horror' developed 'in the early '90s', he claims an earlier history for 'the Japanese splatter movie' (Harper 2009: 24), outlining an extensive field of horror that utilizes many teen horror conventions. In addition to generic motifs like doubling, the return of past trauma, exposure of bodily vulnerability, and revenant monsters, these films often feature adolescent protagonists and a child that isn't a child. The 'not-child' monster recurs in a wide range of teen horror from *The Exorcist* to *Akira* (1988) and beyond. If the successful Japanese films *Ringu* (1988) and *Ju-On* (2000) somewhat stretch the boundary of teen film, they not only feature not-child monsters but spawned the kind of film

series successful with teen audiences (their respective US adaptations won many 'teen' awards) and especially associated with teen horror. Matt Hills, moreover, notes that while fans overwhelmingly read the relationship between *Ringu* and its adaptation *The Ring* (2001) for cultural difference rather than similarity (Hills 2005: 168), one motivation for this is opposing Japanese horror films to 'MTV' movies and thus construing *Ringu* as 'adult' (Hills 2005: 169).

Japanese teen horror has more specific forms, however. It is often *anime* (animated film), a genre and a difference I'll return to in the last chapter. I want to take the ground-breaking *Akira* as exemplarily a story about adolescence. While it takes up the apocalyptic motif of post-Second World War Japanese speculative film, *Akira* also sets adolescents against the institutions designed to manage them but actually turning them into monsters. Directed by Katsuhiro Ôtomo from his own *manga* (graphic novel), *Akira* focuses on gang friends Kaneda and Tetsuyo, who are separated when Tetsuyo comes into contact with a mysterious child. The government scientists pursuing it discover that Tetsuyo is not like other boys and resembles a mystical boy, Akira, who had destroyed Tokyo decades before. Tetsuyo's attempts to discover the extent of his emerging powers and the efforts of Kaneda and a resistance movement to rescue him occupy most of the remaining plot until, assisted by various supernatural interventions, a conjunction of Tetsuyo and Akira's powers destroys Neo-Tokyo.

From j.d. biker gangs to the eruption of monstrosity from the adolescent body, *Akira* is a teen film. The idea that teen film must be 'live action' in order to make realist claims about adolescence was always undermined by its fantasy dimensions (including in horror film) and made redundant by the blatant special effects of horror production. In content and style *Akira* is a teen film, including in its central story about maturity. This story unfolds in the responsibility delegated to adolescents when the adult world festers with self-interest, in the romance between Kaneda and Kei as they try to save Tetsuyo and the world, and in Tetsuyo's struggle with his own power. Tetsuyo's adolescence is both deformed by scientific experiment but also a product of mysterious forces. Like *Carrie* and *The Exorcist*, *Akira* uses the body and mind of the adolescent as a conduit for the supernatural, emphasizing an allegorical relation between adolescent transformation and inexplicable supernatural forces. This relation is not only signified by adolescent monsters but itself signifies broader cultural anxieties.

Mutations of this puberty allegory appear across cultural and historical contexts and in different teen film subgenres. *Akira* resonates with Jancovich's (1996: 207) reading of *I Was a Teenage Werewolf*, where science and psychology conspire in a gothic narrative exploiting the uncertainties of youth. In the end, 'Tony's problems are not a product of his family background [or psychology], but of the wider social world' (Jancovich 1996: 210) and its desire to 'dominate and control' (Jancovich 1996: 213). In *Teen Wolf* (1985), this adolescent werewolf takes a comic turn as Scott (Michael J. Fox) watches himself become a monster in the bathroom mirror.

Trailers for *Teen Wolf* pushed this image of puberty as a monstrous transformation. But, unlike Tony, Scott has a father who was also a teen wolf, and his nurturing management of adolescence allows *Teen Wolf* to work as a conventional high-school comedy about identity development.[6]

The werewolf/puberty allegory usually centres on boys because the wolf figure is opposed to the domestic and interior stories that characterize gothic girlhood. The Canadian film *Ginger Snaps* (2000) exploits this established opposition to represent the girl-becoming-werewolf as a refusal of puberty. While *Carrie* begins with menarche as the emergence of horrifying power, Ginger (Katharine Isabelle) embraces her werewolf-self as a displacement of menstruation. 'I get this ache,' Ginger tells her sister, 'and I thought it was for sex, but it's to tear everything to fucking pieces' (Craig and Fradley 2010: 89–90).

The puberty allegory also appears in *Buffy the Vampire Slayer* (1992, *Buffy1*), written by Joss Whedon and directed by Fran Kuzui. Buffy (Kristy Swanson) begins the film as a stereotypical Californian teen queen. She is interested in shopping, her friends, and her superiority to others. But her life is disrupted by a stranger, Merrick (Donald Sutherland), who claims that a mystical birthright invests Buffy with both supernatural strength and an obligation to kill vampires. Persuaded to try and help, Buffy must withdraw from her usual life and is thrown into the company of Pike (Luke Perry), also committed to fighting vampires because they killed his best friend Benny (Arquette). *Buffy1* takes up the puberty allegory – the presence of vampires is signalled by pain resembling menstrual cramps – but is also a coming-of-age story in which Buffy realizes her personal and physical strength.

Buffy1 was not the first cinematic conjunction of teen genres and vampires. In fact there was a proliferation of vampires during the 1970s and 1980s, telling stories that were more gothic, and often more comic, than terrifying. In the UK, films like *Dracula A.D.72* (1972) explored the translation of traditional vampire narratives into contemporary youth culture, and in the US vampires tempted teens in films like *Fright Night* (1985) and *The Lost Boys* (1987). In *Fright Night*, television vampire hunter Peter Vincent (Roddy McDowell) insists that vampires have gone out of fashion: '*Unfortunately* none of *your* generation seems to be [serious about vampires] ... *I* have just been *fired* because nobody wants to see vampire killers any more, or vampires either. Apparently all *they* want are demented madmen running around in ski masks, hacking up young virgins.'

In these films it is adolescents who understand vampirism's deathless attractions and also adolescents who must defeat it. Teen spaces are consistently unsafe spaces because vampires occupy the same state of in-between-ness (half human and half demon). Thus signs of vampirism also signify adolescence, as *The Lost Boys* makes explicit.

The gothic novel is often discussed as taking distinct romance and horror forms, a distinction sometimes gendered as respectively 'female' and 'male', but an emphasis on relations between power and knowledge and between what is seen and

unseen cross this distinction. Teen gothic stresses the presence of the supernatural in everyday teen life, but especially through the dialectic between sex and romance proper to teen film. If sex is integral to the vampire story (Gelder), teen gothic has added ageless fun to the vampire's attractions, exemplified in *Buffy1*'s citation of *The Lost Boys* when Benny floats at Pike's window tempting him with eternal play. In *Buffy1* also, Lothos (Rutger Hauer) is a sexual challenge and a sexual threat, inflicting Buffy with red satin bedroom nightmares. Despite his motorbike and leather jacket, Pike is by comparison a non-threatening romantic attachment, suited to prom but not sex (Kaveney 2006: 88). In the subsequent television version of Buffy's story (1997–2003, *Buffy2*), many things have changed but the sexual charge associated with monstrous rather than human boys has not. Buffy (now played by Sarah Michelle Gellar, Figure 5.1) reprises traditional narratives about the dangerous erotic charge of the vampire, once even with 'Dracula' himself. But her romantic and sexual relationships also transform men into monsters, or monsters into different monsters, and save and destroy the souls of vampires.

Any comparison between a single movie and seven years of episodic television across two networks would be spurious.[7] But a sketch of the different generic orientations of these texts raises some useful questions about the conventions of teen film and its televised counterpart. The narrative premise of 'Buffy' is a contradiction between expectations built on stereotypes – between 'Buffy' the cheerleader (superficial adolescent girl) and the 'Slayer' or fighter.[8] In *Buffy2*, created by Whedon and often written and directed by him, Buffy begins the story younger, and the series emphasizes the socio-legal limits on adolescence in contrast with Buffy's supernatural power as guardian of a 'hellmouth'. Her mentor in supernatural battles, her 'Watcher' Giles (Anthony Stewart Head), is also a father figure whose opposition to the mundane world of teenage girls and to scientifically explicable modernity is entwined and emphasized by his being British. This relationship allows *Buffy2* to continues the cheerleader vs slayer narrative of *Buffy1*, where Buffy's retort to her mentor Merrick – 'I'm the chosen one and I choose to be shopping' – could equally be a line Buffy delivers to Giles.

In *Buffy2*, Buffy has moved with her mother to the Californian town of Sunnydale. Seasons 1–3 focus on her school life and friendships with Willow (Allison Hannigan) and Xander (Nicholas Brendan), and later Cordelia (Charisma Carpenter), Oz (Seth Green), and others. Pike is split into the figures of Xander and Angel (David Boreanaz), Buffy's doomed vampire love interest. Their competition for Buffy's affection also links everyday teen narratives to supernatural ones. And *Buffy2* provides Buffy with institutional authorities to battle as well as supernatural ones, although in line with the puberty allegory of teen film these always eventually intersect. The villains of each series shift between bad parental figures and peers until the final season, in which Buffy's antagonist is evil itself. As Buffy moves on to college and then working life across the series her personal life becomes increasingly demanding as a counterweight to more exotic powers around her. Her

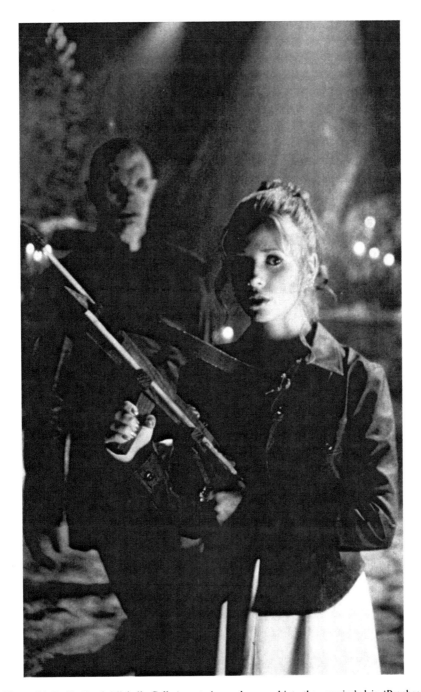

Figure 5.1 Buffy (Sarah Michelle Gellar) venturing underground into the vampire's lair. 'Prophecy Girl', *Buffy the Vampire Slayer* (1997). Creator, Joss Whedon. Courtesy of 20th Century Fox Television/ The Kobal Collection/Cartwright, Richard.

love-life remains central to the entanglement of the banal and the supernatural, and if Xander remains a reference to normality she gains a new vampire lover/antagonist in Spike (James Marsters).

While Buffy is referenced in both *Scary Movie* and *Not Another Teen Movie* as a sexy, aggressive, wise-cracking girl she more substantially shapes a highly successful field of teen-directed vampire texts, including the 'Twilight' series. The most telling difference between 'Buffy' and 'Twilight' is what they do with the gothic heroine as high-school girl. In *Twilight* (2008), Bella's on-screen style is less conventionally feminine than Buffy's but, despite her plaid shirts, motorbikes, and 'emo' music, Bella's storyline is one of empowerment through submission. 'Twilight' also returns an emphasis on virginity to the vampire narrative. Buffy's first sex is with a vampire, and is catastrophic in that it transforms Angel into the evil Angelus, but this does not remove Buffy from the processes of girlhood. For 'Twilight', virginity is a rite of passage in which both adolescence and humanity will be overcome – Bella (Kristen Stewart) cannot have sex with Edward (Robert Pattinson) and remain a girl.

The 'Twilight' films assemble rites of passage ('the prom', graduation) and limit experiences (first love, near death) but while they centre entirely on the question of maturity they foreclose on any coming-of-age story. If there is a puberty allegory in *Twilight* it is one in which the changefulness of adolescence and youth culture are equally horrifying. *Twilight* deploys teen film conventions to represent adolescence as a painful space and experience, but also as the only space in which the work of perfecting the self can be done. While Edward and his siblings could pass as adults more easily than they can pass as teenagers in the closely monitored space of high school, they choose not to, moving instead from one high school to another, endlessly repeating classes on *Romeo and Juliet*, cafeteria dramas, and graduation caps. Their command of all cultural forms includes youth culture but, unlike the vampires of 'Buffy', they remain unchanged. Bella's desire to stop aging thus takes on a meaning detached from youth and adolescence – it is a rejection of maturity as a transformative process and dedication instead to replicating tableaux of teenage beauty.

–6–

Teenage Wasteland

Gilbert: God Arnie, you're getting so big. Pretty soon I ain't gonna be able to carry you no more.
Arnie: No, you're getting littler Gilbert. You're getting littler, you're shrinking!

What's Eating Gilbert Grape (1993)

Teen film does not accurately portray the lives of adolescents despite its use of the 'fabulously consuming trivia of everyday teen life' (Martin 1994: 65). But as John Frow argues, every genre entails a particular 'structure of address', a 'moral universe', and a set of 'truth effects' (2006: 9). This chapter focuses on teen film's structure of address; on how it invokes an audience which understands adolescence in particular ways. This is not necessarily, as Roz Kaveney would have it, a celebration of adolescence. Teen film often represents adolescence as a trial or as a scene of failure and loss. In this chapter I consider a set of films which focus on the risks and frustrations of adolescence, but also films which others might dispute calling teen film at all. As with all genres, the perspective from which teen film is defined shapes what it means. Here I want to suggest that the structure of address defining teen film is also one that dismisses the idea of teen film. It is one within which adolescence is both idealized and critiqued as a fraud; within which adolescence is a transient shimmering promise of possibilities that rarely materializes, never holds, and quickly passes away.

Brian de Palma's *Carrie* might well have been more prominent in the last chapter, but most discussions of *Carrie* do not class it as a teen film. Shary (2002: 147) includes it as a precursor to 1980s teen horror and Craig and Fradley (2010: 89), despite praising its 'scathing depiction of the horrors of high school socialization', call *Carrie* a 'significant generic template' rather than locating it within the genre. But why? *Carrie* has an adolescent protagonist, school bullies, a makeover plot, a prom, and conflict between peers, between children and parents, and between teachers and students. Carrie (Sissy Spacek) even gets a moment of romantic transcendence when the popular Tommy (William Katt) kisses her on the dance floor. The scene with Carrie and Tommy dancing is central to why *Carrie* is generally excluded from teen film. It drags on, spinning closely around the dancing couple. The lights of the prom become increasingly disorienting and the movement of the camera around the dancers speeds up, sliding from convention to disorienting threat in line with the

soundtrack. That is, *Carrie*'s stylistic originality seems to make it something *more* than teen film. Rick Altman might say *Carrie* was semantically but not syntactically teen film. But as the reach from *Rebel Without a Cause* (1955) to *Halloween* (1978) to *She's All That* (1999) suggests, the syntactical shape of teen film is very broad indeed. The presumption that teen film excludes artfulness or stylistic originality defines the genre not by its content but by what is presumed to be its mode of address; by a particular relation to the audience.

A *Clockwork Orange* and *Donnie Darko*: 'What's it Gonna Be, Then?'

In Stanley Kubrick's *A Clockwork Orange* (1971), Alex DeLarge (Malcolm McDowell) leads his 'droogs' (friends) in pursuit of violent pleasures. In a dystopian world that is both futuristic and highly familiar (and now also a period classic), the droogs blend images and practices of childhood with adult criminality. In the first half of the film, Alex evades the expectations of his parents and a 'post corrective adviser' whose presence acknowledges he has been arrested before. We see Alex and his gang assault, fight, steal, invade, rape, and finally kill. But Alex's droogs turn on him, leaving him for the police. In jail, Alex joins a brainwashing programme designed to cure him of violent behaviour and secure an early release. Alex is injected with drugs and subjected to a stream of violent film images. Altered so that he becomes physically ill at the thought of violence, Alex is released. The story then moves through several reversals – Alex's parents reject him, his droogs (now police) attack him, and a former victim conspires to provoke his suicide. In hospital recovering from the attempt, Alex discovers that he is a useful tool for all sides of politics but he also discovers that his treatment has been reversed.

A Clockwork Orange was withdrawn from UK distribution by Kubrick in 1973 following media controversy centred on its impact on adolescents (Chapter 7). But is it a teen film? On DVD commentary for a special edition of *The Breakfast Club*, Amy Heckerling, director of *Fast Times at Ridgemont High* (1982), *Clueless* (1995), and *Loser* (2000), notes that teen film contains 'a lot of different movies'. Arguing for that diversity one of her examples is *A Clockwork Orange*. Calling Kubrick's film a teen film is at least controversial but also worth considering. Alex is fifteen, in line with the novel by Anthony Burgess (1968) on which the film was based. He is under his parents' care and clearly supposed to be in school. But McDowell plays Alex as a far more ambivalent sort of age. This is necessary at a narrative level to clarify that Alex makes an informed choice to be a violent criminal. An Alex whose attitudes to self and world resembled the fifteen year olds of suburban and high-school-centred teen film, rather than those of gang-based movies, would raise different questions about culpability and punishment. But the film's restrictive ratings acknowledge that Alex's charismatic youth is central to its story.

The opening of *A Clockwork Orange* is justly famous. It begins with a close up of Alex staring intently into the camera, his expression perhaps amused but certainly threatening. Despite the intimate relationship established between Alex and viewer in this shot, the intensity of Alex's expression also has a distancing effect. He looks at us in a knowing and assessing way, clearly separated from us by the artful composition of his own style. The shot begins with just Alex's eyes, one decorated with false and painted eyelashes, staring from under the rim of a bowler hat. The tension between Alex's commanding gaze and this mockery of feminine make-up is accentuated by the *mis-en-scène* (the contents of the filmed scene) revealed as the camera pulls back. Alex is surrounded by three other members of what is obviously a gang from their shared costume: white trousers, shirt, and suspenders combined with conservative men's hat and a codpiece. Alex's voice-over tells us they are preparing for a night on the town in the Korova Milk Bar. The Korova is a dramatically sexualized setting, furnished with milk-pumping naked female mannequins in provocative poses. Among the many elements of *A Clockwork Orange* that depend on ideas about adolescence, this field of self-conscious stylistic display warrants further consideration.

The heavily stylized portrait of youth delinquency belongs to its time. In the context in which both novel and film appeared, the British government and media were debating a youth problem focused on images of riots, gangs and stylistic displays of youth marginality (like the mods and the punks). This is also the context in which the Centre for Contemporary Cultural Studies at the University of Birmingham (founding what is known as 'the Birmingham School') began studying youth culture, and that in which Stanley Cohen (1972) devised his theory of 'moral panic' to explain how relations between state, media, and public produced shared anxieties about youth. Burgess (1978: 91) noted that:

> in Britain, about 1960 ... respectable people began to murmur about the growth of juvenile delinquency and suggest [young criminals] were a somehow inhuman breed and required inhuman treatment ... The delinquents were, of course, not quite human beings: they were minors, and they had no vote; they were very much them as opposed to us, who represented society.

Burgess (1978: 92) set out for Alex to 'be sympathetic, pitiable, and insidiously identifiable with us, as opposed to them.' But if contemporary debates about the youth problem are clearly apparent in *A Clockwork Orange*, a broader idea about youth is also at stake.[1]

In Kubrick's adaptation Alex commands contemporary youth culture, strolling the arcade imperiously, in complete control of the fashion sense and other taste regimes around him. Despite his more specialized attachment to the music of Beethoven, Alex's commanding style is crucial to *A Clockwork Orange*'s ongoing success as a representation of youth. Its cinematography, characterization, and focus

on hypocritical discourses of citizenship and maturity have influenced decades of subsequent teen film but also drew on preceding films, including McDowell's performance in *If* (1968) but also the j.d. subgenre more generally. In many j.d. films the home environment is as questionably decrepit and disinterested as in *A Clockwork Orange*. In *I Was a Teenage Werewolf* (1957), the j.d. asks for expert help to stop the behaviour constantly pushing him into conflict with authority, only to find the experts as wholly self-serving as those who treat Alex. Even Alex's age has precursors. In *Dino* (1957), for example, the sixteen-year-old antihero comes home from reform school (where he's been as an accessory to murder since he was thirteen) a burden and disappointment to his family, and if expert guidance in Dino's case is well intentioned it is equally unable to save him. *juvenile delinquent*

The psychologically trained adviser is a recurring image in the j.d. film and deployed in many teen films to elaborate adolescent difficulty. Alex's advisers are either deluded, like the priest, or disinterested. Alex's 'post corrective adviser', Deltoid, bills himself as 'The one man in this sordid, sick community who wants to save you from yourself!' but he is as cynical as he is sleazy and he abandons Alex as bad for his record. This failure of expert guidance suggests one link between *A Clockwork Orange* and *Donnie Darko* (2001). In Chapter 2 I suggested that j.d. films always raise a question we might express, lifting a line from *The Wild One* (1953), as 'Whatta you got?' The j.d. film is a demand that the options, or lack of options, available to the delinquent be made explicit. But the maturity question that threads through teen film contextualizes the 'Whatta you got?' question in a larger demand, one we might express, lifting a line from *A Clockwork Orange*, as 'What's it gonna be, then?' The subject of teen film is in the process of becoming a 'subject' – a person with a recognized place in the world, however fraught with contradictions. If modern adolescence is a crisis from which the adult subject is presumed to emerge, teen film is interested in the limits and possibilities of this process.

Donnie Darko, written and directed by Richard Kelly, is also often distinguished from teen film as something more substantial. On the film's release, unimpressed critics often accused it of being 'adolescent' and, according to Kelly, disliked it for representing 1980s adolescence very differently than John Hughes had done (Kelly et al. 2003: 1). But for admiring critics, *Donnie Darko*'s value lies partly in being a film that speaks to experiences of youth neglected by teen film (by which they generally mean teen film in the Hughes style). *Donnie Darko* is undoubtedly organized by the dominant conventions of teen film, mixing teen sci-fi, teen gothic, teen romance, and teen high-school drama. Kelly frames this as a conscious intervention in the genre:

> There are elements of the teen film in 'Donnie Darko'; you have some of the archetypes such as the new girl in town, the bullies, the annoying gym teacher. I wanted there to be recognisable signals that viewers would relate to but that existed on a different level to a point where we could poke fun at these plot contrivances. We put the whole package together in a way that is really provocative, that will hopefully speak to young people

and will give them a puzzle to try to solve, as opposed to just giving them the Prom, and the dissing. (Huggins and Salter 2002)

If *Donnie Darko* is an unconventional teen film, however, this is mainly because it refuses to resolve the central drama of Donnie's (Jake Gyllenhaal) identity into a single linear story.

Donnie is unhappy in his suburban home and school. His parents worry that he might be mentally ill and send him to a psychiatrist, but Donnie's general anomie seems to save his life. Wandering the streets at night, Donnie is not in bed when, in a freakish accident, a plane engine falls through his bedroom ceiling. The attitude that seems problematic at home and school also helps him strike up a rapport with new girl Gretchen (Jena Malone). But while their romance is the positive story in this film, its narrative counterweight is a spectral figure haunting Donnie. 'Frank' looks like a man in a bunny suit wearing a grotesque mask (see the cover image). Whether he's something Donnie dreams, or a symptom that appears when Donnie stops taking prescribed medication, 'Frank' is associated with Donnie's alienation from adolescent adjustment and with his increasingly destructive attacks on authority. Visions centred on 'Frank' in his 'stupid rabbit suit' ominously guiding Donnie in his 'stupid man suit' lead Donnie through a series of coincidences up to the narrative climax. Gretchen is accidentally killed – hit by a car driven by a real life Frank, Donnie's sister's boyfriend. It's also these visions that Donnie believes have given him the secret to time travel, which he uses to go back to the beginning of the story and let the plane-engine kill him, leaving Gretchen alive because she never met him.

Donnie's difficulties can be understood not only as adolescent struggle for identity and agency but also as signs of mental illness (Rapfogel), or as a supernatural/sci-fi experience (Stewart). But all these readings are stories about adolescence. The first thing we hear 'Frank' tell Donnie is that the world will end in twenty-eight days, six hours, forty-two minutes, and twelve seconds, and the film is punctuated by cuts to a clock, counting down to the reversal of the narrative since this opening scene. While accepting a time-travel narrative means that Donnie committed suicide, it also means Donnie develops an almost superheroic command of time and space. Gretchen makes this explicit when she claims 'Donnie Darko' sounds like a superhero's name, and for this storyline 'Frank' is Donnie's displaced and distorted superhero costume. Not accepting the time travel narrative means that the film's action can only be a dream or fantasy, for which reading 'Frank' (which also means honest) is something like Donnie's unconscious.

Donnie's story uncovers some typical high-school injustices and blatant displays of adult hypocrisy. The two most carefully explored both deal with representations of adolescence. Donnie objects to the school's ban on Graham Greene's short story 'The Destructors', set by his English teacher Karen (Drew Barrymore), and he confronts a motivational speaker for teens, Jim Cunningham (Patrick Swayze), with charges that his rhetoric about having a good attitude is empty hypocrisy.

Donnie's responses are ultimately violent – he floods the school and he burns down Cunningham's house – but in both cases he attempts to engage in argument first. Donnie is intensely aware of the limits imposed on him as a problem youth – 'held back in school; can't drive till I'm 21' – but in *Donnie Darko* all minors are excluded from decisions about how they should be represented. The debate over whether 'The Destructors' should be set excludes them, as does the decision to dismiss the teacher who set it. Donnie's destructive behaviour is also presented as heroic revelation because not only is the school oppressively unjust but burning down Cunningham's house reveals a secret stash of paedophilic pornography. Teen film is directly implicated in this revelation. The cover image for this book is a still from the scene where Gretchen, Donnie, and 'Frank' watch teen horror – *Halloween* and *Frightmare* (1983). The movie screen subsequently transforms into a portal leading Donnie to Cunningham's house.

Thinking about *A Clockwork Orange* and *Donnie Darko* as teen films engages with their complex stories about the representation of adolescence and with the broader discourses on youth to which these stories belong. The discussion of ratings and censorship in the next chapter takes up this question from a different perspective but both these films raise questions about the focus inside teen film as well as outside it, on the effect of media on youth.[2] *Donnie Darko* may be a story about time travel, or about mental illness, but it is certainly a story about the disempowerment of youth. By comparison, the problem of why Alex does what he does seems far more inexplicable.

A Clockwork Orange was influential on the stylized gang narratives of later films, like *The Warriors* (1979). But the droogs also exemplify what the Birmingham School studies defined as 'youth subculture': 'focussed around certain activities, values, certain uses of material artefacts, territorial spaces etc. which significantly differentiate them from the wider culture. But, since they are sub-sets, there must also be significant things which bind and articulate them with the "parent" culture' (Clarke et al. 1975: 100).

Clarke, Hall, Jefferson and Roberts argue that subcultures articulate a group identity through ritual, dress and argot (language). Some of these subcultures particularly formed around music, like the punks Dick Hebdige studied, but all formed around protest, including the stylized violence of the skinheads studied by John Clarke. Clarke claims skinhead identification arose from '"*Nothing*" more than any territorial or group factor.' It is 'merely something ... in nothing' (Clarke et al. 1975: 105).

For the Birmingham studies, subcultures were compensatory distractions from alienating social conditions and were thus essentially inauthentic, eventually displaced by incorporation into the mainstream. In *A Clockwork Orange* the other droogs become policemen, taking up 'A job for two who are now of job age – the police!' Donnie's experience of youth seems radically different less because his clearly middle-class lifestyle is dominated by family and school than because no

subculture is available or relevant to him.[3] While both Alex and Donnie alarm their friends as well as the authorities who want to manage them, Donnie's friendships are not bound to a group identity. If Donnie's relation to the world is radically different to Alex's this is most of all because adolescence means something different to him – not youth and promise to be defended to the last against horrors of disgusting old age, but disempowerment and the frustrating search for meaning. In *I Was a Teenage Werewolf*, Tony is also genuinely alarmed by the way he can't help frightening people and similarly frustrated, but there is an important historical shift in the surrounding public discourse on youth between 1957 and 2001. This is a slow rather than dramatic change in which *A Clockwork Orange* also has a place.

The title for this chapter comes both from an iconic rock song by The Who – 'Baba O'Riley (Teenage Wasteland)', released the same year as *A Clockwork Orange* – and from Donna Gaines's *Teenage Wasteland: Suburbia's Dead End Kids* (1998), an anthropology of 1990s suburban teens identified as 'burnouts'. The lyrics of 'Baba O'Riley' offer little narrative beyond the sentiment of living life while you're still young. It's the refrain, 'It's only teenage wasteland', accompanied by thrumming power chords, that makes the track memorable. The combination of protest and resignation it conveys offers a potent symbol for a dominant mood and important refrain in teen film. This frustrated alienation is at one level from 'adolescence' itself. The passionate feeling represented in the performance of this track is also dismissed in it – 'It's only teenage wasteland.' I take this refrain as signifying not only adolescent frustration, but frustration with the apparently impossible ideals of adolescence.

In *Teenage Wasteland*, Gaines describes the lives and contexts of a group of New Jersey adolescents who have failed to succeed at adolescence: to complete school, find a job or commence training for one, become independent of parents and look for a partner, and otherwise seek stable productive adult roles. Gaines's burnouts are either disinvested in these goals or find them unattainable. She identifies the contradictions between adolescence and the conditions of these kids' lives as especially 'destructive: "adolescence" continues to serve as a psychic holding pen for superfluous young people, stuck in economic and social limbo, in between childhood dependence and adult autonomy' (Gaines 1991: 256). For Gaines's kids, as for Alex and Donnie, crime and even suicide are tactical responses, however self-defeating, to disenfranchisement. If the process of adolescence involves taking up a place in the world this is a strictly prescribed place unavailable to many.

Donnie Darko is set in 1988. While many period details are included, the film particularly revels in 1980s music. In 2001 this music spoke to multiple audiences – currently fashionable as a newly installed set of 'classics'. The inclusion of Joy Division's 'Love Will Tear Us Apart' (1980) is paradigmatic in this respect, but a cover of the 1982 Tears for Fears hit 'Mad World' by Gary Jules and Michael Andrews, which shifts the tenor of the track from danceable beat to introverted ballad, features prominently and was included as a separate music video on the successful

DVD release. This translation matters because the nostalgia often built into teen film becomes an optional part of the text. Teen film nostalgia always speculates about how one might go back and do adolescence differently. But when Gretchen and Donnie present a school project on altering the past by happier representations of it they attest that this question is as fascinating to people for whom adolescence is a present tense set of questions as for those for whom it looks like time travel.

Teen Film for Grown-ups: *Freaky Friday, Almost Famous, What's Eating Gilbert Grape?*

What has value in teen film is rarely what is on the other side of growing-up, but the process itself. A wide range of teen films represent that passage as filled with frustration and as sometimes impossible to navigate; but at least it is not over. The pleasures of teen film partly lie in restaging and recrossing the fantastic line between childhood and adulthood. This is a key component of teen film's dialogue with an 'adult' audience. Teen film often speaks not only of but to an audience that defines itself – sometimes in a hostile way, sometimes suspiciously, sometimes romantically, and sometimes nostalgically – as now past adolescence. Addressing an adult audience through the recollection of adolescence is most common in films that operate at the slippery border between 'family' and 'teen' films. If 'youth culture' comprises 'cultural *signs*' of youth 'invested, by the dominant culture, with meanings, associations, social connotations' (Clarke et al. 1975: 109), these signs can be used to convey youth for those who no longer identify as youth outside the film audience.

The three themes that I discussed in Part I as organizing modern images of adolescence – youth as problem, the teenage institution, and youth as party – together represent modern adolescence as a fantasy of escaping responsibility and of open possibilities which is always being countered by institutionalizing and disciplinary discourses. The core teen film narrative of coming-of-age and its central thematic questions concerning maturity are always in conflict. They produce an image of adolescence as potential continually checked by the demand to grow up in the right way. This adolescence is a struggle adults are presumed to already have negotiated, whether satisfactorily or not, and a field of possibilities they have had to leave behind. The outsider view presumed for adults in the field of teen film is thus often nostalgic for lost spaces of potential but also identified with what blocks adolescent opportunities. This is made even more complex by the difficulty of drawing borders between adolescence and adulthood, and the audience presumed by teen film often tensely juxtaposes adolescent and adult perspectives.

In 1976, at fifteen, Jodie Foster starred as three radically different versions of the problem adolescent girl: the cynical child prostitute Iris in Martin Scorsese's *Taxi Driver*, for which she was widely acclaimed; the jaded child-woman cabaret

performer Tallulah in the surreal 'family' gangster movie, *Bugsy Malone*; and the ungrateful insensitive suburban daughter Annabel in Gary Nelson's *Freaky Friday* (1976, *Freaky1*). Across this range, Foster offers a complex picture of girlhood in 1970s American cinema but only the last is clearly a teen film. This film was remade a generation later in Mark Waters's *Freaky Friday* (2003, *Freaky2*). Both *Freaky Friday*s were released by Disney. They centre on the story of Annabel/Anna and her mother Ellen/Tess exchanging bodies for a day, so that the mind of a thirteen/ seventeen-year-old girl is in the body of her thirty-/forty-something mother, and the other way around. The social situations across which this exchange takes place, however, are very different.

Freaky1, released under the Disney imprimatur as family viewing, was explicitly directed at young children and adults as well as adolescents. The central characters' transformations operated within the nuclear family and could engage future and past images of adolescence as well as present ones. The story centres on relations between Annabel, her parents, and her younger brother. Annabel comes to realize the extent of Ellen's (Barbara Harris) responsibilities and skills, to criticize her hitherto idealized father's sexism, and to appreciate her little brother's charm. The experience also alters Annabel's relationship to the boy-next-door on whom she has a crush because it provides an opportunity to talk to him without childhood baggage, an extension of Ellen-in-Annabel's making over tomboy Annabel as a teen beauty.

The only element of this plot beyond the body-swap that is unchanged in *Freaky2* is the little brother, still providing an anchor in the field of 'family film' for the Disney audience and tracking emotional change in Anna (Lindsay Lohan). The sexist father has been replaced by a new soon-to-be stepfather; thirteen-year-old Annabel's tomboy styling and hockey game with seventeen-year-old Anna's rock styling and band competition; and Tess (Jamie Lee Curtis) is not an unappreciated housewife but a professional mother who's lost her cool. *Freaky1* raises a range of questions about cultural change through the differences between Annabel and Ellen, but such change is almost invisible in *Freaky2*. In line with Anna being older, the romance plot is also more developed, not only for Tess-in-Anna's body experiencing the thrills of young love once more but also for the sexual challenge of Anna-in-Tess's body interacting with a man she is about to marry. Making the mother's love interest not the daughter's father displaces the incestuous possibilities of *Freaky1*, in which the danger of not resolving the body-swap before daughter-in-wife and husband are alone is immanent but never declared. It also, however, allows mature love to be represented as sexually active and in a Disney film this demands Anna be over sixteen and the age of consent.

While in *Freaky1* the primary lessons were learned by Annabel – that she is pretty, how to appreciate her mother, how to talk to boys – the primary lessons in *Freaky2* are learned by Tess. Anna-in-Tess's body experiences a field of adolescent excitement long lost to her, while Tess-in-Anna's body brings an outdated and irrelevant prudish reserve to Anna's life, which at best results in a new wedding-appropriate outfit and

the capacity to forgive her mother for remarrying. In *Freaky2*, adolescence offers urgent and multiple opportunities, while adulthood offers so few they must be seized whenever available. This theme is established early in the film through Christina Vidal's 'Take Me Away', the central refrain of which – 'Don't wanna to grow up / I wanna get out' – speaks as much to Tess's story as to Anna's. Both films expose the freedom and losses of adult life and the freedom and obstacles of adolescent life, and they recall adolescence as a place where one was still choosing who to be. Tess closes the opening conflict scenes with the anxious imperative, 'Bye honey! Make good choices!' The relegation of possibility (without power) to adolescence is integral to modern discourses on adulthood as well as adolescence, and thus to institutions like the nuclear family that are supposed to produce both adolescence and adulthood by defining the relations between them.

The adolescent/adult body-swap subgenre clearly involves a metaphor for adolescence itself. It includes films like *Big* (1988) and *13 Going on 30* (2004), clearly directed to adult more than youthful audiences by their emphasis on the obstacles and losses of adult life. The emphasis on what adults can relearn from adolescence in *17 Again* (2009), however, along with its starring role for Zac Efron, clearly marks it, like the *Freaky Friday* films, as a teen film.

There is, however, more than one kind of teen film that plays openly to an adult audience. The retrospectivity of films like *American Graffiti* (1973), *Grease* (1978), and *Stand By Me* (1986) is quite different from the body-swap films.[4] The teen film for grown-ups is thus not a subgenre but a strategy, one that complicates the point of view within teen film by overlaying adult and teen roles. It takes comic forms, like the 'Wayne's World' series (1992; 1993), as well as dramatic ones.[5] Some films use this doubled perspective to represent not only the symbolic power of adolescence but the oppressive expectations captured in its idealization. *Almost Famous* (2000), written and directed by Cameron Crowe, centres on William (Patrick Fugit), whose mother has arranged for him to skip so many school grades that he's unaware of a substantial age difference between himself and his classmates until puberty makes it obvious. When his sister accuses their mother of having robbed William of adolescence, she replies 'Adolescence is a marketing tool.' But the film continues to amplify its significance.

Taunted by his peers with a sign that reads 'William Miller is too young to drive or fuck', William resolves to skip adolescence entirely, taking up a role as a freelance rock journalist and leaving home on tour with the band Stillwater. But because Stillwater comprises twenty-something adolescents experimenting with identity, art, and irresponsibility, William ends up negotiating adolescence after all. *Almost Famous* is heavily invested in components of teen film but the age difference that leaves William always less desirable than the lead-singer Russell (Billy Crudup) stands in for a generation gap between the film's ideals and contemporary adolescence. *Almost Famous* is a nostalgic story about the music and youth of 1973, which William remains on the edge of, looking in. It is thus different from nostalgic

teen films like *American Graffiti* and *Grease*, where the protagonists are the point of nostalgic identification.

But neither nostalgia nor regret is necessarily required for the teen film for grown ups. The doubled adolescent/adult protagonist can be appropriated into melodrama in ways that allow for an adult point of view which is not an outsider one. My example is the 1993 drama *What's Eating Gilbert Grape?* As I will discuss further in Chapter 8, cast and crew bring particular associations to a film – in this case an array of teen film credentials that shaped its expected audience as well as performance and direction. Swedish director Lasse Hallström was best known in the US for the art-house adolescent drama *Mitt Liv som Hund* (*My Life as a Dog*, 1985). And Gilbert is played by Johnny Depp, who came to this role from the hit teen TV series *21 Jump Street* (1987–90), and then the successful teen gothic romance *Edward Scissorhands* (1990). But the diverse audience invited by art stylings and unconventional setting does not impede its central rite-of-passage/coming-of-age narrative.

Gilbert is stuck in his small home town of Endora as principal bread-winner for a family dominated by the disabilities of his mentally retarded brother Arnie (Leonardo DiCaprio) and his morbidly obese mother. Gilbert's adolescent angst is thus distinguished from the suburban middleclass-ness of much teen film; but then so was Edward's in *Edward Scissorhands*. *What's Eating Gilbert Grape?* works at a tangent to the usual teen narratives about maturity because Gilbert already has serious responsibilities. But exactly this limitation on his potential mobility chafes at Gilbert. He is trapped in an uninspiring job at a failing store, a frustrated parent figure and the diffident lover of an equally frustrated married neighbour. Gilbert's adolescence is starkly contrasted with that of his brother. While Gilbert's style says alienated adolescent, Arnie's says happy rural boyhood. Arnie's family had never expected him to live past ten but as the film opens he is about to turn eighteen. This attainment of majority is bitterly ironic. Arnie is definitively going nowhere despite having learned by rote to say 'I could go at any time.' The equally rote lines repeatedly exchanged between Gilbert and Arnie are, on Gilbert's side, both loving and despairing: 'You're not going anywhere'; 'Gilbert's not going anywhere. We're not going anywhere.'

Gilbert's frustration is finally exposed by the arrival of Becky (Juliette Lewis), stuck with her mother in dead-end Endora until their car is fixed. Becky is the insightful alternative girl to Gilbert's angst-ridden loner. As in *Donnie Darko*, young love finally brings about a catharsis. Gilbert brings Becky to meet his mother, who afterwards determines that she will go upstairs to her room, a climb she's felt unable to make for years. And there she dies. Knowing she is too big to be removed without a public spectacle, Gilbert burns down the house. *What's Eating Gilbert Grape?* closes on the suggestion that they're all now going somewhere despite remaining in Endora, with Gilbert and Arnie on the highway waiting for Becky to return. The film demonstrates that the melodrama of adolescence remains metaphorically available to diverse audiences.

As the rite-of-passage model suggests, the transitions of adolescence leave adolescents stranded between categories, functions, and meanings. As *liminal* in this sense, adolescence is both transitional and a non-place. As Martin (1994: 68) puts it: 'In one way or another, most teen stories are about what cultural theorists call the liminal experience: that intense, suspended moment between yesterday and tomorrow, between childhood and adulthood, between being a nobody and a somebody, when everything is in question, and anything is possible.'

This idea of liminality is derived from anthropologists like Victor Turner's work on adolescents undergoing rites of passage in 'primitive' societies. The liminal adolescent is neither child nor adult, and has no clear social role except in being neither and both these things: 'This coincidence of opposite processes and notions in a single representation characterizes the peculiar unity of the liminal: that which is neither this nor that, but both' (Turner 1967: 99). At the same time this no-place is also a utopia (literally 'no place'), a fantasy of freedom and possibility based on the contradictions of the present.

Kids Today: Realism and 'Teen' Film

The teen film for grown-ups obviously overlaps with films that are not teen films at all. A genre label is only conceptually useful because some things are outside it and teen film's cohering themes require that a film do something more than represent adolescence. In the continuum from puberty documentaries for pedagogical purposes to films with adolescents used as local colour, there are films that are centrally *about* adolescence but look *at* rather than *through* that experience. In this section I want to turn to films that only problematically work as teen film because of their objectifying distance from adolescent experience. My central example is Larry Clark's 1995 film *Kids*, which I will contrast with two other films that claim to approach adolescent experience from a realist point of view: *Fast Times at Ridgemont High*, and *Saturday Night Fever* (1977). Teen films are often marketed as being realistic, and very often this marketing strategy claims that teen film in general is *not* realistic. Such claims are often made extra-cinematically, in promotion and commentary on the films, for films that otherwise have quite straightforward relationships to teen film as a genre.

Kaveney gives the example of Luke Greenfield's *The Girl Next Door* (2004), in which a high-school boy falls for a beautiful girl who turns out to be a porn star. Kaveney claims Greenfield sees *The Girl Next Door* as dealing with issues 'too serious to be pigeon-holed in what he sees as a lightweight genre' (Kaveney 2006: 158). In general, however, Greenfield's representation of this distinction is far more ambivalent. He refers to his film as an unconscious homage to *Risky Business* (1983), which he describes as 'flawless'. He praises the 'realism' of John Hughes and *Fast Times at Ridgemont High* but he distances *The Girl Next Door* from the teen sex farce re-popularized in *American Pie* (1999) in ways that do also dismiss

teen film in general (Epstein 2004). This lays claim to an audience in a strategic attempt to make a teen film for grown-ups: 'it was important for us to get audience members of all ages to feel like they're 18 again' (Greenfield in Gilchrist). *The Girl Next Door* is very strictly a teen film despite stretching the content of prom to include porn stars. Like *Almost Famous* and *What's Eating Gilbert Grape?* this is a film about the importance of adolescence for those who feel they've missed out on it.

In explaining the difference between teenpics and other films about adolescents, Doherty (2002: 76) stresses 'tacit respect' for youth culture and adolescent life. While my definition of teen film is broader than Doherty's this is a point on which we agree. Teen film is sympathetically located in the world of adolescents. One of the most exemplary teen films in this respect is *Fast Times at Ridgemont High*, based on a script by Crowe and directed by Heckerling. While it includes fantasy scenes, *Fast Times at Ridgemont High* is committed to a documentary tone. As scriptwriter, Crowe took a journalistic approach starkly opposed to the later semi-autobiographical *Almost Famous*. Crowe left *Rolling Stone* to conduct fieldwork for the book, passing as a teenager in a Californian high school. 'A year's worth of observed and overhead language, fashion and lifestyle choices form the content of the Teen Like Me expose, *Fast Times at Ridgemont High*. The book quickly became a movie.' (Bernstein 1997: 13–14) Heckerling's innovation of the high-school 'anthropology shot' discussed in earlier chapters draws on and reinforces this tone. The first such shot, however, actually surveys a mall, observing youth styles of life and work. *Fast Times at Ridgemont High* focuses on the detail of adolescent life, from bedroom posters to boring jobs to graffiti. In one key scene, as Stacy (Jennifer Jason Leigh) is escaping her home for a date with an older boy on which she will lose her virginity in a graffiti-filled dugout, 'WASTED YOUTH' is spray-painted on the wall behind her.

Anthropology of adolescent life is also offered in earlier films, if with different emphases. The post-title sequence of *Saturday Night Fever* might be approached in this way. It echoes the opening of *West Side Story* (1961), a narrative that *Saturday Night Fever* both shifts east and reverses angle on. The film opens with a long establishing shot of the Brooklyn Bridge, drifting in along the bridge into Brooklyn, its smooth entry first cut by a train going in the opposite direction and then replaced by a close up of a man's shoe.[6] Our first shot of Tony (John Travolta) doesn't give us his face but his rocking hips, which stop, paint can in hand and in frame, to compare his own fashionable shoe to the one in the window. The significance of the heel height on Tony's shoe is an obscure detail for later viewers, but we cannot mistake Tony's investment in his own style. The disco rhythm puts the viewer in Tony's shoes in a literal sense and the camera has firmly aligned us with Tony before we pan up to his face. Only after an extended picture of Tony as lord of his streets – the famous sequence backed by the Bee Gees' 'Stayin' Alive' (1977) – do we see the contexts other people have for him: the paint-shop employer waiting impatiently and his family's disappointment. The only context Tony thinks matters is in the

mirror upstairs, where his fantasies of power and glamour intersect dreams of the disco and the action hero posters on his walls. Tony rules both the disco floor and his young friends, who are all looking to find meaningful post-school lives. But these can't break Tony's dependence on home and a boring job and they can't win him Stephanie (Karen Lynn Gorney), an office worker with pretensions to Manhattan sophistication.

Directed by John Badham, *Saturday Night Fever* had a longer than usual screen life because Travolta's success in *Grease* the following year led to the film's re-release in an edited version directed at a younger audience (Chapter 7). In the elements I have stressed here it is conventionally a teen film and its reference to sex and violence are not outside the general terrain of teen films. Its stress on frustration, limitation and deflated ambition takes up themes from the j.d. films and is incongruous only in being framed by a dance competition. However, teen dance films before and after *Saturday Night Fever* have often used a class narrative to frame the dramatic taste conflicts of learning to dance *together*. The conflict between Tony and Stephanie is centrally over – as Clarke et al. would have it the same year in England – the way style is used to negotiate class destiny and mobility. Disco is their shared escape from offices, gangs, and paint stores.

Saturday Night Fever contributed to a re-emphasis on gritty realism that inflected films like *Fast Times at Ridgemont High*. Its narrative of young class consciousness and stylistic mobility is based not on the score for which it became famous but on adaptation of a *New York* magazine article by Nik Cohn. 'Tribal Rites of the New Saturday Night' was originally framed as reportage, if not ethnography:

> Over the past few months, much of my time has been spent in watching this new generation. Moving from neighborhood to neighbourhood [sic], from disco to disco, an explorer out of my depth, I have tried to learn the patterns, the old/new tribal rites ... Everything described in this article is factual and was either witnessed by me or told to me directly by the people involved. Only the names of the main characters have been changed. (Cohn 1976)

In 1994 Cohn admitted the piece was fictional, in fact amalgamating his knowledge of British mod subculture with New York disco night life (LeDuff 1996), but the film retains its claim to realism through its sympathy with adolescent desires. This is where *Saturday Night Fever* offers an interesting comparison to *Kids*.

Kids was released by Shining Excalibur Picture, a subsidiary created by Miramax for this project because its parent company, Disney, does not release NC-17 films. The controversy over *Kids* reflected in this detail centres on the spectacle of kids involved in casual sex and crime (including drug use and street violence). These were not shockingly novelties for teen film but *Kids* represents its central kid, fifteen-year-old Telly (Leo Fitzpatrick), as entirely unchecked by morality or any other authority. Thus far, some parallels with *A Clockwork Orange* seem possible.

But while he acknowledges illegality at some points, no authority even gives Telly pause. Throughout the day on which *Kids* centres, Telly and his friend Casper (Justin Pierce) move between public, private, and domestic spaces in New York searching for drugs, friends, skating, food, parties, excitement and, at least for Telly, sex with virgins. Telly has decided that virgins give him a greater feeling of seductive power as well as protecting him against sexually transmitted disease. This leads to the film's other key narrative because Telly has given HIV to a previous virgin conquest, Jenny (Chloë Sevigny), who is searching for him to tell him so. Jenny's search leads her through public and private spaces in which she tells fragments of her story and provides an audience for stories about Telly's reputation. When she finds him he's already having sex with another virgin and, stoned and defeated, she passes out, only to be raped by Casper.

As both Telly and Jenny have HIV their stories are framed as going nowhere. While *Kids* is a teen film at the level of raising the 'Whatta you got?' question, it seems to have answered 'What's it gonna be then?' in advance. The maturity question is remarkably closed both in terms of what would count as maturity and whether anyone can achieve it. Scriptwriter Harmony Korine was only twenty-two when *Kids* was released and much publicity around the film prioritized Korine's age, as well as the inclusion of untrained actors in key roles, as verifying the realism of its grim portrayal of contemporary teen life. Korine sees *Kids* as teen film – as one part of a filmic attempt to portray 'adolescence from every angle' (in Womack 1995: 69). Clark himself claims he made *Kids* for 'parents *and* kids' (in Womack 1995: 70), although this is clearly a defence against censorship: 'If you do your job as a parent', Clark expounds, 'there will always be this little voice in your kids' heads telling them they have a choice' (in Womack 1995: 70).

While teen films are often thought to reveal what contemporary adolescence is really like they more clearly uncover, including in their repetitiousness and exaggeration, fantasies attached to adolescence. Considine acknowledges the complexity of assessing teen film for its realism: 'the images we see, the plots we encounter, the recurring themes and motifs that unfold, reflect not simply the views and values of the audience, not only the attitudes and ideas of the film creators, and not just the social conditions of the day, but an intricate and interwoven association of all these factors' (Considine 1985: 11).

This rightly gives priority to any film's presumed audience, and I want to reconsider here what it means to think of this relation as 'exploitative'. *Kids* is an exploitation film but what it exploits is anxiety about youth. Its extensive coverage in art magazines not only reflects Clark's standing as a photographer but the film's objectifying tone.

Kids rewrites the 'youth problem' film for late twentieth-century moral panic, promoted with a blurb from the *New York Times* calling it 'A wake up call to the world.' This is not a description of the audience – *Kids* clearly appealed to many kids – but a mode of address. That the 'language of the kids is so raw it bleeds'

(Womack 1995: 66) is a promotional device used for youth exploitation films ever since the j.d. film emerged. *Kids* resembles in this way not only *Blackboard Jungle* (1955) but also sensational anti-drug films like *Tell Your Children* (1936, re-released in 1973 as *Reefer Madness*). But the mythology of *Kids* is more tightly bound to documentary claims. While the main actors were all 'discovered' for *Kids* in various ways, including through traditional casting, casting from the street (which had been used in many films before, including *Blackboard Jungle*) was particularly emphasized in promotion. Fitzpatrick acknowledges this as a marketing strategy: 'I think that was part of the distributor's scheme. Miramax didn't introduce the actors at any of the screenings. That's why a lot of people thought *Kids* was a documentary.' (in LaBruce 2005).

Despite Clark's declared ambition 'to make the Great American Teen-age film' (Cohen 1996), *Kids* objectifies its teens as a public threat, often using the spectacle of underage drug use or sex as narrative enough in itself. While Clark stressed that every word and pause in the film was scripted, the film aimed for a documentary style, from its use of camera movement to its stylized naturalism. Unlike the young thugs of *Blackboard Jungle* or *A Clockwork Orange*, nothing counters the kids in *Kids*. They occupy a dystopia in which modern adolescence in fact does not exist because there is no institutional context for the experience of youth – no parents, no school, no limits except those established by its version of youth culture. Telly wanders his world spreading seductive harm, unchecked except by a doom he can't see. In an incisive overview of the moral difficulties of *Kids* for several critics, Shary (2002: 233–4) describes it as 'a radical revision of the teen sex-quest' stories of many party films and the 'sexually curious teen characters' of PG-13 films. The fact that Telly never knows about the repercussions of his actions and is allowed a triumphant closing voiceover, makes his declaration that he doesn't care about the future very different than Tony's in *Saturday Night Fever*.

Like all teen film genres, the youth problem film deploys a range of stereotypes that make it as comforting as it is confronting. Despite its emphasis on realism, the youth problem film operates at a distance from the material conditions of most youth as great as any high-school comedy. Only a particular kind of adolescent problem fits the j.d. formula. This formula continues, for example, to overwhelmingly centre on boys. If *American Graffiti* and *Stand By Me* were clearly boy-centred films it's difficult to imagine the differences needed to construct a girl-centred narrative that resembles *A Clockwork Orange* or *Donnie Darko*. *Kids* in fact emphasizes this distinction in that Telly and Casper are the problem in ways Jenny is not. Where there are girl delinquent films, like *Foxfire* (1996), these generally overdetermine girl delinquency as a reaction to personal situations, like domestic or sexual violence, rather than as a demand for an answer to questions like 'Whatta you got?' or 'What's it gonna be then?'

In teen film, adolescence, like its central maturity question, must remain open. The modern adolescent – defined by the institutions of post-pubescent minority, high

school and the extension of dependence for the purposes of training in citizenship, the psychologized nuclear family, and commodified 'youth culture' – is categorically in process and unfinished. Teen film in this sense is not 'American', however usefully available US examples continue to be. Teen film as we know it coalesced out of modern ideas about adolescence in relation to the new cultural forms and practices that constitute cinema. There is nevertheless not one audience for teen film, which is a broad field unified by questions rather than statements. Among those questions, teen film is consistently interested in asking about whether teen film can really represent adolescence, whose adolescence, and for whom.

Part III
Liminal Teen Film

–7–

Classification

Dave: With no power, comes no responsibility. Except, *that* wasn't true.

Kick-Ass (2010)

The three chapters that make up the final part of this book involve a change of direction. Instead of overviewing the genre and scholarship and commentary on teen film, this third part aims to be more speculative. While the first two parts discuss historical questions about the genre and the genre's conventional motifs and strategies, in this final part I want to ask if those approaches really exhaust the question of what teen film is.

This chapter asks what would happen if we tried to argue that, instead of being defined by themes or styles, teen film was primarily a product of film censorship and classification. Such an approach would not give up historical thinking about teen film because the institution of, and renovations to, systems for monitoring the distribution of film have been crucial to that history. It wouldn't ignore the core thematics of the genre, like coming-of-age, rites of passage, and the interrogation of maturity, as these are central not only to what is classified but how that classification works – they are ways of talking about what adolescents are supposed to be, want, and know. But it would approach both of these discussions from a different perspective. From this perspective, not only does defining film as 'teen film' belong to a set of definitions of adolescence as a social problem in need of management, it is a pedagogical form, for which 'teen' is the one in need of training.

Ratings and the Teenage Question

In 2010, the new release *Kick-Ass*, directed by Matthew Vaughn, incited controversy over its representation of age, maturity, power, and ethics, giving fresh visibility to the presumptions that underlie film classification. Before turning to a description of the international field of film classification within which teen film needs to be contextualized, I want to use *Kick-Ass* to sketch the way social concerns represented in these systems map onto the conventions of teen film.

The central characters in *Kick-Ass* are minors – a high-school student and an eleven-year-old girl. As the key protagonists of a superhero film it matters that they

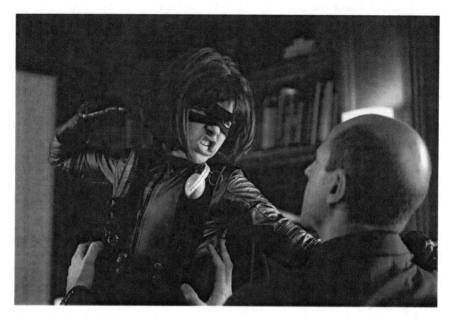

Figure 7.1 Hit-Girl (Chloe Moretz) takes revenge. *Kick-Ass* (2010). Director, Matthew Vaughn. Courtesy of Marv Films/The Kobal Collection.

are not supernaturally distanced from ideas about everyday adolescence like the teenagers in *Spiderman* (2002) or *Akira* (1988). *Kick-Ass* does not use the surreal violence typical of superhero narratives but instead that typical of a contemporary blend of martial arts and action-hero movies, including in its representations of injury and death. The most generically action-hero scenes centre on the eleven-year-old Mindy/Hit-Girl (Chloe Moretz, Figure 7.1), while Dave/Kick-Ass (Aaron Johnson) is primarily courageous rather than a skilled fighter.

At eleven, Mindy is right at the beginning of dominant contemporary ideas about adolescence as articulated by an international field of film classification systems. This field situates films in relation to a conception of majority as the end of adolescence (both its goal and its termination). This gives social and even legal centrality to teen film in understanding how film does and should relate to culture more broadly. Majority is a legal specification that does not equal the cultural markers of adulthood. While adolescence is supposed to move towards the more amorphous cultural meanings of adulthood this has a very unclear relation to the many fragmented limits that make up majority. Voting age is generally not the same as the dominant age of sexual consent, for example, and other recognitions of agency arrive at various points within and between different social systems. Teen film as defined by film classification represents this fragmented liminal state.

There are two central plots to *Kick-Ass*. In the first, Dave decides to become a superhero even though he has no special powers. In the second, Mindy poses as

a superhero in order to distract investigators from private vengeance by her father Damon/Big Daddy (Nicholas Cage) – to make it seem like a public good. These are very different plots for the relation between majority and social agency on which film classification systems depend. Murray Pomerance (2002: 113) offers a useful gloss on social agency, derived from Erving Goffman: 'The adult owns action, if not formally and economically a property then at least morally, and to the degree that his [sic] moves can be taken as indicative of his intent, alignment, and will.' Mindy's relation to majority is problematic because it is aligned with this idea of agency, which categorically cannot apply to her. She has been trained to fight by Damon and, given the legal and social meanings of Mindy's age on a scale where agency is not relative to experience but to demographic categories, like being twelve, sixteen or eighteen, Damon must be responsible for anything Mindy does that is disturbing. Many characters suggest as much and Mindy even teases Damon with the gap between what girls are presumed to do and what he expects from her. Key dimensions of the film's comedy rely on the fact that Mindy seems to be in control when she shouldn't be. Dave instead is drawn into the crime plot that drives the film by his own ingénue heroism; by trying to do the right thing. When Big Daddy is killed, effectively punished for the questionable ethics of training his daughter to kill, it is Hit-Girl who draws Kick-Ass into a revenge narrative.

As with Alex in *A Clockwork Orange* (1971) (Chapter 6), Mindy's age should make holding her responsible for her actions problematic. But when she seems unaffected by the violence she inflicts the effect of this is different from the same lack of empathy in a fifteen year old. In the UK, the British Board of Film Classification (BBFC) classified *Kick-Ass*'s violent scenes as 'presented in a comically excessive manner ... designed to play up the rather ridiculous idea of having trained a young girl to be an assassin.' In the US, film critic Roger Ebert's response was quite different: 'This isn't comic violence. These men, and many others in the film, are really stone-cold dead. And the 11-year-old apparently experiences no emotions about this' (Ebert 2010). Acknowledging that the film was framed as a satire, Ebert implies that it failed to satirize anything at all. In Australia, critics Margaret Pomeranz and David Stratton argued with uncharacteristic heat over *Kick-Ass* along similar lines. Pomeranz defended the film as a refreshing take on the superhero genre. For her, Mindy is 'this 11 year old creature who is sort of like completely, compellingly entertaining and confronting' ('Kick-Ass'). In the exchange between Pomeranz and Stratton Mindy's age was reiterated many times while Dave's wasn't mentioned beyond calling him a 'schoolboy'.

The problem with *Kick-Ass* is Hit-Girl's representation of the relation between film classification and presumed social values. Pomeranz excused the inclusion of an eleven year old who is a foul-mouthed violent killer because she had been warned – the film's rating made it clear that *Kick-Ass* would be confronting. Stratton's repeated concern was 'Doesn't it say something about society ... that we find this entertaining?' But if Mindy's age is the 'this' that shouldn't be entertaining, the

problem with Hit-Girl is also who she is meant to entertain. Ebert's concern is that 'The movie's rated R, which means in this case that it's doubly attractive to anyone under 17. I'm not too worried about 16-year-olds here. I'm thinking of 6-year-olds.' Given that in the MPAA system R means restricted to people over eighteen unless accompanied by a parent this concern reveals a great deal about the relation between teen film and adolescence.

Kick-Ass manipulates the presumptions of film classification systems, which represent adolescence as a sequence of accumulated maturity. Teen film routinely dramatizes and questions this sequence. In the case of *Kick-Ass*, the maturity narrative around Mindy is somewhat residual – she seems so much older than her age that she almost qualifies as the not-child of horror movies (Chapter 5). Dave's ingénue role is more typical of the high-school-based teen films *Kick-Ass* wants to intersect with superhero and action films. He is a blend of experience and naïveté, moving along a teen film developmental trajectory that maps onto content described by the ratings systems as the work of becoming mature – paradigmatically from thwarted desire to a triumphant sex scene. The fact that *Kick-Ass* is clearly a teen film made the question of its rating both complicated and important.

There is not one ratings system in the trans-national mediascape in which most teen film is distributed. There is not even a common ratings system linking the US and the UK, where *Kick-Ass* was jointly filmed and produced. In August 2010, the available international ratings for *Kick-Ass* were as follows:

Argentina:16 | Australia:MA | Brazil:18 | Canada:18A (except Quebec) | Canada:13+ (Quebec) | Denmark:15 | Finland:K-15 | France:U | Germany:16 | Hong Kong:III | Iceland:14 | Ireland:16 | Malaysia:18 | Netherlands:[12] 16 (re-rating) | New Zealand:R18 | Norway:15 | Philippines:R-13 | Portugal:M/16 | Singapore:M18 | South Korea:18 | Spain:15 | Sweden:15 | UK:15 | USA:R.[1]

Despite differences in labels, these ratings all depend on a conceptual framework mapping what adolescence is supposed to achieve. Asking what content assigns *Kick-Ass* a place within these systems presumes that we know that these classifications are conceptually similar enough to be compared. To consider whether this is the case, Table 7.1 overviews some widely released films discussed in other chapters as they are rated across selected systems.

These systems are broadly designed to restrict access to images of sex, crime, and violence, along with ideas and language deemed too 'mature' for the age bracket excluded.[2] Maturity implicitly means being able to contextualize un-citizenlike or prohibited behaviour. In the case of most sex and many drugs this means prohibited for a certain age group rather than in general, but the 'mature theme' criterion depends on a very varying set of social expectations rather than any legal prohibition. Negotiating maturity in relation to norms and laws, film classification depends on an idea of adolescence, helps construct and monitor that idea, and repeatedly reinstalls

Table 7.1 Film classification. Ratings refer to cinema releases. A dash indicates that the film was banned. Alternatives after a slash are re-ratings. Blank spaces indicate that a rating is unavailable, not necessarily that the film was not released in that country.

Film	USA	UK	Australia	Norway	France	South Korea	Hong Kong
Rebel Without a Cause (1955)	A/PG-13	X(cut)/AA / PG	M	12	16/U	15	
Grease (1978)	PG	A/PG	PG	12/7	U	12	
The Breakfast Club (1985)	R	15	M	L	U	15	IIB
American Pie (1999)	R	15	MA	11	U	18	IIB
Akira (1988)	R	12/15	M	14	12/U	15	
Scream (1996)	NC17/R	18	MA	15	16	–/18	IIB
Freaky Friday (2003)	PG	PG	PG	7	U	All	
William Shakespeare's Romeo + Juliet (1996)	PG-13	12	M	15	U	15	IIA
Bride and Prejudice (2004)	PG-13	12A	PG		U	12	I

it as the process of coming to citizenship. It manifests in a benchmark system that distinguishes absolutely between minority and majority and yet complicates it at the same time. This set of arrangements is in fact part of the historical emergence of teen film and clearly also attests to the transnational distribution of ideas about adolescence along with those about film. This last point is one that I address in chapter 9. In the remaining sections I am more particularly concerned with the developmental ladder underpinning and produced by these systems. This ladder represents both teen film and adolescence as a scale of increasing maturity, but this maturity is a very particular image of what a citizen should have learned and been equipped for.

Cinema Markets and the Limit Experience

The US dominates scholarship on film classification and censorship, although it was not the first or always the most influential system. If none of the available histories consider the relationship between adolescence and film censorship in any detail there are also no extended comparative histories. Discussions of film censorship, whether starting from the position of film studies or policy studies, tend to have a national frame of reference and to approach the classification question ('should this be seen and by whom?') without reference to the idea of development on which it depends.[3] It's true that 'by whom?' in these systems is determined in part by national citizenship but the developmental model is not about citizens but about citizens-in-training. Classification takes as its object not only film but also adolescents, whose permissible knowledges (rather than practices) it is designed to determine and monitor.

The US MPAA classification system appeared in 1968 but has an influential pre-history. This is carefully outlined by Thomas Doherty (2007) and Jon Lewis (2002), whose books on teen film are followed by books on censorship, although unfortunately without much dialogue between the respective ideas of censorship and adolescence. While I've referred to this history in previous chapters I want to consider here the historical relation between teen film and film classification, drawing in general on Doherty and Lewis.

In 1930, the MPAA established the Production Code, in 1934 forming the PCA to enforce the Code among members. This was technically voluntary, and the MPAA has never been a state authority. But as both theatre owners and distributors were active participants the Code had real authority when studios and theatres were owned by the same companies. Moreover, before the Code a plethora of authorities had actively monitored films under law and in public debate. Individual states had their own censorship systems which meant there might be several different versions of a film cut to suit particular objections. In the midst of these conflicting demands the Code was a sound commercial proposition and the classification system continues to

have this defensive role for the film industry. And protecting film through claims to protect society always privileged claims to protect the young.

When the 'Paramount decree' of 1948 applied anti-trust laws to the US cinema industry and ruled that film production companies could not own distribution companies and picture theatres the security provided by the Code was immediately threatened (Doherty 2002: 12–18; Lewis 2002 : 103–4). Closely tied to political intervention in film content (by the famous HUAC commission but also religious groups), the legislation based on this decision also extended 'free speech' to film. It is from this position that the film industry, as well as groups more directly concerned with the governance of adolescence, sought new ways to manage the distribution of film content.

The prolific and varied uses that adolescents make of media in *Kick-Ass* comes together with their fascination with superheroes in the film to recall a related stage in the history of censorship – the 'Comic Book Code' (CBC). This was a tight set of regulations for what could and could not be represented in American comics, drawing heavily on the Production Code.[4] In the superhero movie, drawing on comics shaped by the CBC, virtue battles vice, and if some superheroes are ethically questionable the genre's use of fantasy and the gothic clarifies that standards for ordinary behaviour are necessarily different. The CBC worked on the presumption that adolescent readers learned from the behaviour of talking ducks and dark knights and particular conventions appeared in response to the code as clearly as the juvenile delinquent and the bobby-soxer romance were responses to the Production Code. The 1968 replacement of that Code with a classification system that segmented the adolescent audience into different types of adolescents similarly both allowed and inspired new types of teen film directed to more specific audiences.

Doherty makes it clear that the ratings code was in part about marketing. It was instituted by MPAA president Jack Valenti at the same time as Valenti was focused on the importance of adolescents to the film audience. Also in 1968, Valenti released audience research clarifying that 'teenagers still filled out the lines at box office windows and older folks still stayed home. The sixteen-to-twenty-four age group made up 48 percent of box office admissions; 54 percent of that group were "frequent moviegovers," a number that rose to 78 percent when only the sixteen- to twenty-year-olds were considered ... [It] also pointed up the fascinating fact that the more "adult" films have become, the more they appeal to teenagers' (Doherty 2002: 188).

This appeal, as well as the problem the MPAA system aimed to address, belonged to new public ambivalence about youth. In *Generation Multiplex*, Shary (2002: 6) makes only passing reference to the 1968 scale, but links it to fresh uncertainties around the distinction between youth and citizen in the US, including the establishment of a national voting age of eighteen in 1971 and the visibility of young soldiers in Vietnam.

The MPAA scale began with four terms: G (general), M (mature), R (restricted to people over sixteen), and X as a warning for explicit content, a label that could be self-applied but restricted films to people over sixteen. These ratings were adjusted in 1970, 1971, and 1972 to settle on G, PG (for parental guidance recommended), R (now designating over seventeen) and X (now also a limit at seventeen). PG-13 was not added until 1984 and the principal early change was the removal of 'M'. As the *New York Times* put it at the time, 'Many people thought the word mature automatically rules the film out for children. Some pictures with that rating could have been Disneys' (Thompson 1970: 46). The replacement of M with PG reveals an important slippage. The difference between a designation of maturity and of adulthood was unclear to audiences for whom those concepts were equivalent aspirations. Uncertainty about the relations between children and maturity was also obvious when the X classification was replaced with NC17, meaning no 'children' under seventeen, although later amended to read no 'people' under seventeen.

As Doherty's (2002) history of 1950s teen film in the US suggests, there are close ties between changes in film regulation and developments in the teen-film genre. Every significant change in this well documented history can be shown to have commercial imperatives as well as imperatives driven by moral debate in the public sphere. The idea that youth had different cinematic needs became a commercially important one continuous with new fields of youth culture. Nevertheless, we should not reduce the map of audiences produced by film classification systems to a form of niche marketing. All film classification systems involve complex interactions between public debate, commercial and aesthetic aims, trans-national trade and production networks, and specialized as well as popular discourse on adolescence. Buffeted by such varied and often contradictory forces, these classification systems are all also unstable.

The UK's centralized film censorship authority, the BBFC, was established in 1912 and was a model for the US Code as well as for others, including the 1917 Australian system. At the same time as the US Code was being invested with new power in the 1930–4 period, the BBFC introduced its first system of ratings advice in the addition of an 'H' category for horror films, introduced in 1932 and designed to warn parents about 'unsuitability' for children. In 1951, the BBFC added an X certificate legally enforcing an age limit of sixteen for restricted films, which is the origin of the MPAA's early X classification. Stressing these interactions makes it clear that such systems are a transnational dialogue. In 1971, in the wake of the new MPAA code, the BBFC expanded its certificates to classify films as U, A, AA (explicitly described as for teens), and X for adults. Further changes to the scale in 1982 – to PG, 15, 18 and R18 – and the later introduction of 12 (in 1989) and 12A (in 2002) are also part of exchanges with other national systems as the idea was taken up in various countries. While, in line with the ongoing transnational success of US film, the MPAA ratings system has been very influential it is only one piece of this exchange. A wide range of countries were using classification systems

before 1968, including Iceland (since 1932) and Japan (since 1949). The Japanese system was in fact installed at the insistence of US occupying forces. The UK also used twentieth-century colonial and military occupations as well as trade treaties to spread their classification system, entwining ideas about adolescence and citizenship with expanded markets for their film industries.

There is a worldwide tendency towards increasingly fine-grained classification systems, which represent adolescence as a sequence or ladder from innocence to experience to be guided by the restriction of undesirable influences. Although some nations depend on the classification systems of others, independent film classification systems appear in much of Europe, most of Asia (notably excluding China but including Hong Kong), much of South America, and Australasia. In countries like China that have no classification system there is usually a permit authority that also frames its film censorship in terms of protecting the immature and building the right kind of citizens. A film classification system has been much debated for China as well (Xu 2004; Zhu 2010) in part because such systems are about both economic and cultural trade relations.

The specific genre economy of teen film naturalizes both ratings categories and the desire to transgress them. Many 'unrated' releases on DVD are unrated as a marketing device, promising material that couldn't be screened in a theatre, but in the cinema as well teen film uses this ladder to promise more than the audience is allowed to see – an appeal that, in every sense, only works for teen film, where negotiations around choice, supervision, and restriction are in play. Films in production aim for a rating that names not only an audience but a set of relations to different audiences, some explicitly declared and some implicitly aspirational. Teen films claim an image of adolescence identified with one of two or three classificatory categories but these do not have a single audience.[5] The existence of restrictively rated 'racy' teen films like *Little Darlings* (1980) and *Fast Times at Ridgemont High* (1982) makes sense in no other way (Dresner 2010: 175–6).

The organizing concepts for these ladder systems are now broadly General, Parental Guidance, Restricted, and Adult. This often extends with few variations to include other media, such as television and video games, always with a similar emphasis on what adolescents might and should consume. Although the ladder may have three to six rungs explaining this progression, the greatest consensus appears around limits that map onto, first, the onset of puberty and the beginning of mature schooling and, second, the age of sexual consent, which clusters transnationally between sixteen and eighteen but extends from twelve to twenty-one, more or less the same span as the non-general ratings categories. A few film classification systems still resemble age of consent laws. Belgium, for example, labels films as either for everyone, or for people over sixteen.

The concept of consent is more broadly important to film classification because the ladder system is modelled on it: categorizing experiences according to who is old enough to consent to them.[6] It is thus crucial that the 'Restricted' concept

generally means restricted to (roughly) the age of sexual consent and where the classification system is a voluntary one this is often where the limits become legally enforceable. The fact that puberty, sexual consent and voting age are the broadly shared parameters for the film classification ladders explains one of the things that has been most controversial about them – their focus on sex. Fine distinctions proliferate around and between these limits, however, and the content of these categories generally does not equate puberty with the onset of sexual maturity or the age of consent with access to sexual content. Instead, all of these proliferating rungs on often contradictory ladders are developmental steps within a field of guidance.

Parental Guidance: Learning from Teen Film

The 1968 US classification system was a response to the instability of the preceding censorship system, which was perceived as out-of-date. In its final years this system included a 'suggested for mature audiences' label and, in the year before the ratings were introduced, Lewis (2000: 146) records, 'roughly 60 percent of the films released by the studios carried' this label. When the classification system appeared it was by no means clear that G meant films for children and it was only as parental guidance categories expanded that G was clarified as a category in which films for the clearly 'immature' should be placed. Internationally, guidance categories are not confined to those which use the word, like 'PG' and 'PG-13'. France classified *Kick-Ass* as U, meaning a generally appropriate film, but U 'avec avertissement', in effect with a cautionary notice or, in effect, recommending parental guidance. In the US, the categorization 'R', designating that a film 'Contains some adult material' glosses this statement as follows: 'Parents are urged to learn more about the motion picture before taking their younger children with them.' Indeed, the entire classification system functions in the place of a parent (*in loco parentis*).

The 'parental guidance' categories in all these ratings systems, unlike the 'age of consent' ones, are entirely unenforceable and not meant to be. They name a zone of anxious judgement calls that is completely unsure where guidance ends and maturity begins. Changes to the MPAA ratings in 2007 included published guidelines which revealed much uncertainty around the determination of what constituted 'adult activities' ('CARA Rules Revisions Chart'). Variations in the way the ladder relates to film content are often referred to as if they are always becoming more permissive, for example using the term 'ratings creep'. Table 7.1 also includes examples of reclassification. Considering the 1950s j.d. movies discussed in Chapter 2, the BBFC refused classification for *The Wild One* (1953) until 1967, cut the knife fight from *Rebel Without a Cause*, and rated *Blackboard Jungle* (1955) X until 1996, when it was downgraded all the way to 12. But the assessment of affects and effects used to adjudicate ratings are more complex than 'ratings creep'. A film that appears 'old', such as black-and-white films with outdated fashions and music, cannot be suspected of inspiring imitators among impressionable youth as easily as when new.

At the same time the structure of address built into teen film, which is sympathetic with adolescent experience even if it also dismisses it as trivial and transient, invites treatment as adolescent, and thus restriction. Thus, the ratings for *Bride and Prejudice* (2004) are higher than for the 2005 adaptation of *Pride and Prejudice* addressed to adults, even though both include off-screen reference to underage sex and the latter displays as much sexual activity, in the form of kissing, as the former.

Sixteen Candles (1984) is an interesting case because in both narrative and classification it foregrounds a line between adolescents who need parental guidance and those who might not. It was subject to considerable classificatory uncertainty: initially rated R in the US but re-rated PG on appeal; receiving three different ratings in different Canadian provinces; and re-rated down in both Canada and the UK but up in Australia in order to be screened on television. The US appeal claimed the film's inclusion of nudity, sex and discussion of off-screen sex, drug use, and foul language, was appropriate in context, because that's how adolescents behave and because the negative consequences of such behaviour are represented. But *Sixteen Candles* is not, in fact, a controversial PG judgment. It was released immediately before the introduction of the new PG-13 rating in 1984. 'Parental guidance' is a key theme of the film, which at PG claimed a place in the middle zone of teen film that became awkward only when the PG-13 rating transformed R from 'Adult' to a more advanced form of parental guidance. This is another way of understanding the 'renaissance' of US teen film in the 1980s (Chapter 3). While there were many teen films in the 1960s and 70s there was no PG-13 category to label films as not for children or adults but for some category in between.

Doherty rightly claims that John Hughes made 'a virtual franchise of PG-13-rated and G-sensibility teenpic fare' (Doherty 2002: 201), if only because PG-13 is a definition of what was new about 1980s teen film, just as testing the limits of the Approved rating is what characterizes 1950s teen film. Labelling Hughes 'G-sensibility' draws attention to his films' tendency to moralize about maturity despite their representation of 'risky' behaviour and rebellious sentiment. A comparison of *Sixteen Candles* and *Grease* indicates that sexual content could be packaged into a PG narrative but that the successful containment of adolescent risk within institutions for its management is required to secure it. 'PG-13' is often credited to Steven Spielberg, who suggested an intermediary category in response to complaints about violence in the 1984 films *Indiana Jones and the Temple of Doom* and *Gremlins*.[7] But this is not the whole story. PG-13, designed to be a specific nomination of 'teen' films, was also modelled on the BBFC's AA category, in effect since 1971. And the PG-13 category also responds to new pressure on cinema attendance in the wake of the emergence of home video systems. In a story that strikingly replicates that of teen film diversification in the 1950s in response to declining cinema attendance, in the late 1970s and early 1980s theatrical releases had to find additional appeal for the big screen experience when teen audiences could avoid ratings restrictions and watch a wider range of movies at home.[8]

If PG, PG-13, and R (and their corollaries in other systems) are all teen film, alignment in this teen film zone is often a question of editing rather than larger distinctions between story or style. Films often move ratings categories by editing, as with the re-release of *Saturday Night Fever* (1977) edited from R to PG. What Chapter 6 discussed as a desire for realism within a certain style of teen film was articulated around the border between PG and R before the emergence of PG-13, which took up the task of distinguishing mainstream teen films from 'family' films and accentuating the link between R and realism. Thus, claiming he wanted to make a teen film that would not be teen film at all, Luke Greenfield, director of *The Girl Next Door* (2004), rejects the possibility of a PG-13 version: 'They said we could make so much more money if it was PG-13 ... It was not for tawdriness at all, but for getting the reality. When we were writing the script, we were so careful to keep it real and write it how kids talk. If you went PG-13, you would lose the reality of a normal kid tasting the wild life' (Epstein 2004).

More rungs on the developmental ladder mean more marketing categories with associated limit experiences. A minority of teen films also make it into the adult category with a provocative promise to exceed teen film entirely. In fact, the international importance of the age eighteen also belongs to this guidance narrative. While eighteen is the most common age of majority across democratic states it is by no means universal. Moreover, the history of adjusting the voting age to eighteen internationally, including in the United States, has often *followed* the institutionalization of eighteen as a film classification limit.

The ratings system is a story about training for citizenship. As the dominant shared concepts for the classification ladders stress sexual development sex is evidently crucial to this citizenship. It is widely accepted that the limits for film representation of violence, relative to what would be acceptable in 'real life', are very loose compared to those that limit film representation of sex.[9] This is another element of teen film that *Scream* uses as both ludicrous and serious. Billy climbs in Sidney's bedroom window explaining that he 'was home, bored, watching television, *The Exorcist* was on and it got me thinking of you.'

'Oh it did?'

'Yeah, it was edited for TV. All the good stuff was cut out and I started thinking about us and how two years ago, we started off kinda hot and heavy, a nice solid "R" rating on our way to an NC17. And how things have changed and, lately, we're just sort of ... edited for television.'

Their exchange offers a ratings-derived ladder of sexual activity where 'on top of the clothes stuff' is for general consumption as distinct from the 'raw footage' she's not ready for. It derives its narrative tension at this point from Sidney's father being in the house and liable to check on her at any moment. This security underpins Sidney's offer of a 'PG13 relationship' that permits flashing her breasts but not sex. In fact *Scream* wasn't PG-13 anywhere but its R rating allows display of murder and mutilation while requiring concealment of its one sex scene with a before-to-after cut.

The MPAA claims that its ratings system does not evaluate films aesthetically or morally but it in fact it depends entirely on a claim that there are shared understandings of what constitutes both art and morality among 'American parents' ('Reasons for Movie Ratings (CARA)/About Us'). MPAA ratings are not assigned by professionals, but by a panel of parents selected by the MPAA-designated Classification and Ratings Administration (CARA), charged with rating films 'as they believe a majority of American parents would rate it, considering relevant themes and content' ('Film Ratings' 2010). The emphasis on parents to the exclusion of all other kinds of expertise in classifying films is distinctively American, and warrants further consideration, but parents are part of the rhetoric framing these classifying systems internationally. CARA claims 'Ratings do not exist to cast judgment on a film or dictate the viewing habits of adults. Grown-ups have no use for such an approach in a free society' ('Reasons for Movie Ratings'). Adolescents are presumed to not only need such external judgement but populate a shifting liminal field defined by it.

The *difficulty* of film classification appears in the middle zone described by and describing teen film. In this zone, classificatory categories shift, appear and disappear while General and Adult categories on either side remain comparatively stable. They taxonomize (divide into discrete categories) adolescence but without distinguishing between teen film and *not* teen film. Like the teen film rite of passage these distinctions remain internal to adolescence and help continually construct the adolescent as the subject of guidance in part because the distinctions between maturity and immaturity are rendered more explicitly unclear by this system. This suggests another approach to the importance of sex in institutionally managing adolescence. Historian Michel Foucault's influential analysis of the nineteenth-century production of 'sexuality' includes reference to the institutionalization of modern adolescence. Foucault's discussion of modern schooling's investment in the sex of children in *The History of Sexuality; An Introduction* (1984: 139ff) requires some adjustment to be a helpful tool for analysis of schools today. But it requires no adjustment whatsoever to be applicable to film classification's role in protecting children – including, ironically, many over the age of sexual consent – from sex on screen. But because the emphasis in this argument is on self-management I think another of Foucault's concepts might be more useful for considering teen film as a liminal genre.

Foucault coined the term 'governmentality' to describe the way governance works as a network of systems, institutions and practices that exceeds the state (Foucault 1991a). Film classification systems are as a rule not fully (and sometimes not at all) mandated or regulated by the state. Large corporations, governments within but also working across national boundaries, public groups, religious and other institutions with vested interests in teaching morality, small businesses like cinemas and video stores, local communities, families, media advocacy groups, the many components of film-making, and critics and media commentators, all play

integral roles in these regulatory networks. Governmentality helps us consider 'both the way in which power guides the conduct of individuals and the modern rationality which demands everything and everyone be "managed"' (Moss 1998: 3). However it also acknowledges that self-governance of this kind is something for which subjects must be trained.

One reason for keeping classification as much outside the domain of legislation as possible is undoubtedly to protect the capacity of film makers to respond to consumer interest, sometimes even with an adjustment to the ratings system. But classification also constrains choice. For example, despite being a little shocking, Hit-Girl and Kick-Ass are almost entirely within the realms of that old Comic Book Code. They are the best possible citizens they can be under the circumstances and Hit-Girl in particular suffers for her difference from normative adolescent processes. In fact, Damon and Mindy reinforce the importance of parental guidance – he even watches Youtube clips with her – and verify that modes of citizenship can be reproduced through guidance of media consumption.

Film classification demands and endlessly refines a relationship between genre, audience, and personal and social development that is now intrinsic to adolescence. Coming back to my epigraph, it is these relations between citizenship and pedagogy for which adolescents, without the power to determine representation on such a grand scale as cinema themselves, are held accountable. Thinking about film classification as governmentality allows for the importance of attempts by filmmakers and viewers to shift and evade that classification and the incorporation of their disruptions into that system. Censorship and classification have brought teen film to be the genre it is, repeatedly installing the necessity of particular ideas about adolescence 'through ritual recitation, pedagogy, amusement, festival, publicity' (Foucault 1991b: 60). Film classification systems simultaneously define a marketplace as naturally existing and monitor a narrative about citizenship that explains why and how the legal and social minority of adolescents should be maintained.

–8–

Adaptability

> Chad: Look, you're a hoops dude. Not a musical singer person. Have you ever seen Michawl Crawford on a cereal box?
> Troy Bolton: Who's Michael Crawford?
> Chad: Exactly my point.
>
> *High School Musical* (2006)

This chapter asks if teen film can be defined by its audience – not in the sense of reflecting particular values and expectations but in the sense of referring to a specific marketplace. Rick Altman (2004: 681) suggests as much in a telling quip about the instability of genre labels: 'When is a musical not a musical? When it has Elvis Presley in it.' If Elvis Presley draws a musical into the genre of teen film instead of musicals *per se* this can only be because Elvis is consumed in a different way to musicals. Does teen film thought through its audience thus become a critical version of the joke in my epigraph, intersecting generational and taste distinctions? I've already argued that the relationship between teen film and its audience is not a demographic one. Instead, I want to suggest that teen film is partly defined by generic liminality. Teen film appropriates the conventions of whatever genre might provide a new mix of components for a familiar story about adolescence. And while teen film encompasses the pool of tropes and themes I have discussed in previous chapters it has no definitive style. Its liminality is not confined to narrative, then, but is entwined with modes of consumption prioritized for youth culture. What this encourages in teen film might be called 'intertextuality' or, with more emphasis on marketing, 'transmedia'. This chapter intersects these approaches to consider teen film's liminality under the label 'adaptability'.

High School Musical(s): Inside and Outside Genre

As Jon Lewis (1992: 3) argues, teen films are 'artefacts of youth culture' but this relation is complicated. In comparison to youth-directed music, for example, teen film employs and represents youth far more than it is produced by youth. Doherty claims that the teen film 'receives its marketplace validity' from youth culture, but 'its textual values mainly from' a parent culture: 'To the extent that the solid ground

of cinema can be said at all to "express," "reflect," or "represent" the cloudy realm of ideology, the narrative of the teenpic typically advances the values of the creator, not the consumer culture' (Lewis 2002: 73).

These 'values' are themselves shaped by the history of teen film. This section considers the relation between values and market evident in the teen musical. My key examples are *High School Musical* (2006), a teen film that may not be a film and may not be teen, and *Grease* (1978), a film where the teens are not teens and the youth culture is not youth culture.

High School Musical is a Disney production directed by Kenny Ortega and followed by sequels in 2007, 2008, and 2010. It is possible to argue that it is not a teen film because the series was made for cable television rather than theatrical release (with the exception of the third film, which opened in cinemas). This strongly affects its cinematic style, which in turn accentuates *High School Musical*'s representation of adolescence as closely monitored and explicitly staged, a representation consistent with both its G-rating and its musical format. Cable television also determines its tighter mode of address. Its audience is that of the US Disney Channel after school hours – the channel airs programming for pre-school children during the day – sometimes called 'tweens'.

The category 'tween' is as difficult to pin down to an age range as adolescence itself (Mitchell and Reid-Walsh 2005) but it is definitively *before* adolescence in the way that adolescence is before adulthood, and clearly associated with compulsory schooling before high school and unrestricted media classifications. *High School Musical* keeps its G rating in the foreground, but there are several problems with setting it aside as 'pre-teen'. I have argued that teen film centres on an idea of adolescence rather than on any chronological age. If this is the case then it must be possible for teen film to bleed into generally rated film categories as well as restrictively rated ones. And *High School Musical*'s relation to a pre-teen audience is defined by the sequential and monitored ladder of adolescent experience on which film classification is based. In these senses it must be a teen film.

Gabriella (Vanessa Hudgens) arrives at a new school to discover that the boy she had shared a moving (but very G-rated) connection with over the holidays already attends that school. Troy (Zac Efron) is the school's basketball star. His interest in her leads him to try out for the school musical, much to the consternation of his team-mates, father, and teachers, who are as used to thinking of the kids in terms of categorical types as the kids themselves. Despite resistance from kids who think they are the musical stars of the school, Gabriella and Troy not only succeed but bring the school to accept that no kid has only one possible talent or interest.

High School Musical clearly reprises the 'clean teen' version of the rock/pop musical that Doherty represents as the pinnacle of transmedia merchandising in the 1950s, exemplified by Pat Boone's films in which he contractually refused to kiss on screen (Doherty 2002: 153–4). In the 1950s teen musical subgenre, Boone was the virtuous alternative to Elvis, although the tie-in between film stars and pop music

was equally characterized by both Boone and Elvis. The cleanness of clean-teens is not established by their sale-ability but by teen film elements packaged very carefully for a general audience. The British film *Angus, Thongs and Perfect Snogging* (2008) offers a counter example. It does have kissing, and even representations of sexual desire and its explicit hierarchy of sexual activity problematizes the clean teen status its funding by Disney's rival kids cable channel Nickelodeon would suggest.[1] But if requiring mature parental guidance (12A in the UK, PG-13 in the US), excludes *Angus, Thongs and Perfect Snogging* from being clean-teen, clean-teen-ness is also not equal to a G-rating. It would be possible for Troy and Gabriella to kiss in *High School Musical* without jeopardizing that rating. Indeed, there's a surreal spectacle to the film's avowed 'cleanness' that, in line with the musical form itself, eschews realism. To be cleanly teen, references to sex must not include realistic expectations and the possibility of including them as dramatically staged song makes the musical especially appropriate to clean teens. *Grease*, which packages its sex into stagy musical numbers not only includes kissing but even includes the word 'fuck', although in a comic song and in Italian.

Grease, like *High School Musical*, opens with a holiday couple who will be reunited when the girl, Sandy (Olivia Newtown-John), discovers that the boy, Danny (John Travolta), attends her new school. Danny's persona at school is not the same as the one Sandy fell in love with. At Rydell High he belongs to a gang of tougher boys and dates only girls who fit that image. Despite several failed attempts to fit into each other's roles and expectations Danny and Sandy are eventually reunited when both appear at the carnival closing the high-school year dressed to perform the preferred identity of the other – Sandy in skin-tight black and sultry styling and Danny in a Boone-style cardigan. It's Sandy's transformation that wins the gang's approval, a closure that Timothy Shary (2005: 46–7) sees as a capitulation to conservative gender roles the film associates with 1950s adolescence, although in fact Danny meets her equally prepared to change.

Grease sold its romance as part clean-teen ideal and part sexy makeover fantasy, dimensions emphasized in promotion of the soundtrack and merchandise and in the packaging of successful video hits and teen magazine profiles. While Travolta appeared in this film known from the teen sit-com *Welcome Back Kotter* (1975–9), the spectacular success of his disco-dancing scenes from *Saturday Night Fever* (1977) was also crucial. Despite the restrictive rating of *Saturday Night Fever* the dancing scenes were sold to a broad audience through the growing genre of music television. *Grease* was never as clean as *High School Musical*, always marked by the presence of sex, uncertainty, failure, fear, and, especially, nostalgia.[2] But the unreality of *Grease*, emphasized by the car flying a happy couple off into the sky at the end of the film, undercuts its other layers and, in effect, works to clean its story of too much adolescence.

The teen musical consistently uses song and dance to add narrative complexity. The wave of 1980s US teen dance movies, including *Flashdance* (1983), *Footloose*

(1984), and *Dirty Dancing* (1987), used this more expressionist story-telling to supplement PG-13 romance narratives with more controversial implications. Jane Feuer (2004: 233) suggests these films introduced 'new conventions – the main one being the use of "non-diegetic" rock music over the images.' But the dance sequences also both express and resolve problems, and using music to suggest an alternate story is one of the elements of teen film that crosses cultures. In 'Bollywood' film, for example, where representations of adolescence are often veiled in metaphor (Chapter 9), singing and dancing offer opportunities to raise questions central to teen film that otherwise would be impossible.

If the high-school musical is particularly conducive to clean-teen narratives it is also perfect for broadcast television, where the absence of regulated classification means a more general audience needs to be addressed. *High School Musical*'s intersection of film and television echoes, in some respects, the 1980 hit *Fame*, remade in 2009 after *High School Musical*'s success but also drawing heavily on the *Fame* (1982–7) television series based on the first film. *High School Musical* also largely provided an opening for the hit television series *Glee*, which features singing delinquents, gay teens and pregnant cheerleaders but also focuses on empowering the disempowered by discovering their hidden talents. In fact, Disney has influenced this subgenre more generally because the high-school musical's space of training and tableau draws on the talent show and child prodigy factory of *The Mickey Mouse Club* television series (1955–9, 1977, 1989–94). Understanding how teen film stories are told across this complex field of cinema, television, music, and celebrity is helped by the concept of 'transmedia' promotion.

Marsha Kinder used the term 'transmedia' to discuss the relation between television, advertising, and merchandising, but also referred to film. The *High School Musical* star with an ongoing transmedia life is Efron, who has appeared on pencil cases and posters, on major US television talk and awards shows, and on myriad magazine covers. Disney's most explicit transmedia star-making exercise might be Miley Cyrus, who stars as tween-becoming-teen Miley Stewart, and her alter-ego popstar Hannah Montana, in the Disney channel series *Hannah Montana* (2006–). But this suggests an important caveat because the *teen* star needs to be more specialized, less pervasive and less obviously a franchise commodity in order to work effectively as a story about individuating adolescence. Cyrus exemplifies the conjunction of industries, media, and practices that we call 'transmedia', but she is not presently a teen star because her story is too uniformly sold. Efron's slightly more diverse career, including the sexier body-swap *17 Again* (2009), is more typical of the teen star, as is Lindsay Lohan. Lohan's breakthrough roles included not only *Mean Girls* (2004, Chapter 3), but two Disney roles: *Freaky Friday* (2003, Chapter 6) and *Confessions of a Teenage Drama Queen* (2004). Several Lohan singles from these films were heavily cross-promoted in ways that helped Lohan authenticate *Mean Girls*' status as youth culture.[3]

Kinder understands transmedia as a form of 'intertextuality', a concept she credits to 'Julia Kristeva, elaborating on Mikhail Baktin's concept of dialogism' (Kinder 1993: 2). Kinder cites Bakhtin's 1934 essay directly, arguing that the 'actual meaning' of any 'utterance' (any communication) 'is understood against the background of other concrete utterances on the same theme, a background made up of contradictory opinions, points of view and value judgments' (Kinder 1993: 2, quoting Bakhtin 2002: 281).[4] This *understanding* is obviously not confined to the manipulations of advertising but part of how texts work in general. It is also, as John Frow suggests, how genres work (Frow 2006: 45–50, 148).

Intertextuality describes a field of connections between a text and other texts but not every element of a film's cultural context equally shapes its meaning for an audience. *Genre* explains how some of those connections are guides for the text's interpretation. While all genres work this way one of the characteristics of teen film is that the connections it foregrounds easily slip across media forms, openly taking meaning from peripheral connections like the image of a band whose track plays for just a few seconds in one scene. A teen film text knows it is a transmedia text and that the material it works with is the whole of youth culture. And the transmedia story told by teen film is shaped by the constraints of different media as well. The film *Flashdance*, for example, entered into dialogue with the dance narratives about youth, race and style in Michael Jackson's 'Thriller' video clip via its hit theme song 'What a Feeling' released the same year (Denisoff and Romanowski 1991). But packaging as a single or video for an audience who hadn't necessarily seen the film dissolved *Flashdance*'s class and sex-work narratives. The pastiche strategies of late-twentieth-century horror parodies discussed in Chapter 5 are also examples of teen film foregrounding and strategically manipulating intertextuality. The next section focuses on a version of teen film intertextuality that has generated considerable critical commentary.

Classic Teen: Shakespeare in Teen World

A 2008 special edition of the journal *Shakespeare Bulletin* dedicated to teen film adaptations of Shakespeare includes a forty-five page survey of scholarly work on this subgenre. Jose Fernandez's survey is structured around a very full list of teen Shakespeare films, which I won't attempt to replicate. It includes: passing references to Shakespeare in teen film, such as that to *Hamlet* in *Clueless* (1995); explicit adaptations of Shakespearean plays to teen film, such as Gil Junger's *10 Things I Hate About You* (1999); and the looser use of ideas about youth and youth culture in adapting Shakespeare to film, such as the use of well-known teen stars to play young men still negotiating family dramas and the formation of sexual identity in Gus van Sant's *My Own Private Idaho* (1991).

Shakespeare is a known reference not only for people educated in English liter-ature but people trained in Western history by its embedding in popular culture. Shakespeare is recognized by a vast array of people who may not even know that what they just recognized was Shakespeare. 'Teen film' actually works in a similar way. The gradual generationalization of popular culture across the twentieth century has produced teen film as an audiovisual language for representing youth, so that any film reference to youth brings with it the capacity to 'become' or 'perform' teen film. Not only references to well-known teen film motifs, like high-school corridors and j.d. styling, or references to the core thematics of teen film (the question of maturity, the rite of passage, coming-of-age), but also participation in youth culture can mean a film about adolescence is using or doing teen film. Approached in this way, to name something teen film is always to show how it uses the idea of teen film, and of the teen film audience, sometimes very closely, as with *10 Things I Hate About You*, and sometimes differently, even queerly, as with *My Own Private Idaho*.[5]

The storyline for Baz Luhrmann's 1996 adaptation, *William Shakespeare's Romeo + Juliet* (Figure 8.1), is so familiar it seems almost unnecessary to summarize it. Romeo (Leonardo DiCaprio) is the son of Montague, a powerful nobleman whose family and followers constantly struggle with those of his rival, Capulet. But Romeo meets Capulet's daughter, Juliet (Claire Danes), and falls in love. They secretly marry, but before their love can be revealed Romeo kills Juliet's cousin Tybalt (John Leguizamo) in anger at the death of a friend and is banished from the city. When Juliet's father tries to force her to marry someone else, she fakes her death, only to have Romeo believe she is really dead and kill himself. Juliet commits suicide.

Luhrmann interprets this story first of all as gang war and in this adaptive strategy intertextuality is already at work. Making the rival families rival gangs refers to contemporary US culture of the time – the criminalized racial subtext of the mid-1990s elided from *Clueless* (Chapter 3) – but it is also indebted to *West Side Story* (1961), which was a much looser adaptation of the same Shakespearean play. *West Side Story*, and the image of rioting youths in the streets at the time, also influenced the emphasis on crowded street scenes in Franco Zeffirelli's earlier adaptation, *Romeo and Juliet* (1968). The influence of *West Side Story* on Luhrmann is explicit in the opening cityscape and in the racialization of the gangs as loosely white and Hispanic.[6] But Zeffirelli's influence is also pervasive. Luhrmann's editing of the final stages of the play makes Romeo a far more innocent victim than does the play, a shift accentuated by replacing the disease-filled tomb with a cathedral of light. Zeffirelli had also edited the ending to centre on the actions of Romeo and Juliet and exclude some of Romeo's less justifiable actions. A range of other editorial interpretations are exchanged between this set of films. But, quite without having seen the other films, any audience will take from each of them a connection to current public debate about youth problems and generational divides.

Stylistically, *Romeo + Juliet* is dominated by frenetic juxtaposition of shots, rapid changes of scene, and an intimate relation between these editing strategies and

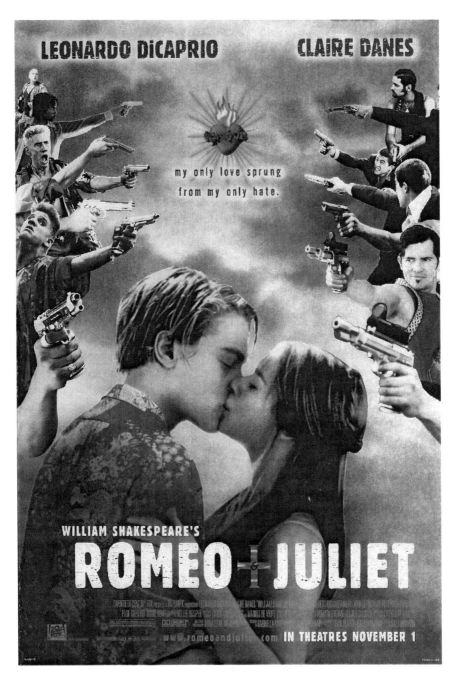

Figure 8.1 Promotional poster used for theatre lobbies, also adapted to promote DVDs, videos, CDs and other merchandise. *William Shakespeare's Romeo + Juliet* (1996). Director, Baz Luhrman. Courtesy of 20th Century Fox/The Kobal Collection.

the score. In commentary this was often explained by references to 'music video'. Music is crucial to *Romeo + Juliet*. The incorporation of narrative and symbolic elements of the play into a soundtrack of popular songs assembles into the film not only music and lyrics, but the extra-filmic connotations of the musical artists used. Even in these respects, however, Zeffirelli's *Romeo and Juliet* is a precursor. It was also promoted as a transmedia text, and its 'Love Theme' was a hit single in several countries. As Deborah Cartmell (2007: 218) argues, Zeffirelli's film 'is unmistakably of its time', obsessively interested 'in the generation gap' (Cartmell 2007: 218) and condemning the 'older generation ... in order to give full expression to the young' (Cartmell 2007: 218–19). It is also broadly tied to the fashion and media culture of its own time (Burt 2002a: 252) through flowing hair and the use of purple chiffon and other fashionable mixes of style, colour and fabric.

Contemporary attitudes to youthful passion underpinned Zeffirelli's casting of younger actors to play Romeo and Juliet than had been used before – Leonard Whiting (Romeo) was seventeen and Olivia Hussey (Juliet) was sixteen when the film premiered – causing significant controversy around the semi-nude scenes, which were part of its claims as an art film. Although Zeffirelli's film was obviously not shot in an 'MTV' style that didn't yet exist it was stylistically determined by contemporary debates around art cinema style, sex, nudity, and impressionable youth that led to the introduction of the MPAA system the same year it was released. It was released with a G rating at the time, despite on-screen violence and a sex scene including partial nudity, becoming one of those films re-rated more restrictively after the classifications shifted in the early 1970s (Chapter 7). The only other option for the film would have been R and the film was not only clearly aimed at youth but, because it was an adaptation of Shakespeare, claimed to have something serious to say to them.

While *Romeo + Juliet* was thus not the first adaptation of Shakespeare addressing a young audience, it was the first, as Emma French (2006: 107) puts it, 'that positions itself towards the teen market in such an exclusive manner in its marketing campaign.' This is heralded in the title, where the authorizing use of Shakespeare's name is supplemented by 'the playful use of the plus sign rather than "and" [which] indicates a desire to abbreviate and update the sacred material' (French 2006: 107). For many commentators this address to youth culture made *Romeo + Juliet* problematic. In a 1998 *Cineaste* 'symposium' of directors who had adapted Shakespeare to film that is effectively a survey on their opinion of *Romeo + Juliet*, Luhrmann defended his stylistic mix of Shakespeare and pop culture as very Shakespearean: 'whatever makes a particular production at a particular moment in time work for that particular audience is "right."' (in Crowdus 1998) This was also his key contribution to the symposium's broad claim that the significance of Shakespeare on film lies in helping audiences learn from Shakespeare. A quotation from Zeffirelli will be representative:

apparently the pseudo-culture of young people today wouldn't have digested the play unless you dressed it up that way, with all those fun and games.

We have to help young people face the past with honesty, courage, and greed, because we learn so much from the past. We live in very dry, very poor times, and we have to go back to when our garden was full of flowers and marvellous fruits, because today our poor plants are sterile, they don't produce anything. Children do learn from the past, because only if you know the past can you properly contemplate the present and the future. (Crowdus 1998: 54)

This defends 'the canon' as especially for adolescents through a curriculum of appropriate human values tightly wedded to the nineteenth-century institutional-ization of Shakespeare in compulsory education. While this should recall the early debates about cinema's educational function discussed in chapter 1 it also, as French elaborates, creates a 'captive audience' for film adaptations of Shakespeare (French 2006: 107; 131).

We might think of Shakespeare's play now as 'Romeo and Juliet' – a series as subject to reinvention as the horror series discussed in Chapter 5. 'Romeo and Juliet' came to the foreground of canonical Shakespeare alongside the emergence of modern adolescence and takes much of its contemporary meaning from modern adolescence as the trauma of identity formation turning around sexual maturity and generational change. Teen film gave visual codes and contemporary cultural reference-points to its central narrative events. Thus the cultural impact of films like *Romeo + Juliet* depends on the same web of media forms used to promote *High School Musical* – as with Figure 8.1, an image adapted to a wide variety of promo-tional purposes.

Before *Romeo + Juliet*, DiCaprio was best known for juvenile and teen roles in TV sitcoms, supplemented by a couple of lesser-known teen films. Although he had also appeared as the mentally retarded Arnie in *What's Eating Gilbert Grape?* (1993; Chapter 6) it was *Romeo + Juliet* that cemented a glamorous movie-star image for him. Promotion of his subsequent role in *The Basketball Diaries* (1995), widely praised as an unglamorous portrayal of j.d. drug culture and street-life, often suggested he had been cast against type, but *Romeo + Juliet* is actually DiCaprio's only major role as a teen romantic hero. Angela Keam discusses also the impact on *Romeo + Juliet* of the extra-filmic 'star body' of Claire Danes, stressing her prior success as alternative-teen soap heroine, Angela, in *My So-Called Life* (1994–5) (Keam 2006: 7). These transmedia images also line up with the pedagogical mean-ing of Shakespeare because much of the 'teen'-directed media across which the film was promoted overwhelmingly understands adolescence as a period of cultural training.

Junger's *10 Things I Hate About You* is a collection of pedagogical narratives united by loose adaptation of Shakespeare's *The Taming of the Shrew*. Cameron (Joseph Gordon-Levitt) is the new boy with much to learn about how the school

works. He instantly develops a crush on Bianca (Larisa Oleynick), but she is only interested in the cruel Joey (Andrew Keegan). While Cameron struggles to learn what will please Bianca and teach her what is valuable about him, Bianca's father Walter (Larry Miller), determined to teach his daughters the dangers of sexual activity, has forbidden her to date until her older sister Kat (Julia Stiles) is dating as well. Enter Patrick (Heath Ledger), who is paid by Cameron and Joey to persuade Kat to date. Bianca must learn that a good-looking popular boy may still be a monster; Cameron, the limits of his intelligence; and Patrick that he, too, can fall in love. Even Walter must learn that Kat is an adult. But Kat has the most to learn, including that past bad experiences do not mean she should avoid and despise boys, and that her cynical attitude, which she and the film understand as feminist, is a shortcoming.

The maturity question centring teen film means many teen film narratives could be rephrased as a series of lessons in this way but *10 Things I Hate About You* presses the pedagogical point harder than most and uses Shakespeare to that end. As with other 'update' adaptations like *Clueless* and *Cruel Intentions* (1999), the classic plot is transformed to represent contemporary high-school life. Junger heavily edits what elements of the play it will adapt, most importantly removing domestic violence and other forms of injustice inflicted on Katherina in Shakespeare. What Kat's feminism doesn't understand in *10 Things I Hate About You* is not, as in *The Taming of the Shrew*, that a woman cannot finally defy her father or husband. What she learns is, however, often also attributed to Katherina in productions and commentary: that all girls want a boy at heart and that there is a boy for every girl. That Patrick learns the same lessons for himself makes all the difference.

While, for Kaveney (2006: 135–6), *Romeo + Juliet* doesn't care enough about teenage life to count as a teen film, *10 Things I Hate About You* is an adaptation of which she approves: 'a modernization of its source material whose games with intertextuality are at times ideological in nature without being heavy-handed' (Kaveney 2006: 119). This counters the dismissal of the same film by Richard Burt, who caustically summarizes it as conservative moralizing: 'Girls ... you can stay a sober virgin, and he'll still be into you!' (Burt 2002b: 206). But neither critic notices the way this film, and the 'classic teen' adaptation subgenre to which it belongs, uses the canon to represent adolescence as a field of transhistorical and transcultural truths in which the audience needs to be educated. French makes this connection with reference to *Romeo + Juliet*, linking the claims to universality embedded in the presumption that Shakespeare is relevant to a 'teen audience' and the promotion of *Romeo + Juliet* in educational terms (French 2006: 108–9). Teen film's openness to adaptation isn't always framed by this pedagogical utility, but the standard process of adapting a classic text for teenagers both embeds the story in contemporary youth culture and draws from comparison between past and present a story about how adolescence works.[7]

Growing up with Harry Potter

Henry Jenkins uses the phrase 'convergence culture' to stress that the field of practices, objects, institutions and industries that make up contemporary transmedia culture opens up opportunities for productive audience participation (Jenkins 2006: 23–4). His *Convergence Culture* (2006) focuses on the activities and contributions of media fans to media production and one of his case studies focuses on young 'Harry Potter' fans (Jenkins 2006: 169–205). He argues that fans' use of the Internet promotes a literacy that extends to the novels, and the other way around, in part via the field of fan fiction.[8] The enormously successful series of 'Harry Potter' films released by Warner Bros doesn't appear in his argument except as a component of the texts' popularity and as a set of legal and commercial interests. And every voice in the debates discussed by Jenkins is invested in what 'Harry Potter' says, or might say, about children. But in this section I want to suggest that the 'Harry Potter' at stake is in fact a teen film text.

While some teen films adapt stories from other fields and genres, teen film is also regularly appropriated to other genres. The 'Harry Potter' film series is a complex but telling example for three reasons. First, the series spans a decade in which much of the enormous audience of the early films passed into and/or through adolescence. Second, the films represent and respond to the progression from childhood through adolescence in the seven published books by J. K. Rowling (at the time of writing two films adapting the last book are in post-production). Finally, the series is supplemented by the significance of adolescence for the 'HP' fandom's many sub-communities.[9]

Teen film conventions are increasingly important to the film series as it progresses in ways that cannot be reduced to discussing the more 'mature', 'dark' or 'gruesome' content of the later books and films. The first film, *Harry Potter and the Philosopher's Stone* (2001) generated considerable uncertainty concerning whether it required parental guidance – the same version even aired on different US cable stations with G and PG ratings. In this film, eleven-year-old orphaned Harry (Daniel Radcliffe) discovers he is a wizard by birth when he is called to attend a magical school. As he is trained in magic he also discovers his family history and the return of an evil wizard who killed his parents. Radcliffe was twelve on the release of this film, and the actors who played his best friends Ron and Hermione were, respectively, thirteen (Rupert Grint) and eleven (Emma Watson). The film stresses Harry's wide-eyed discovery; the scale of things visually as well as conceptually dwarfs him. But in line with the significance of being right on the edge of adolescence I discussed with reference to *Stand By Me* (1986) and *Kick-Ass* (2010), Hogwarts School is a story about puberty, a boarding school for eleven- to eighteen-year-olds.

Lisa Hopkins discusses the emergence of Harry's puberty between the lines of the third to fifth books (Hopkins 31). But *Harry Potter and the Chamber of Secrets*

(2002) already foregrounds immanent puberty. The girls' bathroom is a place of mystery and access to dangerous knowledge – an underground chamber housing the excessively phallic basilisk but also revelations concerning the dangerous desires of the girl to which, at the end of the books, Harry will be married. The story climaxes with Harry's battle, using the sword passed on to him by the Headmaster father-figure, against the basilisk controlled by a spectral bad adolescent (an image of that evil wizard at sixteen).

The 'Harry Potter' films focus on the power of institutions, the question of maturity, and the danger of minority. From the beginning these themes, and hints of a romantic triangle between Harry, Ron and Hermione, overshadow the more usual tween narratives about confidence and independence. While the sexual development of characters in the book series lags considerably behind adolescents of the same age in the real world – at fifteen, Harry is still puzzled by awkward feelings around wanting to ask out a girl – the films can't afford such deferral if they are to accommodate the aging of their existing audience or seem credible to audiences invited by cues like the ratings of increasingly violent content and images of adolescent stars.

The first two films were directed by Chris Columbus, previously known for films on the borderline between family and teen film. For the third film, *Harry Potter and the Prisoner and Azkaban* (2004), Columbus was replaced by Alfonso Cuarón, previously known for restrictively rated films about coming-of-age – the Mexican *Y tu Mamá También* (2001) and an update adaptation of *Great Expectations* (1998). The stars had now reached their mid-teens and were highly visible in teen magazines. And the story itself begins with Harry leaving the house of his childhood determined never to return. At the confluence of these influences, Harry's adolescence is stressed in all aspects of production, from the relegation of 'wizarding robes' to rituals and the styling of the central characters in contemporary fashions to the visual emphasis on Harry's struggle to understand himself. Cuarón's choice to centre the styling of Hogwarts on the swinging of a giant pendulum and ticking of a giant clock not only refers to the narrative climax in which Harry, Ron, and Hermione will turn back time but also symbolically centres the passing of their own time. Transformation is the other central narrative theme. When Harry's teacher turns out to be a werewolf this intertextually picks up the teen film connotations of that figure. And two spells unmentioned in earlier films stress and further blur the lines between human and animal: 'animagus', where a wizard turns into an animal (and a childhood pet is revealed as a monster); and 'patronus', where a spectral animal represents and protects a wizard, literally in the name of the father.

The fourth film incorporates into the representation of Hogwarts more scenarios and conventions of high-school teen film: casual contemporary fashion styling; the 'prom' trope, incorporating a real life pop-star; jealousy plots and first dates; media rhetoric on youth rebellion. These teen plots intersect with but are independent of the political plot in which Harry is caught up with one clear exception. Harry

inadvertently crosses a legal and magical 'age line' into a heroic role supposedly reserved for people in their majority. That this is now a teen narrative is far more explicit in the films than the books, in part because of intertextual visual parallels set up by classroom tensions and the exchange of tentative desiring looks, but also because the audience would expect it. By the fifth film, Radcliffe was eighteen, Grint nineteen, and Watson seventeen. The gap between the age of the actors and of the characters had increased to three years, and these were adolescents over the age of consent, and mostly having reached legal majority, playing what were legally children in the world of the film and most of its audience. This was further complicated by the books, which included what would count as 'disturbing content' for the teen film ratings statements about adolescence. The source text had to be substantially edited to include a younger market. This difficult editing process is even more vital for the remaining films and when he succeeded with *Harry Potter and the Order of the Phoenix* (2007), perhaps because of his experience directing for the more multiple markets of television, David Yates was retained to direct the remaining films.

The fourth and fifth films take from the books what are already teen film standards: peer rivalry, school competitions, Harry's resentful outsider status and romantic frustrations. The opening of the fifth film contrasts the banal school bully with the teen horror of the magical world. Cued to Harry's implicit puberty narrative from the third to fifth films, the Dementor monsters are both stalking demons and disciplinary terrors. In the fourth and fifth films, however, Harry must also deal with more human-shaped threats, particularly the unjust and immoral manipulation of laws restricting minors, even from defending themselves. That Harry resists the guardianship of institutions in these films seems to be a contributing factor in rating both films PG-13 in the US and thus centrally 'teen', while all other instalments, including the sixth with its more explicit horror scenes, were PG.

The 'Harry Potter' books were always received by HP fans as about adolescence. Fan fiction begins with the premise of adolescence; that is, with the possibility of romance and/or sex that adolescence makes viable for fans. Most fan fiction (by which I mean all fan texts, whether written stories or edited 'fan-vids') uses the tropes and themes that centre teen film, with an emphasis on the sex/romance dialectic, for example, and, in the case of fan-vidding, the relation between the visual language of the face in teen film and a contemporary music score. Part of the appeal of 'Harry Potter' for HP stories is the many opportunities for inserting sex where teen film would include it and the 'Harry Potter' films do not (Driscoll 2006).[10] Whether HP stories are set in school, outside of school but with protagonists still of school age, or beyond the school setting altogether, Hogwarts remains a key reference point. The fandom abounds in time travel, age changing, and intergenerational stories in which characters move between generations in order to bring all possible character and plot selections into the realm of adolescence and the narrative themes of teen film. The HP fandom thus exemplifies the ways ideas about adolescence do not just

shape teen film, and are not just communicated by youth culture more generally, but are produced by complex dialogues between texts, audience, and culture. For these dialogues teen film is a powerful interpretative and symbolic frame.

–9–

Which Teen/Film?

Orihime: I had a lot of things I wanted to do … I want to be a teacher … I also want to be an astronaut … and also make my own cake shop … I want to go to the sweets bakery and say 'I want one of everything'.

Bleach, 2007

This chapter considers the continuity of teen film across different cultures while acknowledging differences produced by varying cultural contexts, including variations on the modern idea of adolescence as well as different film industries. I also want this concluding chapter to ask whether we might usefully think of teen film not only as a system of classification produced by transnational dialogues over maturity and citizenship (Chapter 7), and as one component of an transnational field of youth culture adapted to varied economic structures and cultural expectations (Chapter 8), but also as itself manifesting the internationalization of adolescence.

Is there a Global Teen Film?

Scholarship on teen film continues to focus overwhelmingly on US teen film with the general unmarked inclusion of Canada, occasional side-references to other Anglophone nations, and rare invocations of strange differences or parallels in other countries. One exception is *Youth Culture in Global Cinema* (2007), a collection of essays edited by Timothy Shary and Alexandra Seibel. This anthology steps outside the parameters of Shary's other books both in not being an introduction to the genre and in dealing broadly with the question of representing youth culture in and as cinema. The essays are divided into five parts discussing: images of youth resistance on film (with an emphasis on the reception of imported American film); the appearance of the 'youth problem' film across different cultures since the 1980s (China, Eastern and Central Europe, and the US); youth as a site of cultural conflict in the contemporary film cultures of Latin America, Brazil, Egypt, India, and Turkey; changing gender roles in films about adolescents from New Zealand, the UK, France, Italy, Spain, and the US; and finally young 'queer' sexuality in American, Swedish, and German film.

These essays collectively demonstrate a recognizable set of shared themes for films about adolescence from many cultures, further elaborated by an eighteen-page

filmography of 'Global Youth Films' at the end. But what makes these 'Global Youth Films' and not 'teen film'? Why 'Global' as a marker, and why 'youth' rather than 'teen', which is the term Shary uses in his books about American cinema? As Shary concedes from the outset, his list is not exhaustive but it gestures towards a critical mass of films most of which are only excluded from accounts of teen film by being other than American. One reason is clearly the association between the genre label 'teen film' and popular images of America. Not calling these films 'teen film' avoids objections that they are not like US teen film. Another is because these texts seem to less evenly engage with the broader field of commodified youth culture in the ways I discussed in Chapter 8, or they do so with a self-conscious identification of that culture as dominated by imports.

Shary and Seibel's book does not appear unheralded. Pomerance and Gateward's (2005) edited collection *Where the Boys Are: Cinemas of Masculinity and Youth*, in marked contrast to the collection on girls only three years before, includes a substantial range of references to teen film from France, India, Japan, Martinique, and Scotland/the UK. Anne Tereska Ciecko's collection on *Contemporary Asian Cinema: Popular Culture in a Global Frame* (2006) includes a range of essays discussing 'teen melodramas and teen comedies' in Malaysia (90–5), a 'shift toward teen-oriented [films] in response to a number of major teen successes in the 1980s' in Thailand that continued to expand in the 1990s (59–62), and a struggle between Filipino teen films in the 1980s and 'foreign blockbusters such as the American "Brat Pack" films' (34–5).

The Shary and Seibel collection nevertheless addresses a gap in discussions of teen film left by a focus on Hollywood and by Hollywood's ethnocentrism. However, the opposition between 'Hollywood teen film' and 'global youth film' seems problematic, especially given that the film used to preface the collection is *Harry Potter and the Goblet of Fire* (2005), a film that compromises any neat categorizations of Hollywood versus foreign film (Shary and Seibel 2007: xi). In the essays themselves no clear opposition between teen and youth or Hollywood and foreign is maintained. Some discuss their selected films as teen film, some as in dialogue with US/Western teen film, and some as interrogating the relations between adolescence and images of globalization, Americanization, or transnationally distributed youth culture. Jettisoning the label 'teen film', however, clearly intends to lay claims for serious attention to films about 'youth'. But Shary's long introductory list of famous directors who have made famous films about youth (2007: 3) clarifies one more reason for not using the label 'teen film' – many are films with children or adolescents in them without being concerned with the themes and questions that cohere teen film as a genre. The collected essays, however, overwhelmingly deal with the thematic of youth as problem, as institutional nexus, or as celebration, and films that raise the question of maturity and the liminal processes of coming-of-age.

Shary and Seibel (2007: 4) frame non-US films about adolescence, distinguished from teen film, as particularly dealing with 'topics of politics and religion, and

more often, with tensions around cultural and national identity.' US teen film is actually more complex than this suggests. Teen film's descriptive eye on youth culture always embraces a degree of cultural specificity. Thus the beach scenes in Australia's *Puberty Blues* (1981), where the beach is more-or-less the only youth-centred venue in the film, are very different than those in *Fast Times at Ridgemont High* (1982). And Indonesia's *Coklat Stroberi* (*Chocolate Strawberry*, 2007) uses gendered relations to the kitchen to represent a boy's homosexuality while pop cultural taste and personal style do the same work in *Clueless* (1995).[1] But teen film made outside the US, or across the borders of the US, is not *about* cultural specificity or difference to any greater degree than *Fast Times at Ridgemont High* or *Clueless*, both of which have highly American and highly political stories to tell. These four films are linked by generic themes of adolescence, maturity, and coming-of-age, by discourses on youth as problem, institution and party, and by the imperative to describe adolescent relations to norms for citizenship on the one hand and youth culture on the other.

I want to consider here the 'Karate Kid' series of films, stretching from 1984 to 1994 and supplemented by a re-interpretation of the first film in 2010. In *The Karate Kid* (1984), Daniel LaRusso (Ralph Maccio) is persecuted by bullies from the Cobra Kai dojo and rescued by Mr Miagi (Pat Morita), who teaches him karate for both self defence and compensation. The fact that this is a coming-of-age story is heralded in the opening by the removal of Daniel from his known life and transportation to alien California, reinforced by the marking of class and ethnic difference in Daniel compared to everyone else in California. Miyagi's training, like his Japanese-ish home, is a further separation of Daniel from the rest of the world, in which Miyagi imposes on Daniel rituals of commitment that only make sense after the fact. After a series of emotional and physical tests, Miyagi sponsors Daniel's entry into a place of trial where he must complete a rite of passage that transforms him into someone who understands the meaning and uses of violence.

The 'Karate Kid' films are intrinsically American and intensely political, including in their presentation of cultural difference, through narratives of immigration, assimilation and cultural traditions marking racial otherness. There's an additional complexity to *The Karate Kid*, however, because Miyagi does not remain the alien spirit guide but takes on a paternal domestic guidance role: he gives Daniel his first alcoholic drink and a new car on his sixteenth birthday. The bond between Daniel and Miyagi is increased in the sequel, *The Karate Kid, Part II* (1986), by sending them to Okinawa. The stakes of Daniel's tests are raised to life and death and the complicated relation between boy and man is also escalated by addressing the problems of Miyagi's own adolescence. The series remains a cross-cultural encounter in which the secret exotic knowledges of 'the East' allow Daniel a shortcut to maturity. But engaging with the challenges confronting Miyagi in his youth opens a space for cross-cultural dialogue about adolescence – not because *The Karate Kid, Part II* comprehends what matters to Okinawan adolescents but because

it attests to the transnational distribution of ideas about adolescence as well as teen film representations of them.[2]

The remake of *The Karate Kid* (Zwart 2010) shifts the drama to China, Mr Miyagi to Mr Han (Jackie Chan), and Daniel's New York ethnic working-classness to the African-American Dre (Jaden Smith). Japanese-ness is not just replaced by Chinese-ness but supplemented by a tourist gaze and stripped of the overt colonial narrative for a different story about international labour and cultural exchange in which Americans might have to travel to survive. The continuities suggested between American and Chinese youth may not realistically represent the experiences of anyone in China or America but the transnational distribution of this film reinforces a claim that it might. The distribution of the institutions and ideas key to modern adolescence are not simply exported from Western Europe to the rest of the world. China, for example, already had philosophies of the self centred on training before its engagement with modern 'Western' democracy and psychology. And Japan, when it 'opened' its trade borders (again) in 1868 already had an educational system that it could hybridize with the expectations and standards of 'the West'. All versions of the 'Karate Kid' story speak to a transnational trade in cultural forms that encompasses cinema, adolescence, and teen film.

Trainspotting: twisting the genre

Calling Danny Boyle's *Trainspotting* (1996) a teen film is almost as controversial as including Stanley Kubrick's *A Clockwork Orange* (1971) in the genre (Chapter 6). *Trainspotting* actually cites *A Clockwork Orange* in its nightclub scene. A shot of Tommy (Kevin McKidd) and Spud (Ewen Bremner) sitting together against the back wall of the club has them framed by writing on the wall in the same style as that in the Korova Milk Bar scene. But there are important differences at play. While Kubrick's scene begins with a close-up of Alex's face and slowly pans back to encompass his friends and the bar, the *Trainspotting* scene begins with the crowd and moves in. Instead of the ominous clarity of Alex's perspective we have the raucous noise and action of the club. The boys are full of enthusiasm for a culture they feel properly belongs to them: this club and the bands they admire. And alternative perspectives on them are included: the girls in the ladies' room laughing, and Mark Renton (Ewen McGregor) at the bar with sex on his mind. There are multiple voices here, hard to untangle, and all of them are Scottish.

In *Trainspotting*, Renton is a young heroin addict in Edinburgh, repeatedly trying to kick his habit and just as repeatedly trying to find drugs and money to feed it. His family, friends, and acquaintances are all also addicts, although some of their addictions are legal ones, and their stories of frustration, desperation, aspiration, and despair propel and trouble Renton's desires to get high or get clean. Eventually he moves to London trying to escape these expectations and influences. But when his

friends turn up, planning a crime that will make them all rich, he is dragged back in, only to finally run off with their money, swearing to go clean again even as his chosen destination, Amsterdam, suggests that he will not.

Like *A Clockwork Orange*, *Trainspotting* draws its story from a novel characterized by both games with realism and complex ethical situations. In Irvine Welsh's *Trainspotting* (1993) Renton is in his late twenties, a failed postgraduate student, details which are not part of the film, leaving Renton more generically adolescent. He moves between his parents' home and those of friends and acquaintances, negotiating job interviews, moralizing lectures for young men, and the ambiguous developmental status of friends who should be too young (Diane) or too old (Begbie) for the way they behave. Adapting Welsh's book to film benefits here from teen film's juxtaposition of realism and fantasy in order to represent both the limit experiences of intoxication and grim details of young urban life characteristic of mid-1990s youth problem films. Both ground its portrait of a particular adolescent world (unemployed addicts in the UK in the 1980s).

On film, the dialect used to tell the story in Welsh's book is less dominant, allowing a map of fashion, music, and drugs to position *Trainspotting* as a film about youth. But there are different released versions, including a US release with subtitles for scenes where the Scottish accent might have been confusing. Explication is also one of the functions of the soundtrack, which loosely reflects the historical setting of the story (Iggy Pop, Lou Reed, New Order) but also British 'top-twenty' bands of the time as youth market attractants (Pulp, Blur, Elastica).

Trainspotting is thus an example of the intertextuality discussed in the last chapter. It demonstrates how intended and unintended parallels with other texts and discourses constitute the connections that we call genre. In the opening scene, the camera (and the viewer) appears to hit the ground with Renton's shoe as is chased through the streets by the police, laughing and accompanied by Iggy Pop's 'Lust for Life' (1977). This indirectly invokes the opening of *Saturday Night Fever* (1977), in which the disco rhythm puts the viewer in Tony's shoes (Chapter 6). Deliberately, however, the opening of *Trainspotting* quotes the 'Choose Life' anti-drug t-shirts popular in the UK in the mid-1980s while also invoking the contemporary 'Just Say No' anti-drug campaign the US government was directing at adolescents. By such connections *Trainspotting* takes up a place in a cross-cultural field of teen film. This mobility is further supported by the ways youth in *Trainspotting* move from Scotland to England, or Amsterdam.

Trainspotting nevertheless belongs to a history of film representations of adolescence located in the UK which, while it remains in transnational contact with the genre as a whole, has its own emphases. A field of UK-produced films in which popular music centred narratives about adolescents striving for independence was particularly prominent in the 1980s, when US film more often emphasized suburban high-school life. Some of these were gang films, like the retrospective *Quadrophenia* (1979) set to the music of The Who, and some were fictional band

films like *Breaking Glass* (1980).[3] As Andrew Caine points out, the British rock film has its origins in the late 1950s and early 1960s, indebted but not straightforwardly subsequent to rock 'n' roll in the US (115ff). While Cliff Richard might offer an obvious comparison to Elvis (Chapter 2), the slightly surreal comedy of Richard Lester's Beatles film *A Hard Day's Night* (1964) also shaped later teen films. As Denisoff and Romanowski put it, this film is not only a precursor to contemporary music video – a genre I have already suggested is historically and technically entangled with teen film (Chapters 3 and 8) – Lester also 'used Beatlemania as a thematic framework for his critique of British society in the early 1960s' (Denisoff and Romanowski 1991: 134).

The first spoken words in *Trainspotting* are Renton's, spliced into his flight from the police, his fun with his friends, and his drug euphoria:

> Choose life. Choose a job. Choose a career. Choose a family. Choose a fucking big television. Choose washing machines, cars, compact disc players and electrical tin openers... choose DIY and wondering who the fuck you are on a Sunday morning ... Choose a future. Choose life ... But why would I want to do a thing like that?

Choosing heroin, Renton knows, is no more positive. But the alternatives he dismisses are an image of how one becomes a useful citizen of contemporary capitalism. Renton's relation to work is crucial here. On the one hand the state's requirement that he and Spud look for work is exposed as a requirement that they *pretend* to look for work, and on the other Renton's jobs offer him nothing of value beyond some freedom from being monitored and more money for drugs. In this respect the retrospective dating of *Trainspotting* is crucial. The 1980s in the UK were dominated by the leadership of Margaret Thatcher with, among other effects, the extension of adolescent dependence on the family in line with limitation of benefits for students and the unemployed. This should remind us of Donna Gaines's burnouts (Chapter 6) because, as Murray Pomerance puts it, also looking back at the 1980s, 'Today, job restructuring and managed unemployment routinely infantilize persons who would have been considered adults (or young adults) twenty-five years ago' (Pomerance 2005: 133).

To ask whether teen film must be American I might have chosen more obviously 'teen' British films. But teen film requires an expansive definition – one based on thematic concerns and conventions that are dominated less by particular camerawork or production design than by a film's relations to ideas about youth and youth culture. This definition should respect specificity, including that of the Scottish story and cast of *Trainspotting*. But this specificity relates to an international field that reaches across many cultural contexts, for example making a fresh star of McGregor in ways that also worked in Hollywood. The English language certainly facilitates *Trainspotting*'s mobility and the way it belongs to a history of transnational standards for the definition and management of young people. I could have replaced this

section with one on Australian teen film. I want to ask, therefore, whether, if teen film is not American, it might at least be predominantly anglophone.

Bride and Prejudice: International Teen Film

From *Youth Culture and Global Cinema* I want to take another starting point from the section of the book focused on 'inner-national conflict'. While US teen film also politicizes its identity-formation and identity-crisis narratives, such politicization takes particular forms in different cultural contexts. Even when addressed at the more banal level of fitting in and standing out amongst one's peers, teen film tells locally inflected stories about the political work of adolescence. But, as Savaş Arslan's essay 'Projecting a Bridge for Youth: Islamic "Enlightenment" versus Westernization in Turkish Cinema' suggests, the impact of state politics and regional cultures on adolescence can be made much more overt. A choice between a familial culture construed as 'traditional' and an alternative more closely aligned with youth is an important generic convention in teen film.

Teen film represents adolescence as occasioning momentous choices about cultural identity. Arslan's examples stand apart from many teen films in framing the adolescent's choice as representing a choice for the state as a whole. But even this positioning of youth (and especially the girl) at the border between past and present culture is broadly apparent in teen film, as my discussion of the ingénue figure in early cinema suggested. Films like Charles Chauvel's Australian outback films (*Uncivilised* 1936, or *Jedda* 1955) share with Arslan's examples correlation of the choice between tradition and change and that between tradition and international modernity. But the post-1950s teen film imagination of this conflict aligns international modernity with youth culture. There is a consistent tradition/modernity opposition in US teen film, as films as different as *National Lampoon's Animal House* (1978) and *Carrie* (1976) suggest, but the apparently certain modernity of 'America' in comparison to 'Turkey' is manifest for teen film both in access to commodified youth culture and in cultural mobility.

The film I focus on now also centres on the choice between tradition and modernity and does so with reference to both nationalism and internationalism: Gurinder Chadha's *Bride and Prejudice* (2004). It is, on the one hand, fundamentally 'Western', a UK/USA co-production filmed in both countries as well as in India, and centred both on an adaptation of the English novel *Pride and Prejudice* (Austen 1813) and on a fantasy of international modernity in which travel, finance, global popular culture (principally music and fashion), and romantic ideals unite people across all three continents. But *Bride and Prejudice* is also concerned with the beauty of local cultures, the attractions of cultural difference and, in particular, with the narrative and stylistic devices of the form of Indian cinema known as 'Bollywood film'.

Bride and Prejudice is not a Bollywood film any more than *Slumdog Millionaire* (Boyle and Tandan 2008), a film about a street orphan whose life story makes him, by a series of coincidences, a quiz show champion.[4] *Slumdog Millionaire* was a UK production for Pathé Pictures International, the same company that produced *Bride and Prejudice*, but filmed entirely in India with a larger proportion of Indian crew. *Slumdog Millionaire* is also, however, dominated by a social realist narrative quite different from the musical, romance, and fantasy genres that have defined Bollywood, despite the prominent use of Indian choreography and music. If both films are hybrid Indian-Anglo-European films, the fact that adolescents connect Hindi-language cinema and Indian film styles to an international film audience is important to the question of whether there is a Bollywood, or a Hindi, teen-film genre. I've elected to focus on *Bride and Prejudice* because it deploys more teen-film conventions and contexts.

Bride and Prejudice follows the plot of Austen's novel for its love story, exploiting Indian cinema as a context in which marriage is understood to be driven by considerations other romantic love. But the plot also focuses on representing India and Indian culture in relation to both internationalism and the globally informed expectations of adolescents. The Bakshis of Amritsar have four daughters, including Jaya (Namrata Shirodkar), Lalita (Aishwarya Rai), and Lakhi (Peeya Rai Chowdhary) (see Figure 9.1). When they meet British-Indian barrister Balraj (Naveen Andrews), the Austen plot begins: Balraj and Jaya are attracted, while Lalita and Balraj's American friend, Will (Martin Henderson), clash over his

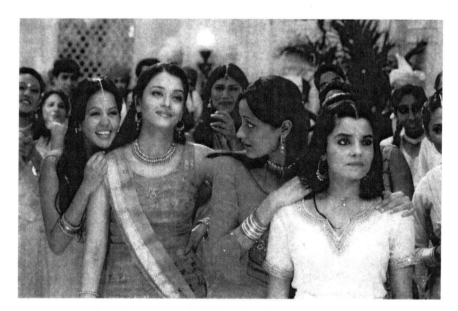

Figure 9.1 Lalita (Aishwarya Rai) and her sisters and friend. *Bride and Prejudice* (2004). Director, Gurinder Chadha. Courtesy of Pathé Pictures Ltd/The Kobal Collection.

apparent opinion of India and Indians. Jaya and Lalita are allowed to travel to Goa with Balraj and his party. Lalita and Will argue over tourist development in India and their antagonism is furthered when she is attracted to Johnny (Daniel Gillies), an old enemy of Will's. Back in Amritsar, her mother has another suitor for Lalita, an Indian-American accountant looking for an Indian wife but Lalita rejects him. This sequence of scenes also exposes her mother's views on profitable marriage.

Kohli (Nitin Ganatra) finds his Indian wife and flies the Bakshis to the wedding. They accidentally meet Will, who now makes a better impression on Lalita and they attend the wedding together only to be separated by his mother's lies and Lalita's anger when she finds Will advised Balraj to stop seeing Jaya because of her avaricious mother. On the way back to India, the Bakshis stop in London, where Lakhi frightens and embarrasses them all by running off with Johnny. Will reappears to reveal Johnny's history of seduction and together they find the runaways in a London Bollywood theatre, resulting in a fight choreographed to match that in the film on screen. When they return Lakhi to her mother Balraj is there apologizing to Jaya and the film closes with a double wedding back in India.

Indian, American, and British adolescence are represented as different and yet comparable in *Bride and Prejudice*; brought together by modern flows of population and culture while maintaining distinct identities. The film appropriates a range of techniques from Bollywood romance, including in its translation of formal dance and dinner scenes from the novel into dance routines and the integration of singing into the storyline. But its narrative turns on the girl's role in both manifesting what India is (for Indians and others) and negotiating what India should be. All of the suitors for the Bakshi girls are not Indian per se but foreigners in India (William, Johnny), descendants of diasporic Indians (Balraj), or members of the Indian diaspora (Kohli). The film's discourse on India, therefore, is also on the dilution of India and the representation of India as a girl whose meaning is made in international marriage. That the Hindi title for *Bride and Prejudice* was *Balle Balle! Amritsar to LA* indicates the extent to which internationalism and America are linked in popular Indian culture as well as suggesting a celebratory diasporic narrative.

Bride and Prejudice needs to be contextualized in relation to Chadha's earlier films. In *Bhaji on the Beach* (1993), a group of women and girls of 'South Asian' origins travel from Birmingham to Blackpool, negotiating the British context in which they live and their own generational and gendered cultural relations. But Chadha's success came with *Bend it Like Beckham* (2002), which paralleled the gender obstacles faced by girls who want to play football and the racialized obstacles faced by British-Indian girls. The film was promoted with the tagline, 'Who wants to cook aloo gobi when you can bend a ball like Beckham?' (Projansky 2007: 204)[5]

Although the heroine falls in love in *Bride and Prejudice,* we never see her kiss the hero. This omission of kissing where it might be expected is entirely appropriate to a Jane Austen adaptation but is also a tribute to Hindi cinema, in which representations of kissing and other sexual contact were effectively banned for decades. In a classic

Bollywood romance the climax would cut to such metaphors for physical union as flowers or birds touching or the sunlight setting on a couple. The Indian film classification system (which took its present form in the 1950s) has only three public categories at present: U, for everyone; UA, the parental guidance rating added in 1983; and A for adults only. Although a U rating has now long been able to include kissing, as is the case in both *Slumdog Millionaire* and *Jaane Tu ... Ya Jaane Na* (*Whether You Know ... Or Not*, 2008), there is still a tendency to include little or no kissing in a Bollywood musical. Generically, these films use music, dance and song to display feeling and emotion in ways that extend the function of these elements in the 'Western' musical.

There has also historically been cautiousness around representations of adolescent rebellion in Hindi film. Like the restrictions on kissing this has declined since the 1970s. While a film like *Teree Sang* (2009), which depicts teen sex, pregnancy and rebellion, was mildly controversial and rated UA, its success rests on that of earlier films, including the US film *Juno* (2007), rated A in India, but also the more successful Hindi film *Kya Kehna* (*What to Say*, 2000), rated UA. These are clearly teen films by the conventions and themes established thus far despite their evident incorporation into a more tightly codified moral framework: in *Kya Kehna* the pregnant girl marries the worthy best friend, and in *Teree Sang* the boy is convicted although given a suspended sentence. Thus, while there are few school scenes in these films, there are more than sufficient institutional frames to monitor adolescent life, including not only parents (a more pervasive presence in Indian teen film) but 'camp' or college. For the most part films about adolescent love and desire, like *Jaane Tu ... Ya Jaane Na*, focus on characters of 'college' age. We should remember that this is also the case if a US teen film about sex and drugs wants to remain a comedy.

In the 1990–2000s, Hindi films centred on college-age characters have often thematically resembled teen films in other countries, except that the transition to adulthood, although just as often unfinished, routinely involves questions of marriage. In the critically acclaimed *Dil Chahta Hai* (*The Heart Yearns*, 2001), for example, the plots surrounding three young men after graduation confronted by what they should do and by assessments of their own maturity could be compared to films like *St Elmo's Fire* (1985), except in its emphasis on marriage and parents as unavoidable components of questions concerning maturity. Comparably to anglophone teen film in the 1920s and 1930s Hindi cinema already produced 'flaming youth' films, but the 1950s locate a dramatic shift because the Republic of India, established in 1947, quickly incorporated cinema into policy, establishing a state structure for encouraging and managing cinema by 1954 in which the teen film narrative about maturity was transparently attached to citizenship. For Corey Creekmur (2005: 360), 'in the 1960s and 1970s the hero of Indian film was an adult, but one fixed by the traumas of childhood and unable to grow up, permanently in an "adolescent stage".' But by the 1970s rebellious college youth films were a popular genre, as were teen romances like Raj Kapoor's *Bobby* (1973), with its influential

cross-class narrative. The 1980s brought new popularity for teen film with the
success of younger actors in hit films like *Qayamat Se Qayamat Tak* (1988) – a loose
adaptation of 'Romeo and Juliet' (Chapter 8).

Hindi teen film has its own tropes, many evident in *Qayamat Se Qayamat Tak*,
including flight and concealment from parents, and some are not only culturally
but generically specific. Creekmur's essay on 'the maturation dissolve' in popular
Hindi cinema adds critical content to this historical sketch. The 'maturation dissolve'
is Creekmur's name for a set of strategies which displace adolescence with an
ellipsis between the experiences and identities of childhood and adulthood using
'flashbacks, montage, sequences, and frame-tales' (351). For Creekmur, this is 'a
cultural perspective condensed into a narrative – and distinctively cinematic tech-
nique' (351) – in which characters do not change. He suggests, however, that recent
Indian films, like *Dil Chahta Hai*, which explore character development, 'proclaim
the true arrival of youth culture in popular Hindi film' (371). Recent teen romances
like *Kya Kehna, Jaane Tu... Ya Jaane Na*, and *Teree Sang* certainly support this
claim concerning a new emphasis on youth culture in Hindi cinema, but in the light
of Creekmur's 'maturation dissolve' we might also notice the way in which youth
is represented via ellipsis in romances focused on older characters – via dreams,
flashbacks, or other fantastic devices, but also by emphasizing the line between
adolescence and adulthood. While a film like *Dil Chahta Hai* is not about teenagers,
just as the touching flowers in classic Bollywood cinema did represent kissing,
Hindi cinema's elisions and suspensions of adolescence do represent its importance.

Watching *Bleach*: Teen Film after Cinema

Cinema is not the overwhelmingly dominant popular genre it once was. If teen film
has been a powerful discourse on adolescence then this power is also no longer as
singular as it once was. My final key text is *Bleach*, but I cannot call it a teen film –
not because its content, style, or audience does not fit the genre but because it is not
a film. *Bleach* is principally a *manga* (graphic fiction in the Japanese style), drawn
and written by Tite Kubo since 2001, and an *anime* (animated film) derived from it,
directed by Noriyuki Abe, and screened on television in Japan since 2004. *Bleach*
is produced in many additional ways, including in volumes collecting the weekly
publications from *Shōnen Jump* and translated into a range of languages including
Portugese, Italian, English, Cantonese, Chinese, and German. The anime is also
screened in translation on at least four foreign channels since 2006, accompanied
by multiple DVD releases of the series. These are supplemented by multiple CD
soundtrack and commentary releases since 2005; three animated feature films since
2006, also directed by Abe; at least five video games based on multiple platforms;
and miscellaneous other products, from live stage show musicals to a trading card
game and t-shirts.

Bleach is, moreover, a range of fan sites and communities in which *Bleach* is not only interpreted, but actively produced. On forums like *BleachWorld* (www. bleachworld.com/) and *BleachAsylum* (http://bleachasylum.com/), working in teams and singly, fans provide translations as well as re-edits, screen captures, and feeds that spread the series across the world at a speed its official publication cannot replicate.[6] They also include fan-texts, commentary on the manga, the anime, and relations between them. These communities bleed into offline activities, including *doujinshi* (self-published art) production. This is obviously another transmedia form of youth culture (Chapter 8) but what, if anything, does it mean to the genre of teen film if film (and even television) has no particular privilege in reproducing popular narratives about adolescence?

As a *shōnen* (boy) manga/anime *Bleach* is already adolescent.[7] But a summary of *Bleach*'s central storyline will hopefully establish its teen film credentials. Schoolboy Ichigo Kurosaki is visited in his bedroom by Rukia Kuchiki, one of the *shinigami* (soul reapers) supposed to summon the dead to the afterlife. Surprisingly, Ichigo can see her and, just as surprisingly, during their conversation an undead spirit attacks him. Rukia gives Ichigo her powers to defend himself, but this leaves Rukia stranded in the living world as a human girl. The story that subsequently unfolds is partly about Ichigo's quest to understand why he is different from other boys, partly about Rukia's endeavour to regain her powers and to defend herself against charges that she betrayed the code that should have governed her, and largely an elaboration of a mystical world of souls and spirits entangled with the banal world of teenage life.

Over the course of the series Ichigo's core friends, including the protective Chad, the knowledgeable Uryū, and the sensitive Orihime, are gradually revealed to have spiritual or magical powers of their own – a strategy for adding new narrative value to existing characters just as evident in the 'Buffy' television series (Chapter 6). However, the series includes classmates and other peers who (like Xander in 'Buffy') offer images of normal adolescence that throw the magical quest version of adolescence into relief. The epigraph to this chapter is spoken by Orihime to a sleeping Ichigo when they are both in fear of their lives, exemplifying the clash in *Bleach* between ordinary adolescent development and supernatural heroism. As in the Harry Potter series, the adult characters also tend to have adolescent characteristics, displaying immaturity at times and uncertainty at others, but often a passion and volatility associated with the young. The crucial fragility of the family in *Bleach* emphasizes its questions about development and maturity and even the shinigami are an extension of this problem. The *Seireitei* (Soul Society) is another world than the human one and yet the same world, obeying other rules at the level of social organization – a puzzle for Ichigo to work out – and yet the same moral order. In short, the 'soul society' which the series gradually uncovers is the adult universe in which Ichigo must strive to find his place, bringing with him his friends and other shifting allegiances that give *Bleach* its complexity and thus longevity in the densely populated manga/anime/fandom market.

If *Bleach* is youth culture, and centred on adolescence, does that make it teen film? After all, however popular the anime, the films, the episode captures, fan-vids, and other online audiovisual versions of *Bleach*, they are not cinema releases. The question of whether *Bleach* is teen film depends partly on the position from which the question is asked. If we are looking for the mass media audiovisual production of ideas about adolescence cohering around the themes, tropes and strategies outlined in the preceding chapters then *Bleach* is certainly teen film, not only in Japan but in the importantly international mediascape where anime is distributed. The popularity of live action teen film adaptations from manga or anime speaks to the mutual influence of these forms. The most common conventions of manga style are a blend of cinematic framing and heavily stylized graphics that valorize youthful beauty, and these conventions pervade Japanese audiovisual youth culture in general.

Shary and Seibel's index of 'global youth film' index lists a range of Japanese films, from 1960 to 2004, but no anime. My stress on this oversight does not mean that live action Japanese teen film does not exist. *Seishun eiga* (youth film) has its own history. The conditions for film as youth culture were established wherever industrial modernity met new theories of adolescence and this was the case in Japan as elsewhere. In the 1950s and 1960s, as critics like Mitsuhiro Yoshimoto and historians like Joseph Anderson and Donald Richie note, Japanese film displayed a new fascination with youth and, as in the US at the same time, particular studios (like Nikkatsu) specialized in producing youth-directed 1950s genres, including the high-school sex picture and a subgenre of *yakuza eiga* (gangster film) populated by 'teen' idols like Akira Kobayashi, who starred in a sequence of j.d. films. It might seem that these similarities arise from experience of US occupation, but pre-war Japan (and especially Taishō Japan, 1912–26) had already linked adolescence, governance and technology in ways we now associate with teen film and *seishun eiga* is an extension of these ideas, and of a dramatic generationalization produced by the colonial situation rather than being simply an imported genre.

The relation between manga, anime, and live action film has not been the only specifically Japanese production network shaping teen film conventions in Japan. Jim Harper discusses the interleaving of video and theatrical releases characterizing teen Japanese horror of the 1980s and 1990s. These 'V-cinema anthologies' (Harper 2009: 21), of which the 'Ju-On' series is a very successful example, were often adapted from manga or anime but might also seem to be directly influenced by US teen film even in manga-adapted storylines like that of *Denei-Shōjo Ai* (*Video Girl Ai*, 1991), in which, much like John Hughes's *Weird Science* (1985), a teenage boy accidentally produces a pin-up girl from a video. These similarities are better explained by synchronous ideas and technologies than by importation. Another example can be found in comparison between Hughes's *The Breakfast Club* (1985) and *Taifû Kurabu* (*Typhoon Club*, 1985), which is also a film about students trapped in a school. *Taifû Kurabu* is more overtly sexual, less dominated by dialogue and more by mood, and the fact that nature rather than school discipline traps the students

and exposes them to one another presents a very different analogy for adolescence. However, adolescence in both is a similar nexus of problems, institutions and passions.

What matters most about *Bleach* for considering the present state of teen film is less its role as a specifically Japanese inflection on, and contribution to, the teen film genre, than the way its transmedia form demands cross-cultural engagements. The role of cross-cultural exchange in *Bleach* is not confined to fans or translation and trade arrangements. The title 'bleach' is itself a 'loan word' – a word adapted into Japanese from another language – reproduced on promotional material in English, with a *katakana* translation. The transcultural transmedia form of teen film in no way overrides cultural specificity just as, for Shary, the essays in *Youth Culture in Global Cinema* gesture towards a 'global youth culture at large' (Shary and Seibel 2007: 5) while most of the essays are concerned with specificity. For critics like Kaveney, US teen film has 'colonized' the imaginations of the Western world, drawing on a 'folk memory' about teenage life, stylized in a US-centric way (Kaveney 2006: 2–4). I have tried to show that waves of teen film production which both blended and distinguished between cultural experiences of and meanings for adolescence have shaped the genre. While there is certainly an international dialogue at stake in the versions of teen film I have discussed in this chapter, they are produced at the border between the international and the local.

Approaching teen film as the internationalizing of modern adolescence is not a matter of discovering how the conventions of 'American' teen film appear in other cultures. Focus on the liminality of teen film should set aside mimetic claims about the representation of adolescence and consider not only its organization around thresholds and transitions but also its organization around the processes of constructing, crossing (and recrossing) and interrogating these thresholds. National borders, of both the structural economic and the imagined cultural kind, are for this discussion as significant and as malleable as any marker of maturity. Teen film's reliance on the presumption of a trans-historical and trans-cultural idea of adolescence is made explicit in the ways the genre helps both produce and question important borders between cultures, generations, audiences, industries, and media. Teen film not only has narrative content centred on coming-of-age trajectories and the question of maturity but has produced, and continually refines, an historically significant audiovisual vocabulary that cannot be reduced to film style. This language crosses borders – a fresh-faced smile to the camera, a shadowed pout at an angle under a fringe of hair, the structured tableau of a classroom, the energy of contemporary beats, the contagious connectedness of young groups – but they are not only national ones. And this liminal sphere of adaptation and translation is continually producing new meanings for adolescence available to a wide range of audiences.

Notes

Chapter 1

1. Hall, as Doherty notes, 'had condemned the nineteenth-century economic environment as "one where our young people leap rather than grow into maturity," arguing that "youth needs repose, leisure, art, legends, romance, and, in a word, humanity, if it is to enter the world of man well equipped for man's highest work in the world"' (Doherty 2002: 41, quoting G. S. Hall 1911: xvii).

2. The emergence of modern adolescence can be closely aligned with the emergence of compulsory schooling to define and manage it. In England, for example, the 1840s saw the expansion of free grammar schools until, in 1880, school became compulsory until ten, an age raised in 1893 to thirteen, and in 1947 to fifteen. This is an influence on teen film considered in more detail in Chapter 2.

3. The 'Oedipus complex' was Freud's name for a crisis in which boys compete with their father for their mother's love or, otherwise, struggle to suppress their desire for that love (Freud 1953b).

4. In 1915, only a few years after the establishment of the BBFC in the UK, it was ruled in a key legal case in the US that film 'appealed to and excited prurient interest in its mass audience, made up, as it was, "not of women alone nor of men alone, but together, not of adults only, but of children"' (Lewis 2002: 90).

5. In 1922, when Pickford was twenty-nine, *Photoplay* captioned a studio portrait: 'The world has been waiting for Mary Pickford to grow up. But Mary says she will continue to leave the maturer roles to others. When we look at her here we think she's right.' But the following year the same magazine declared: 'the time has come when Mary must put up her curls, because life has made a woman of her. Womanliness is in the thoughts behind her eyes and it radiates outward. It is in the new lines of her body. In the warm understanding, the gentle curve of her lips. ... Wifehood, charity for the world, the love of a man, the desire for motherhood, the awakening of the girl-mind, – they're all there. And no curls, no slim, bare legs, no reproduction of child-actions can mask them any longer' (*Photoplay* 1923b: 40).

6. Holden is the central character of J.D. Salinger's novel *The Catcher in the Rye* (1951), an iconic story of adolescence in which an already jaded seventeen-year-old boy escapes the phony demands of the life organized for him to New York, where his adventures in dissatisfaction and fraud teach him little.

7. It is now tempting to consider this rehearsal of ideals as what American theorist Judith Butler (1990) would call performativity. Temple is always *doing* 'little girl' by restating what is already known about little girls. In another context I have discussed the ingénue in this way (Driscoll 2010: 79-81).

8. For detailed discussion of the emergence of girl culture focused on the 'bobby-soxer' figure see Kelly Schrum's *Some Wore Bobby Sox* (2004).

9. Several origins for the term are suggested but 'flapper' is always a label for femininity-challenging codes for both appearance and behaviour. The flapper was opposed to corsets and associated with short hair, shorter skirts, and newly active lives characterized by jobs, cars, smoking, drinking and dancing (Zeitz 2006).

10. In 1925, *Photoplay* states that Clara has 'given this nation of staccato standards its most vivid conception of this fantastic classification of girlhood and declares earnestly that she has folded her flapper ways and is under-taking the serious business of being a grown up young lady' (*Photoplay* 1925: 78).

Chapter 2

1. Considine's and Shary's accounts of teen film draw out similar patterns. For Considine, adolescence on screen is largely concerned with the family, with school and management of adolescents, and with sex. For Shary, the dominant themes are either 'sex, school and delinquency' (Shary 2005: 56) or 'delinquency, romance and schooling' (76).

2. Discussing 1950s girl-centred films, Whitney (2002: 57) also argues that 'The popularity of bastardized interpretations of psychoanalytic models of human desire grew out of [the] desire to reduce the complexities of the adolescent psyche to a system of easily understood rules and models.'

3. Considine records conflicting opinions about the new angst-ridden teen hero produced by these themes. For Joan Mellen, Dean's image allowed 'unprecedented freedom in acknowledging his hurt and disappointments so openly and without shame' (in Considine 1985: 82), but Pauline Kael felt that 'A boy's agonies should not be dwelt on so lovingly; being misunderstood may easily become the new glamorous lyricism' (in Considine 1985: 83).

4. As a check on these claims, the US National Center for Education Statistics records that in 1900 about 6 per cent of students graduated from high school, climbing rapidly from around 20 per cent in 1925 to over 50 per cent in 1940 (http://nces.ed.gov/).

5. As Doherty elaborates, and I will return to this in Chapter 8, the prominent theme track as appeal to a youth audience became a common production strategy equally evident, for example, in *To Sir With Love* (Lulu's 'To Sir With Love') and *Dangerous Minds* (Coolio's 'Gangster's Paradise').

6. Moondoggie's name is a tribute to DJ Alan Freed, who used the pseudonym 'Moondog' on air in 1951–2, until forced by a lawsuit to stop using it (Miller 1999: 57–60, 83–4). This is more than trivia because it is the only presence of the African-American origins of 'rock and roll' in *Gidget*, where the featured band of beach musicians is intensely white.

7. We might also connect Gidget to Barbie in this respect. While Barbie was *about* rather than *for* teenagers, she also appeared in 1959 and, by the 1960s, was predominantly styled as Gidget-ish beach girl with fashion accessories. As narrated by packaging, books, and other merchandising, Barbie intersects in many ways with Gidget: the names of her friends Midge (from 1963) and Francie (from 1966); her adventures, as in the novel *Barbie's Hawaiian Holiday* (1963); and the 1964 fashion sets 'Barbie in Hawaii' and 'Fashion Queen', the latter of which resembles Gidget's Rome styling. Erica Rand's counter-history, *Barbie's Queer Accessories* (1995) is a useful reference for fleshing out this connection.

8. Elvis-style heartthrob movies appeared around the world, and Cliff Richard in England is a particularly interesting comparison. He first appeared as a j.d. in *Serious Charge*, following Elvis's *Jailhouse Rock* in the conjunction of j.d. story and pop song performance. Richard had a shorter career, however, and also more quickly shifted from youth problem to teen party films.

Chapter 3

1. DeVaney employs several concepts that I find very useful for exploring teen film in later chapters, including governmentality (Chapter 7) and intertextuality (Chapter 8), but we have different emphases. For deVaney (2002: 203) the former describes the disciplinary monitoring of adolescents by the institutions of home and school (De Vaney 2002: 204-5), and the latter describes the resonance these 1980s films continue to have for contemporary viewers by citing still-current discourses in their lives.

2. Scott Murray (2009) suggests that Ferris's apparently spontaneous actions have been carefully planned in advance so that, for example, he knows the guest he impersonates at the restaurant will never arrive because it was his own booking. The evident flaw in this interpretation comes with the parade, which Murray claims Ferris must have a prior arrangement to sing in. The possibility that he had also organized teams of passers-by to dance in synchronized harmony seems untenable.

3. Often contested and now somewhat unfashionable, postmodernism generally describes the 'belatedness' of a culture that seems only to repeat the past and is incredulous concerning 'metanarratives' (Lyotard 1984: xxiii) like God, History, and Man.

4. Kaveney and others point out that *Heathers* contains multi-layered references to *The Catcher in the Rye* (Kaveney 2006: 54) – a text that I've now cited with reference to 1950s, 1960s, and 1980s films. In fact, Daniel Waters's shooting script for *Heathers* specifies Heather Duke's favourite novel as J. D. Salinger's novel rather than *Moby Dick* as it is in the film (Waters 1988).

5. The new gay boy Christian is explicitly cast against the Christian Slater type to be less James Dean than Frank Sinatra but, in a more contemporary mode, he is also Luke Perry, who played Dylan McKay, a James Dean figure in the hit teen TV series *Beverley Hills 90210* (1990-2000).

6. The stars of *Ferris Bueller's Day Off* are exemplary. Broderick was cast on the success of *WarGames*. Grey had prior supporting roles in the teen films *Reckless* (1984) and *Red Dawn* (1984) – which also starred Patrick Swayze, Thompson (from *Some Kind of Wonderful*) and Charlie Sheen – and went on to greater fame in *Dirty Dancing* with Swayze. Ruck had supporting parts in *Bad Boys* (starring *Taps*' Sean Penn and *The Breakfast Club*'s Sheedy) and *Class* (alongside Rob Lowe, from *St Elmo's Fire*, *Pretty in Pink*'s McCarthy, and Cusack, from *Sixteen Candles*, *Stand By Me* and *Say Anything ...*) and later supported Sheen in *Three for the Road* (1987) and was part of the youth-oriented Western ensemble film, *Young Guns II* (1990) with *The Breakfast Club*'s Estevez, Kiefer Sutherland from *Stand by Me* and *The Lost Boys*, and Slater from *Heathers* and *Pump Up the Volume*. Sara had previously starred in *Legend* with Cruise. And before his cameo, Sheen had previously starred in *The Boys Next Door* (1985) and with *The Lost Boys*' Corey Haim in *Lucas* (1986).

Chapter 4

1. In his essay 'A Semantic/Syntactic Approach to Film Genre', Altman distinguishes between the historical approach to genre, which implies an 'interpretative community' that agrees on the contents of genres, and the semiotic analysis of genre as a system distinguished from other genres around it. The latter he calls, crediting the influence of linguist Ferdinand de Saussure, structural semiotic analysis.

2. Doherty's associated claim that the teen film protagonist became too young for sex at this time is more spurious. When he could be discussing *Pump Up the Volume* (1990) and *Dazed and Confused* (1993), Doherty casts *Home Alone* (1990) and *Jurassic Park* (1993) as the new teenpics, stressing also the 'loopy humour and chaste decorum of the enormously popular *Wayne's World* (1992; 1994) and *Bill and Ted* (1989; 1993) series' (Doherty 2002: 201). Chaste doesn't seem an especially useful description of these films but this argument more generally fails because it avoids mainstream teen film of the time.

3. Jim's masturbatory drama has generated notable critical attention, usually focused on the importance of masturbation to representing boy sexuality at the end of the twentieth century. See, for example, Steven Schneider (2005) and Greg Tuck's (2010) discussion of masturbation and virginity.
4. *Porky's* (actually a Canadian rather than a US film) is also centred on virginity but, through slapstick and the marginalization of girl characters, it separates the virginity trope entirely from romance. Sex does not produce couples in the *Porky's* series.
5. In follow-up documentary material, *Animal House* writers acknowledged allegorical references to the scandals that brought down the Nixon administration but the film more explicitly parodies campus counter-culture and sophisticated pretentions. Otter tells Kent, anxious to 'score' with girls, that he should just 'Mention modern art, civil rights, or folk music and you're in like Flynn.'
6. Hoover becomes a public defender; Larry, editor of *National Lampoon*; Greg, a Nixon White House Aide; Otter, a gynaecologist; Kent, a 'sensitivity trainer'; and Niedermeyer is 'killed in Vietnam by his own troops'. Two couples explicitly mark the cultural change fermented in the animal house: 'Boon and Katy married 1964 [pause] divorced 1969', and Bluto and Mandy become 'Senator and Mrs John Blutarsky'.
7. In the sequel, *Harold and Kumar Escape From Guantanamo Bay* (2008) the grim jokes about racial profiling extend to Harold and Kumar's sentencing to the terrorist prison Guantanamo Bay, from which they must escape by staging an 'illegal immigration' from Cuba to Florida.

Chapter 5

1. I have watched most but not all films in these series and have relied on the *Internet Movie DataBase* (IMDB – http://www.imdb.com) for my understanding of plot and production details where I have not seen the film, or where the film is in production at the time of writing.
2. These films intersect in the work of scriptwriter Kevin Williamson, who wrote the first two 'Scream' films and *Summer1*. Williamson made his reputation before these films as writer for the award-winning teen soap, *Dawson's Creek* (1998–2003).
3. Freud's essay on 'The Uncanny' overlaps in several respects with his essay 'On Narcissism', in which narcissism produces the judgemental dimension of the self, or 'super ego' (Freud 1953a). This in turn connects to Freud's discussion of a childhood game he calls *'fort da'*, in which a child makes a toy go away and come back repeatedly as a step in understanding the self's separation from the other (or mother).

4. While the Romero franchise became increasingly aware of its own comic potential, it now includes a parodic supplement. In *Shaun of the Dead* (2004) the difficulty of directing one's life through competing expectations is resolved for a young British man by violent confrontation with both literal zombies and the metaphoric ones in his daily life.

5. *Don't Be a Menace* is in turn indebted to *Friday* (1995), a day-in-the-life stoner buddy film set in an African-American neighbourhood, where Smokey and Craig, on the margins of teen film adolescence, could be considered a precursor to *Harold and Kumar* (2004 – see Chapter 4).

6. *Teen Wolf* is more striking in this respect because it follows and cites John Landis's blackly comic *An American Werewolf in London* (1981) and Landis's direction of the famous video-clip for Michael Jackson's single 'Thriller'.

7. For detail on the series see Kaveney (2004). In this context I am omitting a third, non-audiovisual 'Buffy' text, the ongoing series of graphic/comic texts titled *Buffy Season 8* (2007–10).

8. In *Buffy1*, Buffy's valley girl image provides a clear precursor to Cher in *Clueless* (1995). Buffy thinks El Salvador is in Spain, as Cher thinks her Nicaraguan maid speaks Mexican, and while Cher is 'saving herself for Luke Perry' Buffy wants to 'graduate from high school, go to Europe, marry Christian Slater, and die.'

Chapter 6

1. In a playscript version, Burgess included a Shakespearean reference to youth's blindness to consequence and in the novel Alex decides, in the twenty-first chapter, that 'youth' is an unavoidable problem that will pass (Burgess 1968: 196). He determines to end his violent ways, grow up, and settle down. Kubrick, like the novel's American publishers, preferred the story without this closure.

2. *Scream* (1996) raises this debate more overtly when Billy claims 'Movies don't create psychos. Movies make psychos more creative!' But an earlier scene of adult hypocrisy is just as telling. Principal Himbry tells two students terrorizing the school in Ghostface costume that he hates their 'entire havoc-inducing, thieving, whoring generation' and wants to 'expose you for the heartless, desensitized little shits you are.' But we later see Himbry, wearing the costume himself, trying out scary poses in the mirror.

3. In the 1990s 'post-subculture' theory emerged to contest the Birmingham School model. Jettisoning the community- and identity-building image of subculture, the post-subculture argument is either that an identification of one's self with subcultural style was never necessary, or that such identity formation around style is no longer possible (Muggleton and Weinzierl 2003).

4. As Jon Savage (1994: 18) points out, 'A mix of time-travel and self-consciousness marks teen movies from "American Graffiti" to "Reality Bites".' He suggests that,

in the 1990s teen film, the 1970s was the retro period that the 'obsession with 1950s retro was to their parents' (Savage 1994: 18–19). But, as I suggested in Chapter 2, the cult of the 1950s also has an ongoing life in later films.

5. *Wayne's World* was based on comedy sketches for television set in high school. This is especially evident in the characterization of Garth's (Dana Carvey) sexuality as something uncomfortable and at times uncontrolled (as in his fantasy dance sequence to 'Foxy Lady'). Carvey describes the film as driven by the conventions of 'PG13 teen comedy'.

6. *Saturday Night Fever* takes up not only *West Side Story*'s opening pan of the city, zooming in on the young man's life, but also its gang narrative, ethnic divisions (now Italians and Puerto Ricans), dance-floor rivalry and a range of other motifs (Chapter 8).

Chapter 7

1. For this chapter I have taken ratings of films first of all from national classification board's websites, but in some cases these records are incomplete. The Hong Kong site, for example, does not list films for the first fifteen years of its history, and the Australian site lists films only since 1971 although the Commonwealth Film Censorship Board was formed in 1917. So I have supplemented this information with other references from film histories and IMDB.

2. It might seem that language must shape whether or not a film requires a more restrictive rating for its communication of 'mature' themes. However, a site produced by the Netherlands Institute for the Classification of Audiovisual Media comparing European ratings for popular films (http://www.kijkwijzer.nl/pagina. php?id=30) indicates a great deal of agreement in ratings for mainstream films across The Netherlands, Germany, France, Austria, Denmark, and Sweden, although with consistently more restrictive ratings in the UK

3. See, for example, Tom Johnson (2006: 9-14) and David Hutchinson (1999) on Britain, Uhde and Ng Uhde (2006: 71-82) on Singapore. Annette Kuhn's *Cinema, Censorship and Sexuality* (1988) discusses early twentieth-century film censorship as making 'a public sphere of cinema' but it does not focus on censorship as a discourse of protection, paradigmatically of the young, that presumed a model of adolescence.

4. This was also a self-regulatory code in which behaviours and identities defined as immoral or perverse were restricted unless represented with appropriate punishment. Devised in 1948 with explicit reference to the PCA, the CBC was institutionalized and strengthened in 1954, just as the PCA was losing its hold over the movies, framed by the opening claim that 'The comic-book medium, having come of age on the American cultural scene, must measure up to its responsibilities' (Nyberg 1998: 170). It was revised in 1971 after the MPAA ratings systems was introduced, and again in 1989 after 1980s MPAA revisions.

5. They must, however, have a viable declared audience. *Kick-Ass* has not been released in Italy because distributors were advised it would be rated VM18 and thus risk commercial failure with what they presumed would be a primarily adolescent audience (McKenzie 2010).

6. The 'age of sexual consent' is based on nineteenth-century renovations to English common law that shifted 'sexual maturity' from roughly the beginning of puberty to roughly the end (Driscoll 2002: 43-46; Waites 2009). The idea that the physical process of puberty and the social processes of education and training should precede sex spread at varying speeds across the nineteenth and twentieth centuries along colonial lines of power as well as along other transnational trade routes. It was part of a legislative nexus encompassing education, employment and suffrage, which helped define modern adolescence.

7. Snider claims Spielberg's initial suggestion was fourteen. Thirteen, however, was agreed upon by the MPAA and the National Association of Theater Owners, and more aptly fits the periodization of adolescence around entry to high school and puberty. A similar narrative could be offered for the introduction of the classification '9' in the Netherlands in response to *Harry Potter and the Prisoner of Azkaban* (2004). On this Netherlands classification shift, see Patricia Valkenburg (1997).

8. Lewis's (2002: 141–5) analysis of the importance to the introduction of the MPAA system of competition with films produced overseas and outside the US censorship system also offers an interesting parallel to Doherty's account of the impact of imported films on the Production Code (2002). See Shary's *Generation Multiplex* for a discussion of diversifying film distribution on 1980s films, that emphasizes the multiplex but considers home video (Shary 2002: 141).

9. Within media harm studies, overviews of rating practices support the complaint that MPAA treats sex far more restrictively than violence. Kirby Dick's expose of the MPAA system, *This Film Is Not Yet Rated* (Dick 2006) is especially committed to uncovering a bias against sex rather than violence in this system.

Chapter 8

1. The centrality of kissing in *Angus, Thongs and Perfect Snogging* is flagged in the title. But in adapting the book to the film, the 'ten stages of snogging' only get to seven on screen – 'Seven, upper body fondling, outdoors' – before being interrupted by the arrival of 'cute boys'. The climactic fifteenth birthday party can thus remain safely before the relevant age of consent and the triumphant kiss can be witnessed by parents.

2. Recalling the films discussed in Chapter 2, *Grease* explicitly references the adolescent angst and gang images of the j.d. films but most of all the clean-teen/musical sampling of Elvis, Pat Boone and *Gidget* (1959). Leo from the Scorpions

is part Chino (*The Wild One*) and part Buzz (*Rebel Without a Cause*). Sandy's nightgown song to the moon cites Debbie Reynolds in *Tammy and the Bachelor* (1957). From Boone's *April Love* (1957) it takes Sandy's most virtuous outfit and the final fair scene. From *West Side Story* it lifts Chacha Di Gregorio and the dance competition, as well as some elements of the gang dance numbers. And Frankie Avalon even appears as an angel.

3. In 2008, when Lohan was a standard of celebrity gossip magazines, she played Marilyn Monroe in a restaging of her famous 1962 nude photoshoot. Monroe's photographer, Bert Stern, claimed he 'was interested in Lohan because he suspected "she had a lot more depth to her" than one might assume from "those teenage movies"' (Fortini 2008).

4. As Kinder (1993: 2) notes, for media studies this has often come to mean that any text 'must be read ... in relationship to other texts', which is the source of the model of the 'active audience' on which much contemporary media studies is founded. Bakhtin (2002: 282) goes on to insist that 'every concrete act of understanding is active: it assimilates the word to be understood its own conceptual system filled with specific objects and emotional expressions.'

5. My use of the terms 'becoming' and 'performance' draw on much larger theoretical debates than I can discuss here. They are primarily associated now with the work of the philosopher Gilles Deleuze on becoming and assemblage (Deleuze 1990 and Deleuze and Guattari 1987) and that of the theorist Judith Butler, whose model of performativity I referred to in Chapter 1 (Butler 1990; 1993). Whether we think about a film as becoming-teen film through the connections made in its assemblage or as citing a generic ideal, both these approaches must understand genre as intrinsically open to adaptation.

6. Juliet complicates that opposition in troubling ways, given that no other youth on the Capulet side is either white or virtuous. But this is largely an emphasis on gender, as there are also no other girls in *Romeo + Juliet*. The domesticity of Juliet's life is continually opposed to the street, beach, and public life of Romeo and 'the boys, the boys'. When the famous Shakespearean balcony scene is replaced by a scene in a swimming pool it is therefore a meeting of their worlds, domestically confined yet out of doors.

7. Kaveney's reading of *Cruel Intentions* is apposite. She sees teen film as especially suited to the *Les Liaisons Dangereuses* (1872) story, making the fear and risk of total 'social ostracism' and an 'obsession with virginity' surprisingly credible in a contemporary setting (Kaveney 2006: 128). Her reading shows how Roger Kumble's adjustments to the plot represent important tensions in contemporary experiences of adolescence – revealing racism and homophobia in the expectations of teen film that stand in 'for the fine distinctions of class in the original' (Kaveney 2006: 129).

8. 'Fan fiction' is a term for amateur stories based on a pre-existing source text and associated connections (in this case the transmedia 'Harry Potter' text) organized

within a set of communities (most of which are now online) that make up a fandom (in this case 'HP'). In Jenkins's argument, such fan activities are continuous with the media industries that produce these source texts. This means that, on the one hand, the practices of adapting Shakespeare to teen film are a lot like fan texts and, on the other, that producers of later 'Harry Potter' texts will pay attention to fan responses to earlier ones.

9. This section draws on my own ethnographic work amongst HP fans (Driscoll 2006) which has encompassed sites that feature predominantly young participants (for example, http://www.fan fiction.net), sites that carefully structure interactions between younger and older participants (for example, http://www.sugarquill.net), sites with diverse demographics organized around communities with older leaders (for example, http://www.livejournal.com) and sites with generally older participants (like http://www.skyehawke.com).

10. The massive online HP fandom has resisted moves to press the 'Harry Potter' story into images of childhood at the same time as it is, in its community practices, concerned with the problems of monitoring online access to content that the maturity narratives of film classification systems would restrict. The ratings system generally used for fan fiction is the MPAA scale. As this scale is copyrighted and fan fiction communities are centrally concerned with copyright issues, some communities have coined alternative ratings systems, although these do not have the same efficacy in communicating content advice.

Chapter 9

1. It would be perfectly reasonable to argue that *Coklat Stroberi* is not a teen film but a queer film; but as I have already suggested the same argument could be made for US teen film. The tension between the queer coming-out story and teen film coming-of-age stories is grounded in the importance of heterosexual development and sociality to mainstream teen film and of representations of sex in film classification.

2. Again, the series is a little more subtle than it might seem. Daniel is not in 'Japan' but in Okinawa, continuing Miyagi's story about military service by referencing his own youth during the US military occupation of Japan. This is given iconic life for contemporary Okinawan teenagers when Daniel and Kumiko (Tamlyn Tomita) go to a 1950s dance. The fact that 1950s-style jive dancing was very popular in Japan in the 1980s gives a double meaning to this reference, counterposed without commentary, with rituals like tea ceremony and a 'cultural' dance framed as Japanese forms of dating.

3. My emphasis here does not mean the UK film industry has not also produced j.d. films, high-school films, and teen romantic comedies and dramas, including, in the 1980s, films like *Gregory's Girl* (1981) and *Hard Road* (1988). Just as

significantly, the 1980s is also the context in which co-productions across national borders became newly prevalent, including, in films like *Legend* (1985) and *Labyrinth* (1986), foundations for the US/UK collaborations on fantasy films from which the Harry Potter films emerged. Like *Legend* and *Labyrinth* these films prioritize a European history for their fantasies of adolescence and are usually first released in the UK.

4. *Slumdog Millionaire* is heavily indebted to *Salaam Bombay!* (1988), which is also a story of Mumbai street children struggling to achieve a better life. While *Salaam Bombay!* won Indian film awards, *Slumdog Millionaire* won a great deal more foreign critical awards, including, appositely, 'Teen Choice' awards.

5. *Bend it Like Beckham* is another film that I understand as teen film but Roz Kaveney excludes as too serious. For her, this film is too 'concerned to present a wider context in which Jess and Jules have to relate to their parents and the broader communities of which their parents are a part' (Kaveney 2006: 173). While it 'has more in common with American teen movies than one might expect', for Kaveney 'it is a film about issues as much as about having fun' and thus not a teen film (Kaveney 2006: 173).

6. Mizuko Ito has lead research into the labour and other cultural practices of such fan-producers, including detailed research into the practices of fan-subbing communities. Jenkins also aims to give context to this fan 'participation' in production.

7. Shōnen publications have no real equivalent in anglophone contexts, where explicitly gendered teen publishing is largely confined to girls. But its gender framing in a Japanese context crosses cultural borders into a transnational fandom context populated as much by girl-dominated fan fiction communities as by boy-centred fan cultures of expertise (sometimes referred to as *otaku*). In one of few discussions of anime in scholarship on teen film, Frances Gateward (2002: 274) argues that much anime can be read through the convention of women's film and discusses its use of gender at length.

Annotated Guide to Further Reading

Given that the chapters of this book extensively discuss the available scholarly monographs on teen film, these recommended readings focus on the idea of youth crucial to understanding teen film. Full publication details are included in the bibliography.

Joe Austin and Michael Willard (eds) (1998) *Generations of Youth: Youth Culture and History in Twentieth-century America.*
The introduction to this edited volume is a particularly useful discussion of the ambivalent place allotted to 'youth' in the last century of US culture. Subsequent chapters provide a range of different examples of youth culture. They focus particularly on racial difference and secondarily on gendered and sexed differences among youth and in defining youth. There are some direct references to teen film.

Barbara Ehrenreich, Elizabeth Hess, and Gloria Jacobs (1997) 'Beatlemania: A sexually defiant subculture?'
This essay balances the recollections of Beatles fans, media coverage of 'Beatlemania' and a range of contemporary expert discourse on the problem of young female desire in the Anglo-American 1960s. Although very focused, it also offers a subtle argument concerning the complexity that is often missed by discussions of youth culture dominated by an opposition between resistance and conformity.

Lawrence Grossberg (1992) *We Gotta Get Out of This Place: Popular Conservatism and Postmodern Culture.*
Grossberg's essays on popular culture and politics in this volume give a central place to ideas of youth and the politics of youth culture. The second of four parts includes very influential essays on rock and popular music, but youth recurs throughout as a way of thinking about the relationship between history, power and the popular (and its generationalization).

Alan France (2007) *Understanding Youth in Late Modernity.*
There is a wide range of excellent social science work on youth and youth culture that I cannot list here. This text provides a clear and well-referenced history of this field which is also importantly contextualized in the history of modernity. Whether or not a reader agrees with France's own analysis of that field of research, this is a useful introduction.

Donna Gaines (1991) *Teenage Wasteland: Suburbia's Dead End Kids.*
An ethnographic study of suburban New Jersey 'burnouts', this book is an excellent example of inter-disciplinary (if predominantly anthropological) research into youth culture. It combines effective close discussion of a particular mode of experiencing youth and consideration of the way ideas about adolescence are deployed by public policy, the media, and popular culture.

Stuart Hall and Tony Jefferson (eds) (1993) *Resistance Through Rituals: Youth Subcultures in Post-war Britain.*
This collection of essays represents the 'Birmingham School' of Cultural Studies' uniquely influential set of ideas about the symbolic structures and social transitions of youth culture in the British 1970s. It is worth revisiting despite the many later critiques and variations that take up more contemporary examples.

Pam Nilan and Carles Feixa (2006) (eds), *Global Youth? Hybrid Identities, Plural Worlds.*
This collection demonstrates many ways in which youth-directed popular culture and youth subcultural identity cross national boundaries. Although there is limited reference to film centred on youth the arguments presented here about hybrid cultural identification of and amongst youth and the impact of globalization on, and performance of globalization among youth, can be usefully extended to teen film.

Murray Pomerance and Frances Gateward (2005) (eds), both *Where the Boys Are: Cinemas of Masculinity and Youth* and (2002) *Sugar, Spice, and Everything Nice: Cinemas of Girlhood.*
These two collections provide an overview of loosely 'film studies' approaches to gender and youth on film with most essays referring to teen film as I have defined it here (the earlier collection on girls is more US-centric than the latter on boys). While I have cited many of these essays above, all are worth reading and these collections provide a diversity of perspectives that warrants an additional recommendation for their approach to cinematic representations of youth.

Jon Savage (2007) *Teenage: The Creation of Youth Culture.*
From a perspective that combines historical research and a journalistic approach to the cultural resonance of youth culture, this volume offers valuable context for thinking about what 'teen' means to contemporary Western history. While Savage's history is, from a scholarly perspective, comparatively untheorized, the material that he gathers gestures in an accessible way to the vast archives manifesting youth culture since the late nineteenth century.

Filmography (includes television)

10 Things I Hate About You. USA: Touchstone Pictures. Junger, Gil, dir. 1999.

17 Again. USA: Offspring Entertainment. Steers, Burr, dir. 2009.

A Clockwork Orange. UK: Warner Bros. Pictures. Kubrick, Stanley, dir. 1971.

A Hard Day's Night. UK: Proscenium Films; United Artists. Lester, Richard, dir. 1964.

Akira. Japan: Akira Committee Company Ltd. Ôtomo, Katsuhiro, dir. 1988.

Almost Famous. USA: Columbia Pictures. Crowe, Cameron, dir. 2000.

American Graffiti. USA: Universal Studios. Lucas, George, dir. 1973.

American Pie. USA: Universal Pictures. Weitz, Paul, dir. 1999.

An American Werewolf in London. UK; USA: American Werewolf Inc. Landis, John, dir. 1981.

Angels with Dirty Faces. USA: Warner Bros Pictures. Curtiz, Michael, dir. 1938.

Angus, Thongs, and Perfect Snogging. UK; USA, Germany: Goldcrest Pictures; Nickelodeon Pictures. Chadha, Gurinder, dir. 2008.

A Nightmare on Elm Street. USA: New Line Cinema. Craven, Wes, dir. 1984.

A Summer Place. USA: Warner Bros. Daves, Delmer, dir. 1959.

Back to the Future. USA: Universal Pictures. Zemeckis, Robert, dir. 1985.

Back to the Future Part II. USA: Universal Pictures. Zemeckis, Robert, dir. 1989.

Bend it Like Beckham. UK, Germany & USA: Chadha, Gurinder, dir. 2002.

Bhaji on the Beach. UK: Channel Four Films. Chadha, Gurinder, dir. 1993.

Bill and Ted's Bogus Journey. USA: Interscope Communications. Hewitt, Peter, dir. 1991.

Bill and Ted's Excellent Adventure. USA: De Laurentiis Entertainment Group. Herek, Stephen, dir. 1989.

Blackboard Jungle. USA: Metro-Goldwyn-Mayer. Brooks, Richard, dir. 1955.

Bleach. Japan: TV Tokyo. Abe, Noriyuki, dir. Kubo, Tite, creator 2004–.

Blue Lagoon. USA: Columbia Pictures. Kleiser, Randal, dir. 1980.

Boys Town. USA: Metro-Goldwyn-Mayer. Taurog, Norman, dir. 1938.

Boyz n the Hood. USA: Columbia Pictures Corporation. Singleton, John, dir. 1991.

Bride and Prejudice. USA; UK: Pathé Pictures International. Chadha, Gurinder, dir. 2004.

Bring it On. USA: Universal Pictures; Beacon. Reed, Peyton, dir. 2000.

Broken Blossoms. USA: D.W. Griffith Productions. Griffith, D. W., dir. 1919.

Buffy the Vampire Slayer. USA: Twentieth Century Fox. Kuzui, Fran Rubel, dir. 1992.

Buffy the Vampire Slayer. USA: Warner Bros/UPN. Whedon, Joss, creator. 1997–2003.

Can't Hardly Wait. USA: Columbia Pictures. Elfont, Harry, and Deborah Kaplan, dir. 1998.

Carrie. USA: Redbank Films. dePalma, Brian, dir. 1976.

City Across the River. USA: Universal International Pictures. Shane, Maxwell, dir. 1949.

Class of 1984. Canada: Guerilla High Productions. Lester, Mark, dir. 1984.

Clueless. USA: Paramount Pictures. Heckerling, Amy, dir. 1995.

Coklat Stroberi (Chocolate Strawberry). Indonesia: Investasi Film Indonesia. Octaviand, Ardy, dir. 2007.

Cruel Intentions. USA: Columbia Pictures. Kumble, Roger, dir. 1999.

Dangerous Minds. USA: Hollywood Pictures. Smith, John M., dir. 1995.

Dawn of the Dead. USA: Laurel Group. Romero, George A., dir. 1978.

Dead End. USA: United Artists. Wyler, WIlliam, dir. 1937.

Diary of the Dead. USA: Artfire Films. Romero, George A., dir. 2007.

Dino. USA: Allied Artists Pictures. Carr, Thomas, dir. 1957.

Dirty Dancing. USA: Vestron Pictures; Lionsgate. Ardolino, Emile, dir. 1987.

Donnie Darko. USA: Pandora Cinema. Kelly, Richard, dir. 2001.

Don't Be a Menace to South Central While Drinking Your Juice in the Hood. USA: Island Pictures. Barclay, Paris, dir. 1996.

Easy Rider. USA: Columbia Pictures. Hopper, Dennis, dir. 1969.

Edward Scissorhands. USA: Twentieth Century Fox. Burton, Tim, dir. 1990.

Fast Times at Ridgemont High. USA: Refugee Films; Universal Pictures. Heckerling, Amy, dir. 1982.

Ferris Bueller's Day Off. USA: Paramount Pictures. Hughes, John, dir. 1986.

Flaming Youth. USA: Associated First National Pictures. Dillon, John Francis, dir. 1923.

Freaky Friday. USA: Casual Friday Productions; Walt Disney Pictures. Waters, Mark, dir. 2003.

Freaky Friday. USA: Walt Disney Productions. Nelson, Gary, dir. 1976.

Friday. USA: New Line Cinema. Gray, F. Gary, dir. 1995.

Friday the Thirteenth. USA: Georgetown Productions Inc. Cunningham, Sean S., dir. 1980.

G.I. Blues. USA: Paramount Pictures. Taurog, Norman, dir. 1960.

Gidget. USA: Columbia. Wendkos, Paul, dir. 1959.

Gidget Goes Hawaiian. USA: Columbia Pictures International. Wendkos, Paul, dir. 1961.

Gidget Goes to Rome. USA: Columbia Pictures Corporation. Wendkos, Paul, dir. 1963.

Grease. USA: Paramount. Kleiser, Randal, dir. 1978.

Gregory's Girl. UK: ITC Entertainment. Forsyth, Bill, dir. 1981.

Gremlins. USA: Warner Bros Pictures; Amblin Entertainment. Dante, Joe, dir. 1984.

Grit. USA: Film Guild. Tuttle, Frank, dir. 1924.

Halloween. USA: Compass International Pictures. Carpenter, John, dir. 1978.

Happy Days. USA: ABC network. Marshall, Garry, dir. 1974–84.

Harold and Kumar Escape from Guantanamo Bay. USA: New Line Cinema. Hurwitz, Jon, and Hayden Schlossberg, dir. 2008.

Harold and Kumar Go To Whitecastle. USA: Endgame Entertainment. Leiner, Danny, dir. 2004.

Harry Potter and the Chamber of Secrets. UK; USA: Warner Bros. Columbus, Chris, dir. 2002.

Harry Potter and the Goblet of Fire. US; UK: Warner Bros. Newell, Mike, dir. 2004.

Harry Potter and the Order of the Phoenix. UK; USA: Warner Bros Pictures. Yates, David, dir. 2007.

Harry Potter and the Philosopher's Stone. UK; USA: Warner Bros. Columbus, Chris, dir. 2001.

Harry Potter and the Prisoner of Azkaban. UK; USA: Warner Bros Pictures. Cuarón, Alfonso, dir. 2004.

Heathers. USA: New World Pictures. Lehmann, Michael, dir. 1988.

Hell's Angels. USA: The Caddo Company. Hughes, Howard, dir. 1930.

High School Musical. USA: Disney Channel. Ortega, Kenny, dir. 2006.

House Party. USA: Hudlin Brothers, The; New Line Cinema. Hudlin, Reginald, dir. 1990.

Human Traffic. UK: Irish Screen. Kerrigan, Justin, dir. 1999.

I Was a Teenage Werewolf. USA: American International Pictures. Fowler, Gene, dir. 1957.

If. UK: Memorial Enterprises. Anderson, Lindsay, dir. 1968.

It. USA: Famous Players-Lasky Corporation. Badger, Clarence G., dir. 1927.

Jaane Tu … Ya Jaane Na (*Whether You Know … Or Not*). India: Aamir Khan Productions. Tyrewala, Abbas, dir. 2008.

Jailhouse Rock. USA: Avon Productions II. Thorpe, Richard, dir. 1958.

Jawbreaker. USA: Crossroads Films. Stein, Darren, dir. 1999.

Juno. USA: Mandate Pictures; 20th Century Fox. Reitman, Jason, dir. 2007.

Ju-On (*The Grudge*). Japan: Pioneer LDC. Shimizu, Takashi, dir. 2002.

Kick-Ass. USA/UK: Marv/Plan Bf. Vaughn, Matthew, dir. 2010.

Kid Auto Races at Venice. USA: Keystone Film Company. Lehrman, Henry, dir. 1914.

Kids. USA: Shining Excalibur Pictures. Clark, Larry, dir. 1995.

Kiss and Tell. USA: Columbia Pictures. Wallace, Richard, dir. 1945.

Kya Kehna (*What to Say*). India: Tips Music Films. Shah, Kundan, dir. 2000.

Life Begins Andy Hardy. USA: Metro-Goldwyn-Mayer. Seitz, George B., dir. 1941.

Little Darlings. USA: Stephen Friedman/Kings Road Productions. Maxwell, Ronald F., dir. 1980.

Love Finds Andy Hardy. USA: Metro-Goldwyn-Mayer. Seitz, George B., dir. 1938.

Mean Girls. USA: Paramount Pictures. Waters, Mark, dir. 2004.

Meatballs. Canada: Canadian Film Development Corporation. Reitman, Ivan, dir. 1979.

Modern Times. USA: Charles Chaplin Productions. Chaplin, Charlie, dir. 1936.

My Beautiful Laundrette. UK: Mainline Pictures. Frears, Stephen, dir. 1985.

My Own Private Idaho. USA: New Line Cinema. van Sant, Gus, dir. 1991.

National Lampoon's Animal House. USA: Universal Pictures. Landis, John, dir. 1978.

Night of the Living Dead. USA: Image Ten. Romero, George A., dir. 1968.

Not Another Teen Movie. USA: Columbia Pictures. Gallen, Joel, dir. 2001.

Ordinary People. USA: Paramount Pictures. Redford, Robert, dir. 1981.

Our Dancing Daughters. USA: Cosmopolitan Productions. Beaumont, Harry, dir. 1928.

Porky's. Canada: Melvin Simon Productions. Clark, Bob, dir. 1982.

Pretty in Pink. USA: Paramount Pictures. Deutch, Howard, dir. 1986.

Puberty Blues. Australia: Limelight Productions. Beresford, Bruce, dir. 1981.

Qayamat Se Qayamat Tak. India: Nasir Hussain Films. Khan, Mansoor, dir. 1988.

Quadrophenia. UK: The Who Films; Polytel. Roddam, Franc, dir. 1979.

Rebel without a Cause. USA: Warner Bros. Ray, Nicholas, dir. 1955.

Revenge of the Nerds. USA: Interscope Communications. Kanew, Jeff, dir. 1984.

Ringu (Ring). Japan: Omega Project. Nakata, Hideo, dir. 1988.

Risky Business. USA: The Geffen Company. Brickman, Paul, dir. 1983.

River's Edge. USA: Hemdale Film. Hunter, Tim, dir. 1986.

Rock Around the Clock. USA: Columbia Pictures/Clover Productions. Sears, Fred F., dir. 1956.

Romeo and Juliet. UK; Italy: BHE Films. Zeffirelli, Franco, dir. 1968.

Saturday Night Fever. USA: Robert Stigwood Organization (RSO); Paramount. Badham, John, dir. 1977.

Say Anything . . . USA: Twentieth Century-Fox. Crowe, Cameron, dir. 1989.

Scary Movie. USA: Dimension Films. Wayans, Keenen Ivory, dir. 2000.

School Daze. USA: 40 Acres & A Mule Filmworks. Lee, Spike, dir. 1988.

Scream. USA: Miramax. Craven, Wes, dir. 1996.

Serious Charge. UK: Alva Motion Pictures. Young, Terence, dir. 1959.

Shaun of the Dead. UK: Studio Canal. Wright, Edgar, dir. 2004.

She's All That. USA: Miramax. Iscove, Robert, dir. 1999.

She's Having a Baby. USA: Hughes Entertainment. Hughes, John, dir. 1988.

Sixteen Candles. USA: Channel Productions. Hughes, John, dir. 1984.

Slumdog Millionaire. UK: Pathé Pictures International; Celador Films; Film4. Boyle, Danny, and Loveleen Tandan, dir. 2008.

Some Kind of Wonderful. USA: Hughes Entertainment. Deutch, Howard, dir. 1987.

St Elmo's Fire. USA: Columbia Pictures. Schumacher, Joel, dir. 1985.

Stand and Deliver. USA: Warner Bros. Menéndez, dir. 1988.

Stand By Me. USA: Sony Pictures. Reiner, Rob, dir. 1986.

Stowaway. USA: Twentieth Century Fox. Seiter, William A., dir. 1936.

Strictly Ballroom. Australia: M & A. Luhrmann, Baz, dir. 1992.

Superbad. USA: Columbia Pictures. Mottola, Greg, dir. 2007.

Taifû Kurabu (Typhoon Club). Japan: Kuzui Enterprises. Sômai, Shinji, dir. 1985.

Teen Wolf. USA: Wolfkill. Daniel, Rod, dir. 1985.

Teree Sang. India: Karol Bagh Film and Entertainment. Kaushik, Satish, dir. 2009.

The Bachelor and the Bobby-Soxer. USA: RKO Radio Pictures. Reis, Irving, dir. 1947.

The Basketball Diaries. USA: New Line Cinema. Kalvert, Scott, dir. 1995.

The Belles of St Trinian's. UK: British Lion. Launder, Frank, dir. 1954.

The Birth of a Nation. USA: David W. Griffith Co. Griffith, D. W., dir. 1915.

The Breakfast Club. USA: A&M Films. Hughes, John, dir. 1985.

The Courtship of Andy Hardy. USA: Metro-Goldwyn-Mayer. Seitz, George B., dir. 1942.

The Girl Next Door. USA: Twentieth Century Fox. Greenfield, Luke, dir. 2004.

The Graduate. USA: Embassy Pictures. Nichols, Mike, dir. 1967.

The Karate Kid. USA: Columbia Pictures. Avildsen, John G., dir. 1984.

The Karate Kid II. USA: Columbia Pictures. Avildsen, John G., dir. 1986.

The Kid. USA: Charles Chaplin Productions. Chaplin, Charlie, dir. 1921.

The Last American Virgin. USA: Golan-Globus Productions. Davidson, Boaz, dir. 1982.

The Lost Boys. USA: Warner Bros. Schumacher, Joel, dir. 1987.

The Plastic Age. USA: B.P. Schulberg Productions. Ruggles, Wesley, dir. 1925.

The Secret of My Succe$s. USA: Universal Studios. Ross, Herbert, dir. 1987.

The Texas Chain Saw Massacre. USA: Vortex. Hooper, Tobe, dir. 1974.

The Warriors. USA: Paramount Pictures. Hill, Walter, dir. 1979.

The Wild One. USA: Stanley Kramer Productions. Benedek, Laslo, dir. 1953.

The Wild Party. USA: Paramount/MCA-Universal. Arzner, Dorothy, dir. 1929.

The Year My Voice Broke. Australia: Kennedy Miller Productions. Duigan, John, dir. 1987.

This Film Is Not Yet Rated. USA; UK: Independent Film Channel. Dick, Kirby, dir. 2006.

To Sir with Love. UK: Columbia Pictures. Clavell, James, dir. 1967.

Trainspotting. UK: Channel 4 Films. Boyle, Danny, dir. 1996.

Twilight. USA: Summit Entertainment. Hardwicke, Catherine, dir. 2008.

Twin Town. UK: Agenda. Allen, Kevin, dir. 1997.

Up in Smoke. USA: Paramount Pictures. Adler, Lou, dir. 1978.

Varsity Blues. USA: Tova Laiter Production/MTV Productions. Robbins, Brian, dir. 1999.

WarGames. USA: Metro-Goldwyn-Mayer. Badham, John, dir. 1983.

Wayne's World. USA: Paramount Pictures. Spheeris, Penelope, dir. 1992.

Wayne's World 2. USA: Paramount Pictures. Surjik, Stephen, dir. 1993.

Weird Science. USA: Universal Pictures. Hughes, John, dir. 1985.

West Side Story. USA: Mirisch Corporation, The. Robbins, Jerome, and Robert Wise, dir. 1961.

What's Eating Gilbert Grape?. USA: J&M Entertainment; Paramount. Hallström, Lasse, dir. 1993.

Where the Boys Are. USA: Metro-Goldwyn-Mayer. Levin, Henry, dir. 1960.

William Shakespeare's Romeo + Juliet. USA: Bazmark; 20th Century Fox. Luhrmann, Baz, dir. 1996.

Bibliography

Althusser, L. (1994) 'Ideology and Ideological State Apparatuses', in *Cultural Theory and Popular Culture*, ed. J. Storey. Hemel Hempstead: Harvester Wheatsheaf, pp. 151–63.

Altman, R. ([1984] 2004) 'A Semantic/Syntactic Approach to Film Genre', in *Film Theory and Criticism*, eds L. Braudy and M. Cohen. New York: Oxford University Press, pp. 680–90.

Ames, Christopher (2005) 'Cinematic Solutions to the Truancy Trend among Japanese Boys', in *Where the Boys Are: Cinemas of Masculinity and Youth*, eds M. Pomerance and F. K. Gateward. Detroit: Wayne State University Press, pp. 297–332.

Anderson, J. L. and Richie, D. (1982) *The Japanese Film: Art and Industry*. 2nd edn. Princeton: Princeton University Press.

Austin, J., and Willard, M. N. (1998) 'Introduction: Angels of History, Demons of Culture', in *Generations of Youth: Youth Cultures and History in Twentieth-century America*, eds J. Austin and M. N. Willard. New York: New York University Press, pp. 1–20.

Bakhtin, M. M. (1984) *Rabelais and His World*. Translated by H. Iswolsky. Bloomington, IN: Indiana University Press.

Bakhtin, M. M. ([1975] 2002) *The Dialogic Imagination: Four Essays*. Translated by C. Emerson. Edited by M. Holquist. Austin: University of Texas Press.

Barrett, W. A. (1926) 'The Work of The National Board of Review,' *Annals of the American Academy of Political and Social Science* 128: 175–86.

Benton, M., Dolan, M. and Zisch, R. (1997) 'Teen Films: An Annotated Bibliography,' *Journal of Popular Film and Television* 25: 83–8.

Bernstein, J. (1997) *Pretty in Pink: The Golden Age of Teenage Movies*. New York: St Martin's Press.

Bernstein, M. and Pratt, D. (1985) 'Comic Ambivalence in Risky Business,' *Film Criticism* 9(3): 33–43.

Bourdieu, P. ([1984] 1986) *Distinction: A Social Critique of the Judgement of Taste*. Translated by R. Nice. Cambridge, MA: Harvard University Press.

Burgess, A. (1962) *A Clockwork Orange*. London: Heinemann.

Burgess, A. (1978) *1985*. London: Hutchinson.

Burt, R. (2002a) *Shakespeare after Mass Media*. New York: Palgrave Macmillan.

Burt, R. (2002b) 'T(e)en Things I Hate about Girlene Shakesploitation Flicks in the Late 1990s, or, Not-So-Fast Times at Shakespeare High,' in *Spectacular*

Shakespeare: Critical Theory and Popular Cinema, eds C. Lehmann and L. S. Starks. London: Associated University Press, pp. 205–32.

Butler, J. (1990) *Gender Trouble: Feminism and the Subversion of Identity*. New York: Routledge.

Butler, J. (1993) *Bodies That Matter: On the Discursive Limits of Sex*. New York: Routledge.

Caine, A. J. (2004) *Interpreting Rock Movies: The Pop Film and its Critics in Britain*. Manchester: Manchester University Press.

CARA Rules Revisions Chart (2009) NATO, www.natoonline.org/CARA%20 Rules%20revisions%20CHART.pdf, accessed 29 December 2009.

Cartmell, D. ([2000] 2007) 'Franco Zeffirelli and Shakespeare,' in *The Cambridge Companion to Shakespeare on Film*, ed. R. Jackson. Cambridge: Cambridge University Press, pp. 216–25.

Ciecko, A. T, (ed.) (2006) *Contemporary Asian Cinema: Popular Culture in a Global Frame*. London: Berg.

Clover, C. J. (1992) *Men, Women and Chainsaws: Gender in the Modern Horror Film*. London: BFI.

Cohen, M. (1996) *Discussion with Larry Clark,* www.artcommotion.com/VisualArts/indexa.html, accessed 7 October 2009.

Cohen, S. (1973) *Folk Devils and Moral Panics*. London: Routledge.

Cohn, N. (1976) 'Tribal Rites of the New Saturday Night', *New York*, 7 June.

Considine, D. M. (1985) *The Cinema of Adolescence*. New York: McFarland.

Craig, P. and Fradley, M. (2010) 'Teenage Traumata: Youth, Affective Politics, Contemporary American Horror Film', in *American Horror Film: The Genre at the Turn of the Millennium*, ed. S. Hantke. Jackson. Jackson, MS: The University Press of Mississippi, pp. 77–101.

Creed, B. (1993) *The Monstrous-Feminine: Film, Feminism, Psychoanalysis*. London: Routledge.

Creekmur, C. (2005) 'Bombay Boys: Discovering the Male Child in Popular Hindi Cinema', in *Where the Boys Are: Cinemas of Masculinity and Youth*, eds M. Pomerance and F. K. Gateward. Detroit: Wayne State University Press, pp. 350–376.

Crowdus, G. (1998) 'Shakespeare in the Cinema: A Film Directors' Symposium with Peter Brook, Sir Peter Hall, Richard Loncraine, Baz Luhrmann, Trevor Nunn, Oliver Parker, Roman Polanski and Franco Zeffirelli', *Cineaste* 24(1) (Winter): 48–55.

Curnutt, K. (2004) *A Historical Guide to F. Scott Fitzgerald*. Oxford: Oxford University Press.

Davidson, B. (1957) '18,000,000 Teen-Agers Can't Be Wrong', *Colliers*, 4 January, pp. 13–25.

Deleuze, G. ([1969] 1990) *The Logic of Sense*. Translated by M. Lester. Edited by C. V. Boundas. New York: Columbia University Press.

Deleuze, G. and Guattari, F. ([1980] 1987) *A Thousand Plateaus*. Translated by B. Massumi, 2 vols. Vol. 2, 'Capitalism and Schizophrenia.' Minneapolis, MN: University of Minnesota Press.

Denisoff, R. S. and Romanowski, W. D. (1991) *Risky Business: Rock in Film*. New Brunswick: Transaction Publishers.

deVaney, A. (2002) 'Pretty in Pink? John Hughes Reinscribes Daddy's Girl in Homes and Schools', in *Sugar, Spice, and Everything Nice: Cinemas of Girlhood*, eds F. K. Gateward and M. Pomerance. Detroit, MI: Wayne State University Press, pp. 201–16.

Doherty, T. (2002) *Teenagers and Teenpics: The Juvenilization of American Movies in the 1950s*. 2nd edn. Philadelphia: Temple University Press.

Doherty, T. (2007) *Hollywood's Censor: Joseph I. Breen and the Production Code Administration*. New York: Columbia University Press.

Douglas, M. (2002) *Purity and Danger: An Analysis of Concept of Pollution and Taboo*. London: Routledge.

Dresner, L. M. (2010) 'Love's Labor's Lost? Early 1980s Representations of Girls' Sexual Decision Making in *Fast Times at Ridgemont High* and *Little Darlings*', in *Virgin Territory: Representing Sexual Inexperience in Film*, ed. T. J. McDonald. Detroit, MI: Wayne State University Press, pp. 174–200.

Driscoll, C. (2002) *Girls: Feminine Adolescence in Popular Culture and Cultural Theory*. New York: Columbia University Press.

Driscoll, C. (2006) 'One True Pairing: The Romance of Pornography and the Pornography of Romance,' in *Fan Fiction and Fan Communities in the Age of the Internet*, eds K. Busse and K. Hellekson. Jefferson, NC: McFarland, pp. 79–96.

Driscoll, C. (2010). *Modernist Cultural Studies*. Miami, FL, University Press of Florida.

Ebert, R. (2010) 'Kick-Ass.' *Chicago Sun Times* (April 14), http://rogerebert. suntimes.com/apps/pbcs.dll/article?AID=/20100414/reviews/100419986.

Ehrenreich, B., Hess, E. and Jacobs, G. (1997) 'Beatlemania: A Sexually Defiant Subculture?' in *The Subculture Reader*, eds K. Gelder and S. Thornton. London: Routledge, pp. 523–36.

Epstein, Daniel (2004) *Luke Greenfield of Girl Next Door Interview*. UGO, www. ugo.com/channels/filmtv/features/thegirlnextdoor/interview.asp, accessed 9 April 2010.

Erikson, E. H. (1962) 'Youth: Fidelity and Diversity,' *Daedalus* (Winter): 23–34.

Falconer, P. (2010) 'Fresh Meat? Dissecting the Horror Movie Virgin.' In *Virgin Territory: Representing Sexual Inexperience in Film*, ed. T. J. McDonald. Detroit: Wayne State University Press, pp. 123–37.

Fernandez, J. R. D. (2008) 'Teen Shakespeare Films: An Annotated Survey of Criticism,' *Shakespeare Bulletin* 26(2): 89–133.

Feuer, J. ([1993] 2004) 'A Postscript for the Nineties,' in *Popular Music: The Rock Era*, ed. S. Frith. London: Routledge, pp. 228–40.

'Film Ratings' (2010) *MPAA*, www.mpaa.org/ratings, accessed 9 April 2010.

Forman-Brunell, M. (2002). 'Maternity, Murder, and Monsters: Legends of Babysitter Horror', in *Sugar, Spice, and Everything Nice: Cinemas of Girlhood*, eds F. K. Gateward and M. Pomerance. Detroit, MI: Wayne State University Press, pp. 253–268.

Fortini, A. (2008) 'Lindsay Lohan as Marilyn Monroe in "The Last Sitting"', *New York Magazine* (February 8), http://nymag.com/fashion/08/spring/44247/.

Foucault, M. ([1976] 1984) *The History of Sexuality: An Introduction*. Translated by R. Hurley. 3 vols. Vol. 1. Harmondsworth: Penguin.

Foucault, M. (1991a) 'On Governmentality', in *The Foucault Effect*. Chicago: University of Chicago Press, pp. 5–21.

Foucault, M. (1991b) 'Politics and the Study of Discourse', in *The Foucault Effect*. Chicago: University of Chicago Press, pp. 53–72.

France, A. (2007) *Understanding Youth in Late Modernity*. London: Open University Press.

French, E. (2006) *Selling Shakespeare to Hollywood: The Marketing of Filmed Shakespeare Adaptations from 1989 into the New Millennium*. Hatfield: University of Hertfordshire Press.

Freud, S. ([1914] 1953a) 'On Narcissism: An Introduction,' in *The Standard Edition of the Complete Psychological Works of Sigmund Freud*. London: The Hogarth Press, pp. 73–102.

Freud, S. ([1924] 1953b) 'The Dissolution of the Oedipus Complex,' in *The Standard Edition of the Complete Psychological Works of Sigmund Freud*. London: The Hogarth Press, pp. 173–82.

Freud, S. ([1919] 2003) 'The Uncanny,' in *The Uncanny*. New York: Penguin.

Frow, J. (2006) *Genre*. New York: Routledge.

Gaines, D. (1991) *Teenage Wasteland: Suburbia's Dead End Kids*. New York: Pantheon Books.

Gateward, F. (2002) 'Bubblegum and Heavy Metal,' in *Sugar, Spice, and Everything Nice: Cinemas of Girlhood*, eds F. K. Gateward and M. Pomerance. Detroit, MI: Wayne State University Press, pp. 168–84.

Gelder, K. (1994) *Reading the Vampire*. London: Routledge.

Gilchrist, T. (2004) *An Interview with Luke Greenfield*. IGN, 4 February 2004, http://au.movies.ign.com/articles/490/490053p1.html, accessed 9 April 2010.

Giroux, H. A. (1991) *Postmodernism, Feminism, and Cultural Politics: Redrawing Educational Boundaries*. New York: SUNY Press.

Grossberg, L. ([1986] 1994) 'The Deconstruction of Youth,' in *Cultural Theory and Popular Culture: A Reader*, ed. J. Storey. Hemel Hempstead: Harvester Wheatsheaf, pp. 183–90.

Grossberg, L. (1992) *We Gotta Get Out of This Place: Popular Conservatism and Postmodern Culture*. New York: Routledge.

Gunning, T. (2004) 'Re-newing Old Technologies: Astonishment, Second Nature, and the Uncanny in Technology from the Previous Turn-of-the-Century', in

Rethinking Media Change: The Aesthetics of Transition, eds D. Thorburn and H. Jenkins. Boston: MIT Press, pp. 39–60.

Hall, G. S. ([1904] 1911) *Adolescence: Its Psychology and its Relations to Physiology, Anthropology, Sociology, Sex, Crime, Religion, and Education*. 2 vols. New York: Appleton.

Hall, L. ([1930] 1971) 'What About Clara Bow? Will the Immortal Flapper Learn Self-discipline? Or is she Fated to Dance Her Way to Oblivion?' In *The Talkies; Articles and Illustrations from Photoplay Magazine, 1928–1940*, ed. R. Griffith. New York: Dover Publications, pp. 20, 275.

Hall, S. and Jefferson, T. (eds) ([1975] 1993) *Resistance Through Rituals: Youth Subcultures in Post-war Britain*. London: Routledge.

Harper, J. (2009) *Flowers from Hell* Hereford: Noir Publishing.

Hebdige, D. (1979) *Subculture: The Meaning of Style*. London: Methuen & Co.

Herbst, Jurgen (1967) 'High School and Youth in America.' *Journal of Contemporary History* 2(3): 165–82.

Hills, M. (2005) 'Ringing the Changes: Cult Distinctions and Cultural Differences in US Fans' Readings of Japanese Horror Cinema,' in *Japanese Horror Cinema*, ed. J. McRoy. Edinburgh: Edinburgh University Press, pp. 161–75.

Hopkins, L. (2003) 'Harry Potter and the Acquisition of Knowledge,' in *Reading Harry Potter: Critical Essays*, ed. G. L. Anatol. New York: Greenwood Publishing Group, pp. 25–34.

Huggins, N. and Salter, M. (2002) *Richard Kelly, Writer and Director of Donnie Darko*, www.futuremovies.co.uk/filmmaking.asp?ID=1, accessed 7 May 2010.

Hurlock, E. (1955) *Adolescent Development*. 2nd edn. New York: McGraw-Hill.

Hutcheon, L. (2000) *A Theory of Parody: The Teachings of Twentieth-century Art Forms*. Chicago: University of Illinois Press.

Hutchison, D. (1999) *Media Policy: An Introduction*. London: Wiley-Blackwell.

Internet Movie Database, www.imdb.com, accessed 29 August 2010.

Jameson, F. (1983) 'Postmodernism and Consumer Society,' in *The Anti-Aesthetic: Essays on Postmodern Culture*, ed. H. Foster. Washington: Bay Press, pp. 111–25.

Jameson, F. (1991) *Postmodernism, or, the Cultural Logic of Late Capitalism*. Durham: Duke University Press.

Jameson, F. (1992) *Signatures of the Visible*. New York and London: Routledge.

Jancovich, M. (1996) *Rational Fears: American Horror in the 1950s*. Manchester: Manchester University Press.

Jenkins, H. (2006) *Convergence Culture: Where Old and New Media Collide*. New York: New York University Press.

Johnson, T. (2006) *Censored Screams: The British Ban on Hollywood Horror in the Thirties*. New York: McFarland.

Kaveney, R. (2004) *Reading the Vampire Slayer: The New, Updated, Unofficial Guide to Buffy and Angel*. 2nd edn. London: I. B. Tauris.

Kaveney, R. (2006) *Teen Dreams: Reading Teen film from Heathers to Veronica Mars*. London: I. B. Tauris.

Keam, A. (2006) 'The "Shakesteen" Genre: Claire Danes's Star-body, Teen Female Fans, and the Pluralization of Authorship', *Borrowers and Lenders: The Journal of Shakespeare and Appropriation* 2(1): 1–24.

Kelly, R., Gyllenhaal, J. and Conroy Scott, K. (2003) *The Donnie Darko Book.* New York: Macmillan.

Kerouac, J. (1957/2002) *On the Road.* Harmondsworth: Penguin.

'Kick-Ass' (2010) *At the Movies.* ABC, 7 April 2010, www.abc.net.au/atthemovies/txt/s2852859.htm, accessed 9 April 2010.

Kidd, K. (2004) 'He's Gotta Have It: Teen Film as Sex Education.' *Sexual Pedagogies: Sex Education in Britain, Australia, and America, 1879–2000,* eds C. Nelson and M. H. Martin. New York: Palgrave Macmillan, pp. 95–112.

Kinder, M. (1993) *Playing with Power in Movies, Television, and Video Games: From Muppet Babies to Teenage Mutant Ninja Turtles.* Berkeley, CA: University of California Press.

Kleinhans, C. (2002). 'Girls on the Edge of the Reagan Era', *Sugar, Spice, and Everything Nice: Cinemas of Girlhood,* eds F. K. Gateward and M. Pomerance. Detroit, MI: Wayne State University Press, pp. 73–90.

Kracauer, S. (1995) *The Mass Ornament.* Translated by T. Y. Levin. Cambridge MA: Harvard University Press.

Kristeva, J. (1982) *Powers of Horror: An Essay on Abjection.* Translated by L. S. Roudiez. New York: Columbia University Press.

Krows, A. E. (1926) 'Literature and the Motion Picture', *Annals of the American Academy of Political and Social Science* 128: 70–3.

Kuhn, A. (1988) *Cinema, Censorship, and Sexuality, 1909–1925.* London: Taylor & Francis.

Lebeau, V. (1995) *Lost Angels: Psychoanalysis and Cinema.* New York: Routledge.

LaBruce, B. (2005) *Leo Fitzpatrick,* http://www.indexmagazine.com/interviews/leo_fitzpatrick.shtml, accessed 7 October 2009.

LeDuff, C. (1996) 'Saturday Night Fever: The Life', *New York Times,* 9 June.

Lewis, J. (1992) *The Road to Romance and Ruin: Teen Films and Youth Culture.* London: Routledge.

Lewis, J. ([2000] 2002) *Hollywood V. Hard Core: How the struggle over censorship created the modern film industry.* New York: New York University Press.

Lynd, R. S., and Lynd, H. M. (1929) *Middletown: A Study in American Culture.* New York: Harcourt, Brace & Co.

Lynd, R. S., and Lynd, H. M. ([1935] 1982) *Middletown in Transition: A Study in Cultural Conflicts.* New York: Harcourt, Brace & Co.

Lyotard, J.-F. (1984). *The Postmodern Condition: A Report on Knowledge.* Minneapolis, MN, University of Minnesota Press.

Martin, A. (1994) 'Teen Movies: The Forgetting of Wisdom,' in *Phantasms.* Ringwood, Vic.: McPhee Gribble, pp. 63–9.

Mckenzie, C. (2010) *Kick-Ass: In Italia non lo compra nessuno?* (31 March 2010), www.badtaste.it/index.php?option=com_content&task=view&id=12478&Item id=152, accessed 1 May 2010.

Miller, L. (1999) *Flowers in the Dustbin: The Rise of Rock and Roll, 1947–1977.* New York: Simon & Schuster.

Mitchell, A. M. (1929) *Children and Movies.* Chicago, IL: The University of Chicago Press.

Mitchell, C. and Reid-Walsh, J. (eds) (2005) *Seven Going on Seventeen.* New York: Peter Lang.

ModModWorld (2007) *1950s Juvenile Delinquent Movie Trailers #1*, 12 February, www.youtube.com/watch?v=u7nwC0VapnQ, accessed 12 October 2009.

Moss, J. (1998) 'Introduction: the Later Foucault.' In *The Later Foucault: Politics and philosophy*, ed. J. Moss. London: Sage, pp. 1–16.

Muggleton, D. and Weinzierl, R. (eds) (2003) *The Post-Subcultures Reader.* Oxford: Berg.

Murray, S. (2009) '"Cameron Fry, this one's for you." Or: Why the Sausage King of Chicago Doesn't Turn Up for Lunch at Chez Quis.' *Senses of Cinema* (51), http://archive.sensesofcinema.com/contents/09/51/ferris-buellers-day-off.html.

Nash, I. (2010) 'The Innocent Is a Broad: American Virgins in a Global Context,' in *Virgin Territory: Representing Sexual Inexperience in Film*, ed. T. J. McDonald. Detroit, MI: Wayne State University Press, pp. 34–53.

Neale, S. (1984) 'Halloween: Suspense, Aggression and the Look,' in *Planks of Reason: Essays on the Horror Film*, ed. B. K. Grant. Metuchen, NJ: Scarecrow, pp. 356–69.

Nilan, P. and Feixa, C. (eds) (2006) *Global Youth? Hybrid Identities, Plural Worlds.* London: Routledge.

Nyberg, A. K. (1998) *Seal of Approval: The History of the Comics Code.* Jackson, MS: University Press of Mississippi.

Paul, W. (1995) *Laughing, Screaming: Modern Hollywood Horror and Comedy.* New York: Columbia University Press.

Pearce, S. (2003) '"As Wholesome As …": *American Pie* as a New Millennium Sex Manual,' in *Youth Cultures: Texts, Images, Identities*, eds K. Mallan and S. Pearce. Westport, CT: Praeger, pp. 69–80.

Photoplay (1922) 'Review of Salome, dir. A. Nazimova', August, p. 67.

Photoplay (1923) 'Interview with D.W. Griffith', August, p. 35.

Photoplay (1923b) 'How They Do Grow Up', October, p. 40.

Photoplay (1925) 'Clara Bow', June, p. 78.

Photoplay (1927) 'The Quest for It', April, p. 109.

Pomerance, M. (2005) 'The Man-Boys of Steven Spielberg', in *Where the Boys Are: Cinemas of Masculinity and Youth*, eds M. Pomerance and F. K. Gateward. Detroit. MI: Wayne State University Press, pp. 133–54.

Pomerance, M. and Frances K. Gateward (eds) (2002) *Sugar, Spice, and Everything Nice: Cinemas of Girlhood*. Detroit, MI: Wayne State University Press.

Pomerance, M. and Frances K. Gateward (eds) (2005) *Where the Boys Are: Cinemas of Masculinity and Youth*. Detroit, MI: Wayne State University Press.

Projansky, S. (2007) 'Gender, Race, Feminism, and the International Girl Hero: The Unremarkable US Popular Press Reception of *Bend It Like Beckham* and *Whale Rider*', in *Youth Culture in Global Cinema*, eds T. Shary and A. Seibel. Austin, TX: University of Texas Press, pp. 189–206.

Ramsaye, T. (1926) *A Million and One Nights: A History of the Motion Picture through 1925*. New York: Simon & Schuster.

Rand, E. (1995) *Barbie's Queer Accessories*. Durham: Duke University Press.

Rapfogel, J. (2002) 'Teen Schizophrenia: *Donnie Darko*.' *Senses of Cinema* (21), http://archive.sensesofcinema.com/contents/02/21/darko.html.

'Reasons for Movie Ratings' (2010) *Classification and Ratings Administration*, www.filmratings.com/filmRatings_Cara/, accessed 10 April 2010.

Regester, C. (2005) 'The Feminization and Victimization of the African American Athlete in *Boyz N the Hood*, *Cooley High*, and *Cornbread, Earl and Me*.' In *Where the Boys Are: Cinemas of Masculinity and Youth*, eds M. Pomerance and F. K. Gateward. Detroit: Wayne State University Press, pp. 333–49.

Roberts, K. (2002) 'Pleasures and Problems of the "Angry Girl"', in *Sugar, Spice, and Everything Nice: Cinemas of Girlhood*, eds F. K. Gateward and M. Pomerance. Detroit: Wayne State University Press, pp. 217–34.

Robson, E. (2007) 'Gothic Television', in *The Routledge Companion to Gothic*, eds C. Spooner and E. McEvoy. London: Routledge, pp. 242–50.

Salinger, J. D. (1951) *The Catcher in the Rye*. Boston, MA: Little, Brown & Company.

Saturday Evening Post (1944) 'They Showed How Juvenile Delinquency Can Be Licked', 24 April.

Savage, J. (1994) 'Boomers and Busters', *Sight and Sound* 4(7): 18–20.

Savage, J. (2007) *Teenage: The Creation of Youth Culture*. London: Viking.

Scheiner, G. (2000) *Signifying Female Adolescence: Film Representations and Fans, 1920–1950*. New York: Praeger.

Schneider, S. J. (2005) 'Jerkus Interruptus: The Terrible Trials of Masturbating Boys in Recent Hollywood Cinema', in *Where the Boys Are: Cinemas of Masculinity and Youth*, eds M. Pomerance and F. K. Gateward. Detroit, MI: Wayne State University Press, pp. 377–93.

Schrum, K. (2004) *Some Wore Bobby Sox: The Emergence of Teenage Girls' Culture, 1920–1945*. New York: Palgrave Macmillan.

Schulberg, B. P. (1924) 'Meet the Adolescent Industry: Being an Answer to Some Popular Fallacies', *Photoplay*, May, p. 98.

Shakespeare, W. ([1597] 1981) *Romeo and Juliet*. Harmondsworth: Penguin.

Shakespeare, W. ([1623] 1982) *The Taming of the Shrew*. London: Methuen.

Shary, T. (2002) *Generation: Multiplex: The Image of Youth in Contemporary American Cinema.* Austin, TX: University of Texas Press.

Shary, T. (2005) *Teen Movies: American Youth on Screen.* New York: Wallflower Press.

Shary, T. and Seibel, A. (2007) *Youth Culture in Global Cinema.* Austin, TX: University of Texas Press.

Silverblatt, A. (2007) 'Judge Hardy's Nightmare: Generational Role Reversal and Postmodern Adolescence', in *Genre Studies in Mass Media: A Handbook.* New York: M. E. Sharpe.

Snider, E. D. (2009) *Happy 25th Birthday, PG-13 Rating!* 25 July, www.cinematical. com/2009/07/25/happy-25th-birthday-pg-13-rating/, accessed 5 February 2010.

Sobchack, V. (1996) 'Bringing It All Back Home: Family Economy and Generic Exchange', in *The Dread of Difference: Gender and the Horror Film*, ed. B. K. Grant. Austin, TX: University of Texas Press, pp. 143–63.

Stern, L. (1997) *Emma in Los Angeles: Clueless as a Remake of the Book and the City,* www.lib.latrobe.edu.au/AHR/archive/Issue-August-1997/stern.html, accessed 12 January 2000.

Stewart, G. (2007) *Framed Time: Toward a Postfilmic Cinema.* Chicago, IL: University of Chicago Press.

Storck, H. (1950) 'The Entertainment Film for Juvenile Audiences.' Paris: UNESCO.

Stuever, H. (2009) 'Most Likely to Understand.' *Washington Post,* 8 August, www. washingtonpost.com/wp-dyn/content/article/2009/08/07/AR2009080703506. html.

Thompson, H. (1970) 'Film Code Ratings Revised to Include Age and Label Shifts.' *New York Times*, 28 January, p. 46.

Traube, E. (1992) *Dreaming Identities: Class, Gender, and Generation in 1980s Hollywood Movies.* Boulder, CO: Westview.

Troyer, J. and Marchiselli, C. (2005) 'Slack, Slacker, Slackest: Homosocial Bonding Practices in Contemporary Dude Cinema', in *Where the Boys Are: Cinemas of Masculinity and Youth*, eds M. Pomerance and F. K. Gateward. Detroit, MI: Wayne State University Press, pp. 264–78.

Tuck, G. (2010) 'Orgasmic (Teenage) Virgins: Masturbation and Virginity in Contemporary American Cinema', in *Virgin Territory: Representing Sexual Inexperience in Film*, ed. T. J. McDonald. Detroit, MI: Wayne State University Press, pp. 157–73.

Turner, V. (1967) *The Forest of Symbols: Aspects of Ndembu Ritual.* Ithaca, NY: Cornell University Press.

Uhde, J. and Uhde, Y. N. (2006) 'Singapore: Developments, Challenges, and Projections', in *Contemporary Asian Cinema: Popular Culture in a Global Frame*, ed. A. T. Ciecko, pp. 71–82.

Valkenburg, P. M. (1997) *Vierkante ogen: opgroeien met TV en PC.* Amsterdam: Balans.

Waites, M. (2009) *The Age of Consent: Young People, Sexuality and Citizenship*. New York: Palgrave Macmillan.

Wald, G. (1999) 'Clueless in the Neocolonial World Order.' *Camera Obscura: Feminism, Culture, and Media Studies* 42: 51–61.

Wall, W. D., and Simson, W. A. (1950) 'The Emotional Responses of Adolescent Groups to Certain Films.' *British Journal of Educational Psychology* 20: 153–63.

Waters, D. (1988) *'Heathers,' Shooting Script*. Daily Script 14 December 1988, www.dailyscript.com/scripts/heathers_shooting.html, accessed 14 December 2009.

Welsh, I. ([1993] 1996) *Trainspotting*. London: Minerva.

Whitney, A. (2002) 'Gidget Goes Hysterical.' In *Sugar, Spice, and Everything Nice: Cinemas of Girlhood*, eds F. K. Gateward and M. Pomerance. Detroit, MI: Wayne State University Press, pp. 55–72.

Williams, T. (1996) 'Trying to Survive on the Darker Side: 1980s Family Horror', in *The Dread of Difference: Gender and the Horror Film*, ed. B. K. Grant. Austin, TX: University of Texas Press, pp. 164–80.

Womack, J. (1995) 'Teenage Lust', *Spin*, September, pp. 66–70.

Xu, F. (2010) 'Movie Rating System "Unfeasible"', *China Daily*, 27 January.

Yoshimoto, M. (2007) 'Questions of the New: Ōshima Nagisa's *Cruel Story of Youth* (1960)', in *Japanese Cinema: Texts and Contexts*, eds A. Phillips and J. Stringer. New York: Routledge, pp. 168–179.

Young, D. (1926) 'Social Standards and the Motion Picture', *Annals of the American Academy of Political and Social Science* 128: 146–50.

Zeitz, J. (2006) *Flapper: A Madcap Story of Sex, Style, Celebrity, and the Women who made America Modern*. London: Crown.

Zhu, L. (2004) 'First Film Rating Scheme in the Making', *China Daily*, 17 December.

Index

CPSIA information can be obtained at www.ICGtesting.com
Printed in the USA
LVOW10s1636210115

423784LV00004B/19/P